Maritime Sketches
by
Paul C. Morris

Rounding Brant Point, Nantucket, 1860.

A pictorial history of North America's eastern sea coast.

The Illustration on the front cover is a topsail schooner, circa 1812.

COPYRIGHT © 1985 BY PAUL C. MORRIS

All rights reserved.

Library of Congress Catalog Card Number 85-50662

Printed in the United States of America by:
BookCrafters, Incorporated, Chelsea, Michigan

Published by: The Lower Cape Publishing Co.
P.O. Box 901, Orleans, Massachusetts 02653

FIRST EDITION

ISBN 0-936972-07-6

Other books by Paul C. Morris:
American Sailing Coasters of the North Atlantic (1973)
Four Masted Schooners of the East Coast (1975)
The Island Steamers (1977) (Co-Author Joseph F. Morin)
Schooners and Schooner Barges (1984)

FOREWORD

Art is described in the dictionary as skill in performance, acquired by experience, study or observation, carried out with ingenuity, talent and logic. The gamut of marine art is masterfully portrayed in this book with its myriad of nautical scenes. In order to cover the subject, Paul Morris has called on a keen memory and some diligent research to present the variety of maritime sketches with intricate details from the "downeaster" to the "pinky".

Fifteen years ago, during my career as a television news photographer, I was assigned to a story on Nantucket with reporter Arch MacDonald. During the course of the story, we stopped to interview a marine painter who was also a scrimshaw artist. It was here that I met Paul and learned to appreciate the beauty of the work of the scrimshander. I was, at the time, working on my first shipwreck book. Paul and I became fast friends as he assisted me in my effort with some photographs of wrecks around the island of Nantucket.

Shipwrecks often occur at sea where there are no photographers to record them. It is then that eyewitness accounts enable the artist to recreate the scene. Sometime, extensive research is required to render the drawing in true perspective and correct situation. Substantial study was needed to find the position of the "Alma E.A. Holmes" in 1914, when she was struck by the steamer "Belfast". Was she on the port or starboard tack? In May, 1934, the White Star liner "Olympic", proceeding in dense fog, struck the Nantucket lightship and sank her with the loss of seven men. Was she struck on the port or starboard side? After the research was completed, the results proved dramatic. These works of art are included in this book and are among my favorites. The acquisition of this book to ones library is another valuable addition for the collector in the maritime field.

William P. Quinn
Orleans, Massachusetts

Rigged out for fishin'
A portrait of the author rendered by his long time friend and fellow Nantucket Artist, Jack Brown.

Introduction

 This is a sketch book. It is not meant to be an anatomical study in perfect detail. The pictures are, I believe, reasonable representations of the vessels that they are supposed to portray. Back in the days when I was attending school, which is more years ago than I like to think about, I spent many hours drawing pictures of ships; ships of all kinds. Much to the exasperation of my teachers and my parents, when I was supposed to be doing school work I was often sailing away to the seven seas upon vessels portrayed on paper that was supposed to demonstrate my understanding of French, math, English and other "boring stuff." The fact that I graduated with reasonably good grades came somewhat as a surprise to me as well as to some of those dedicated and hard-working school teachers.

 Although my interest and occupations have varied to some extent, I never outgrew my love of tall ships and still like to sit down and doodle over a drawing portraying some kind of salty watercraft. This book contains many maritime sketches done over quite a long span of time for a variety of people and purposes. One fine day, my wife, Signy Ann, suggested that we should gather together whatever drawings that could be located and put them into a book. This we did. We found that from a historical standpoint there were a great many gaps that needed filling in, so I did what I thought was necessary and made some new drawings to fill the gaps. Some of the pictures found on these pages have been used in previous books. A great many were used by my friend and fellow marine historian, Bill Quinn, in his "Shipwreck" books. More than a few were done just for this publication and I must confess, it was fun doing them; almost as much as back in the days when I should have been doing my school work. I hope that you enjoy them, too. Enough said. Let's weigh anchor, Matey, and get this vessel under way.

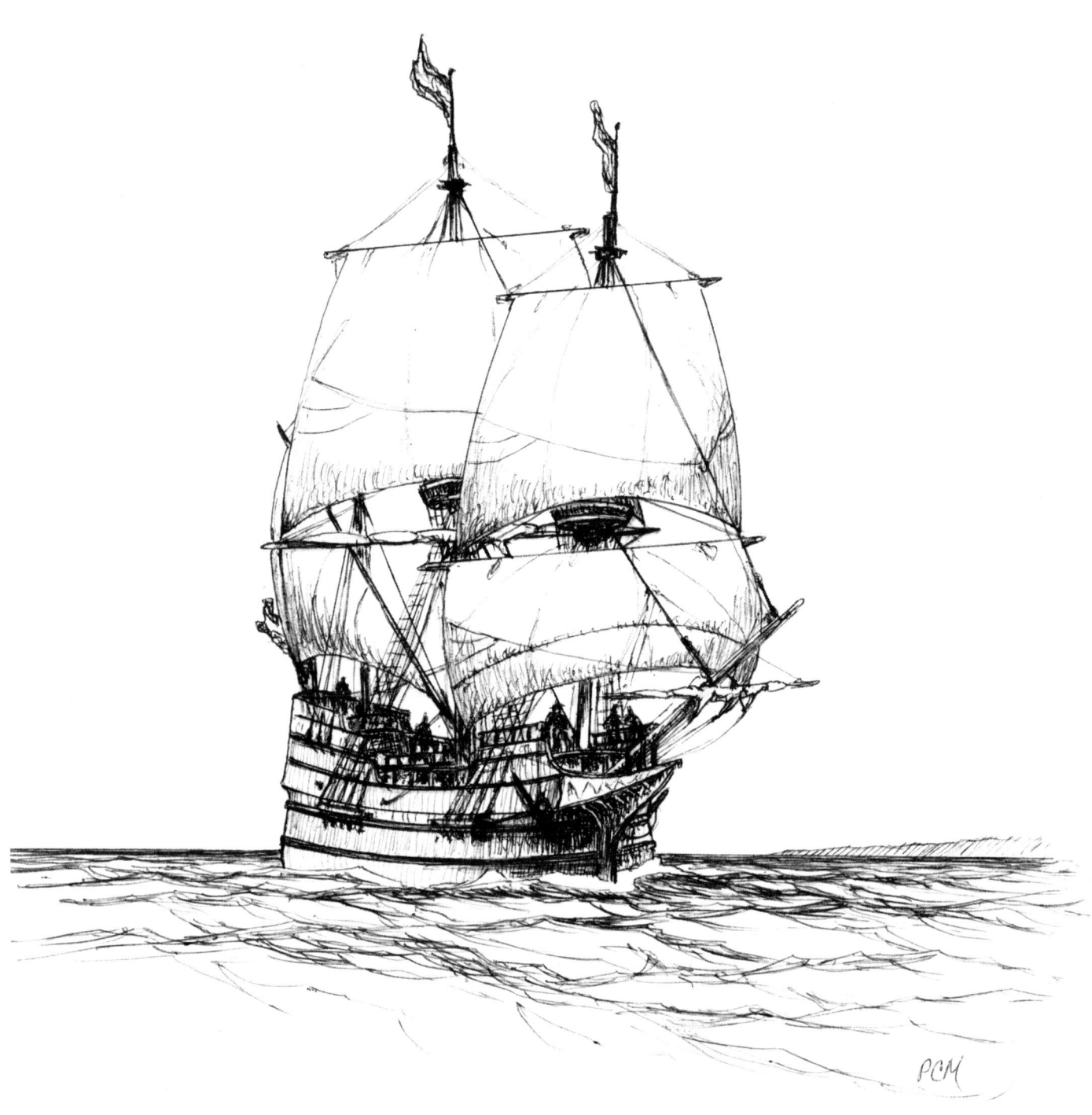

A galleon from Europe cautiously approaches the uncharted shores of the new world. Vessels such as the one shown were used for a long period of time in the late 1500's and early 1600's.

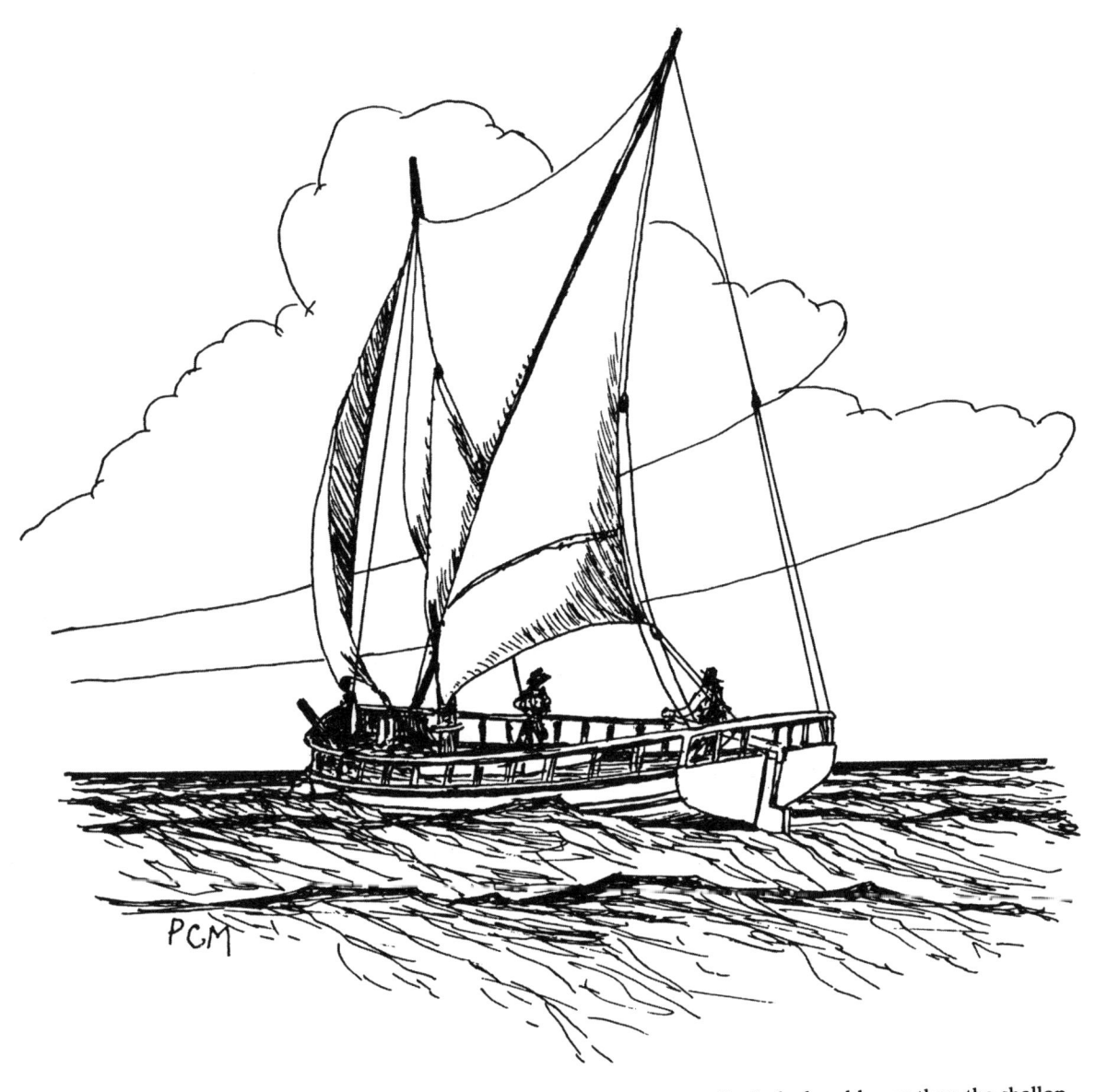

An early colonial pinnace with spritsail and jib. The pinnace was usually decked and larger than the shallop. (Illustration used in *American Sailing Coasters of the North Atlantic*.)

A Brief History

Some of the very early, large sailing vessels that visited our eastern shores looked like the galleon shown on the opposite page. The "Half Moon", the "Mayflower" and many of the European vessels that ventured into the waters off of what we now call our eastern seaboard looked something like the ship pictured here. They belonged to a period that included the late 1500's and the early 1600's. The vessels weren't large by today's standards, but when manned by hardy early mariners, they made some very lengthy voyages.

After the first settlers had arrived and put up their new houses, it wasn't long before they began building small vessels for fishing purposes and for carrying local produce along the coast. One of the earliest of these constructions was the 30 ton pinnace "Virginia", built at Pophams Beach, Maine, in 1607. Most of the colonial ship building in this country was on the small side for a considerable period of time. The differing names given to their vessel types is

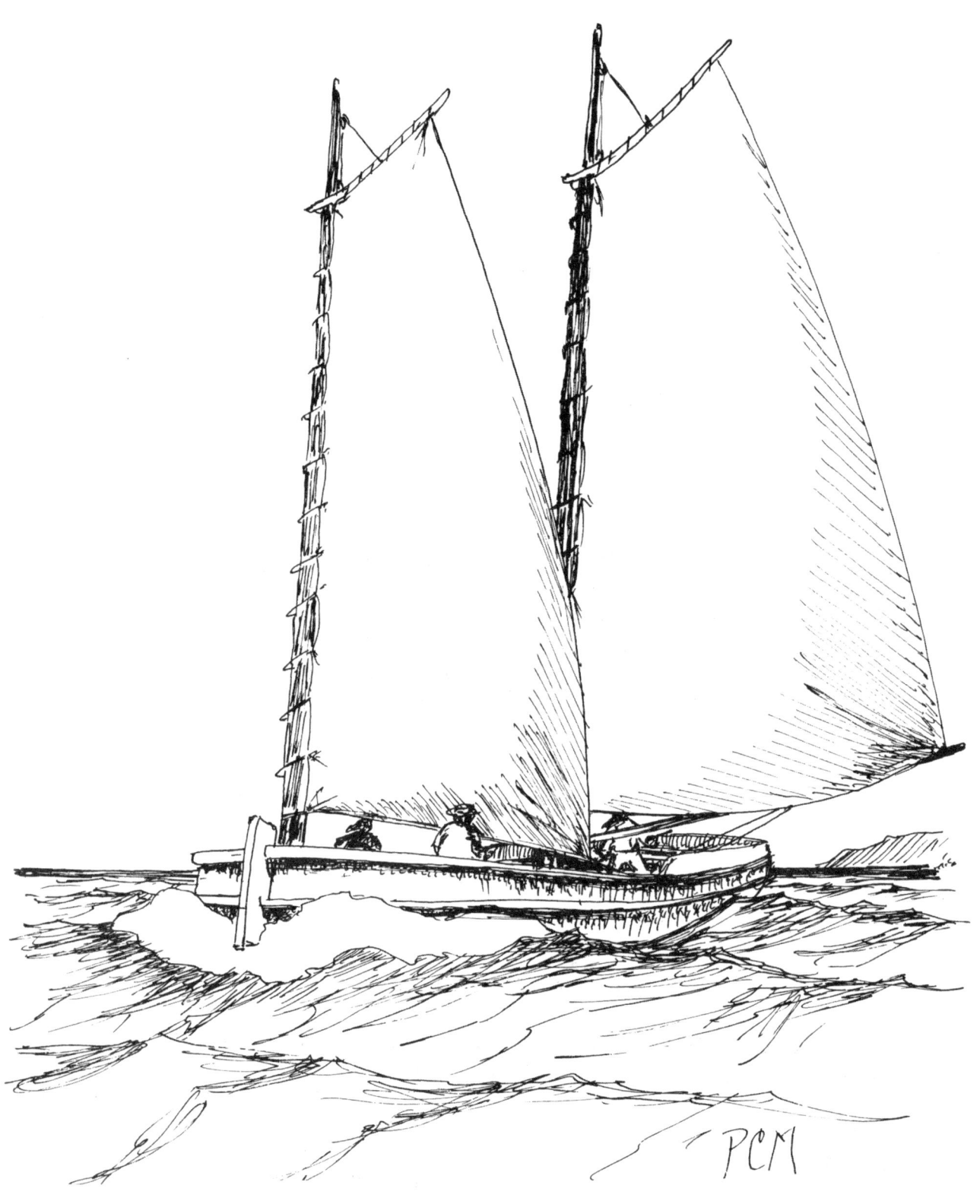

A shallop fitted with gaff rigged foresail and mainsail. The shallop was often open or only partically decked. (Illustration used in *American Sailing Coasters of the North Atlantic.*)

confusing to many of us today. For example, the craft shown in the fourth illustration was called a "bark", and was built in New England around 1640. It is indeed a far cry from the bark rigged vessels of the late 1800's and early 1900's. Shallops, galleys, pinnaces, galleons, sloops and a large number of other types of sailing craft were to be found off of our eastern shoreline in the 1600's. Gradually the names used to identify the vessels changed from those describing hull types to describing rig alone. Although the schooner rig was certainly not invented in America, it was, in all probability adopted, or adapted, from small vessels built in Europe. Historian Howard I. Chapelle stated that he thought that the rig in this hemisphere might have evolved from the colonial ketches, or "catches", built here in the early days. Certainly by the mid to late 1700's, schooners had developed into a well defined rig, having two masts and very often carrying a square topsail, or topsails. Sloops as well as schooners grew in size. Many sloops were also rigged with square topsails. However, being rigged with but one mast had its limitations as far as size was concerned. The schooner rig was eventually the one to prevail on the larger vessels.

A great many of the larger vessels that were sailing in the 1700's were armed. Conditions between nations were often on a warlike level and in addition to the threat of being caught by an unfriendly warship or privateer was the unpleasant possibility of being overtaken and boarded by pirates. This scourge was to be found in a great many of the areas that were traveled by our early seafarers. The West Indies in particular was long a hot bed of piratical activity. The last recorded act of piracy on our side of the Atlantic occurred in 1832, when the brig "Mexican", of Salem, Massachusetts, was attacked and captured by the pirate schooner "Panda". Some of those desperadoes were caught and subsequently hanged for their misdeeds. However, in as much as "Billy Bones" wasn't much inclined towards keeping "business records", it's more than probable that some pirates continued to prey on merchant vessels well into the 1840's and possibly even longer.

As the need for larger carriers arose the size of schooner hulls continued to increase. Just when the first three masted schooner was built is moot. As early paintings show us, some unusual three masted schooners were built in the Baltimore area in the late 1700's and early 1800's. These were built more for speed than for carrying capacity. It wasn't until the 1850's, when the schooners "Kate Brigham" and "Eckford Webb" were launched in New York state, that later day characteristics began to emerge. These three masted schooners were more burdensome than their southern cousins and had three masts that were equal in height.

As our country prospered, travel increased. Passengers as well as freight were carried more easily and quickly by boat in and along coastal waterways. Until the railroads began to cut into the trade, passengers were more inclined to trust their bodies and souls to a sailing packet, or later a steam packet, rather than endure the rigors of traveling by stage coach. Some of the very early steamboats were crude contraptions and for a time boiler explosions, fires and other mishaps kept the more cautious traveling by sail. More and more immigrants were coming to our shores after the War of 1812, and as ship design improved, faster sailing packets were employed. These packets were advertised as sailing on a fixed schedule. Many of the larger packets sailed from Europe to ports such as Boston or New York. The famous Black Ball Line, which was organized around 1817, ran from Liverpool to New York and was the first to sail its vessels on a scheduled basis. As the line prospered their vessels grew in size and by 1850 had become famous both in word and song. Their packets carried both passengers and freight and were the forerunners of our famous clipper ships.

Our so called "Clipper Ship Era" was in fact not a very long lasting period of time. The need for exceptionally fast carriers to transport miners to our west coast arose after the discovery of gold in California in 1849. Voyages to China and Australia also required fast ships and for a brief while ships designed and built in America by people such as William Webb, David Greenman, Irons & Grinnell, Currier & Townsend and of course Donald McKay, made worldwide reputations for their speed. However, the global depression that occurred in the 1850's had a severe impact on our clipper ships and by 1857, many of them were found to be unemployed. Many of the clippers were not large in size and with their lofty rigs, which required large crews and their cargo space reduced to accommodate speed, they had to give way to more burdensome vessels.

By the 1850's, of course, steamships had made great inroads in the passenger trades, especially on coastal routes. In those days, a seaside visitor was apt to see a fairly large variety of seagoing craft appearing over the horizon. The sea still held about it an aura of mystery and romance that beckoned to the spirit of adventure that beat in the heart of many young boys growing up in the eastern United States.

The fishing and whaling industries had been growing and to a great extent, prospering during much of this time. Nantucket had become a leading port in the whaling business and by 1820, vessels from this tiny island were traveling to the far reaches of the Pacific Ocean in search of whale oil. The Sperm Whale was the preferred victim of these venturesome sea hunters. This industry continued until the Civil War decimated the fleets and the bar at the entrance to Nantucket harbor hindered the operation of the larger vessels. New Bedford, thereafter claimed credit for the largest whaleship operation on our eastern shore. The last whaling vessel to leave the port of New Bedford was the schooner "John R. Manta", which left in 1925 on an Atlantic whaling voyage.

Gloucester, Massachusetts, earned for itself the reputation as the leading fishing headquarters of the eastern United States. Boston and New York, however, equally handled delivery of a large portion of the catch. From colonial times right to the present, fishing has been a very important occupation for many New Englanders. There were also a large number of differing types of vessels involved in a great variety of fishing methods. Hand lining from small vessels was the early method used to catch fish. This continued in various types of craft, such as Chebacco boats, "heel tappers", and pinkys, up to the time of the larger schooners. The schooners often carried dories on deck from which to hand line or set tubs of trawl. Large schooners in the mackerel fishery used huge purse seines to entrap their catch and whether caught on a line or in a net, a fast trip back to market was the order of the day. This led to the development of the racing schooners that were built in the early 1900's.

Competition between the fishermen of the United States and Canada was keen and often bitter. One of the results of this fierce competion was the organization of the great fishermens' races that were first held in 1920. The last of these races occurred in 1938 and was between the famous Canadian schooner "Bluenose" and her rival from the United States, the "Gertrude L. Thebaud". The "Bluenose" won three out of five races and was declared the champion.

Following World War One, and into the 1930's, fishing methods were greatly changing. Engines were installed in hulls formerly driven by sail and many lofty rigs were sadly reduced in size. Over the years the dragger with her "A" frames steadily replaced dory fishing. In the 1950's and '60's, about the only sail carried on a fishing vessel was a riding sail used to help keep her steady and any dories on board were for use as life boats more than anything else. Slowly but surely the newer, bigger boats were being built with metal hulls, although there were still a large fleet of wooden boats operating in the 1970's and 1980's.

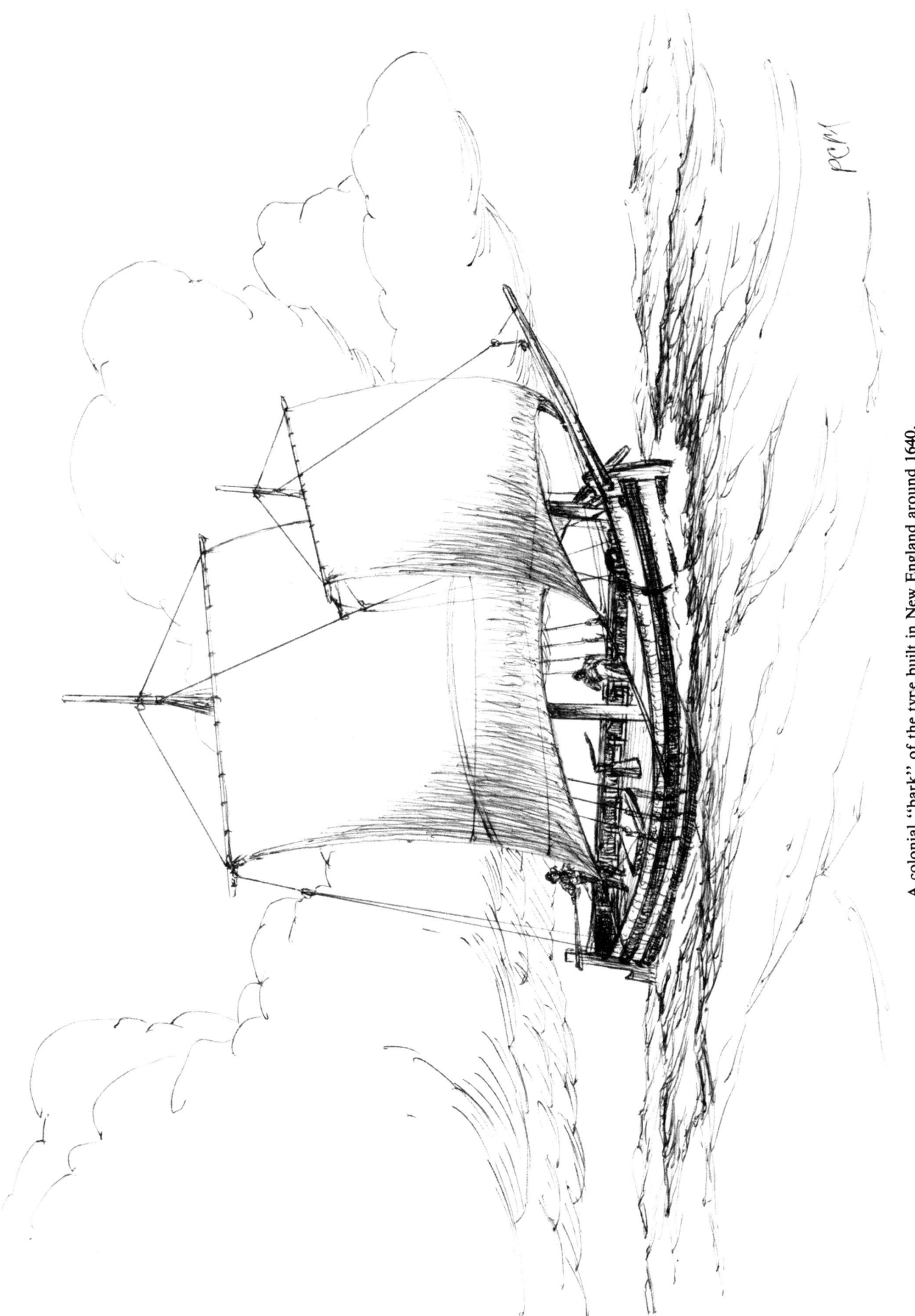

A colonial "bark" of the type built in New England around 1640.

Following the Civil War, the passenger carrying trade was largely taken over by steamboats. Many of these steamers still carried sails. Big "down east" windjammers, such as the "Benj. F. Packard", were built in Maine for deep water routes. Coastal schooners continued to grow in size. The first coastal four masted schooner was the "Weybosset", which had been converted from a steamboat in 1879. The first five masted schooner on the east coast was the "Gov. Ames", launched at Waldoboro, Maine, in 1888. The last square rigged "down easter" to be launched was the "Aryan", which went into the water at Phippsburg, Maine, in 1893. The first six masted schooner, the "George W. Wells", was launched at Camden, Maine in 1900. The one and only seven masted schooner, the "Thomas W. Lawson", was launched at Quincy, Massachusetts in 1902.

The big schooners were bulk carriers with coal being one of their predominant cargoes. During the 1890's old square riggers were bought by a number of individuals and converted to barges. Some of these barges were left with short masts upon which were set very small sails. These so called "schooner barges" were towed by large oceangoing steam tugs and gave rise to fierce competition with the schooner operators. The coastal trade was fraught with many dangers and a large number of mishaps and fatalities occurred to both the schooners and to the schooner barges. In the end the economics of the towing interests prevailed. The last year of any real prosperity for the schooner operators was in 1907. If it hadn't been for World War One and the sudden great demand it caused for almost any kind of shipping, the building of wooden schooners would have in all probability slowed to a near halt around 1910. However, because of the war induced continuation in their building, the last large four masted schooner constructed was the "Josiah B. Chase", launched in Maine in 1921. The last schooner barge to be specifically built as such was launched from a Maine shipyard in 1923. After that the building of large wooden vessels in New England went into a decline that was more or less permanent. Setting aside some fishing vessels and a few "dude" schooners, the building of large wooden ships seems to be a thing of the past.

Steam had really triumphed over sail well before World War One. Steamships built of iron and steel took over from wooden vessels and paddle wheels slowly but surely gave way to propellers. The sails often seen on the early steamers were gradually reduced as power plants became more efficient, until finally only the masts themselves remained and these only served to carry lights and support cargo booms. A lot of the "yo ho ho" went out of commercial seafaring when the windjammers disappeared. Today an electronics expert would be more at home on a modern cargo carrier than an "old salt" who could set up rigging and furl sail in the dead of night. I'm not saying the romance is all gone, but it certainly is a different ball game.

Some training ships still visit our shores. They and our own training bark "Eagle" still carry square rigs representative of the old days and ways. However, these stately ships are few and far between. Not too long ago a vast amount of shipping could be seen sailing in and out over our coastal horizon. If we look out to sea today, we begin to realize how great the change has been. Coal is still in demand and, of course, the need for oil is great. Today huge tankers, container ships, colliers and freighters occasionally loom over the horizon, but not in the great numbers that the old vessels were seen. From time to time a modern ship will somehow go astray and come crashing ashore in a "blow". Much is made of it in the press as a rule. Little do people today realize how common shipwreck used to be.

The drawings found upon these pages will give a modern seaside visitor, or the armchair romantic, a chance to look back in time and view the ocean panorama as seen by those of years ago. There are also some scenes that might have been looked upon only recently.

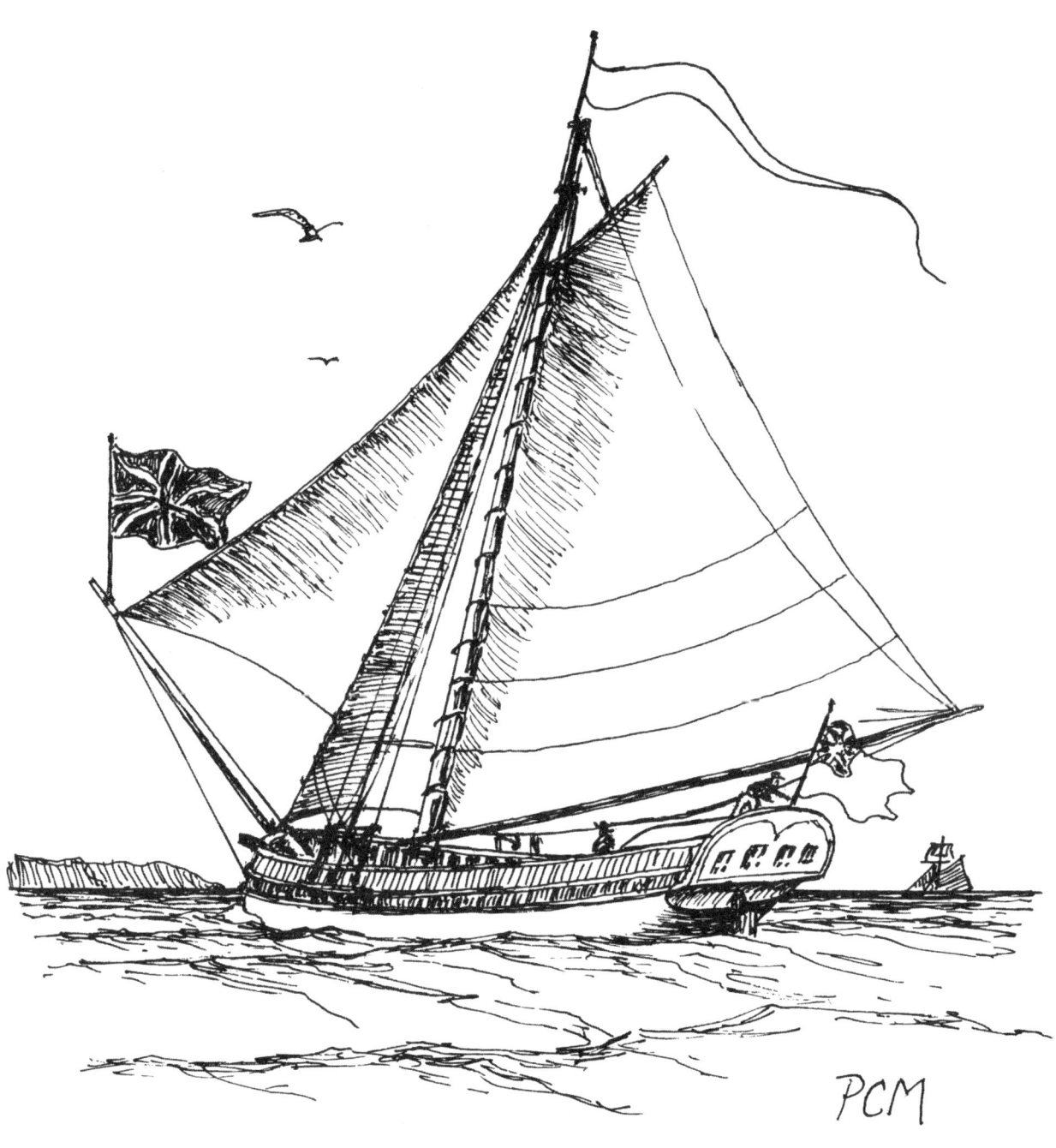

A colonial sloop of the early 1700's entering port. (Illustration used in *American Sailing Coasters of the North Atlantic*.)

ABOVE: A topsail sloop of the style used in the 1700's. Frequently these larger sloops were armed with cannon. **BELOW:** A Carronade was a type of muzzle-loading short cannon used for armament on vessels in the 1700's and early 1800's. (Illustrations used in *American Sailing Coasters of the North Atlantic*.)

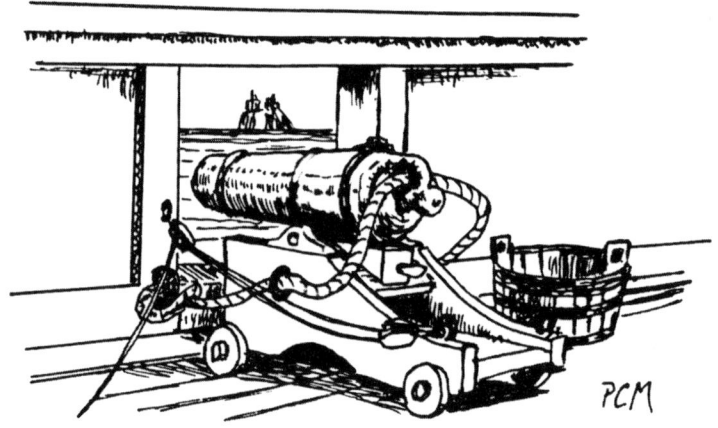

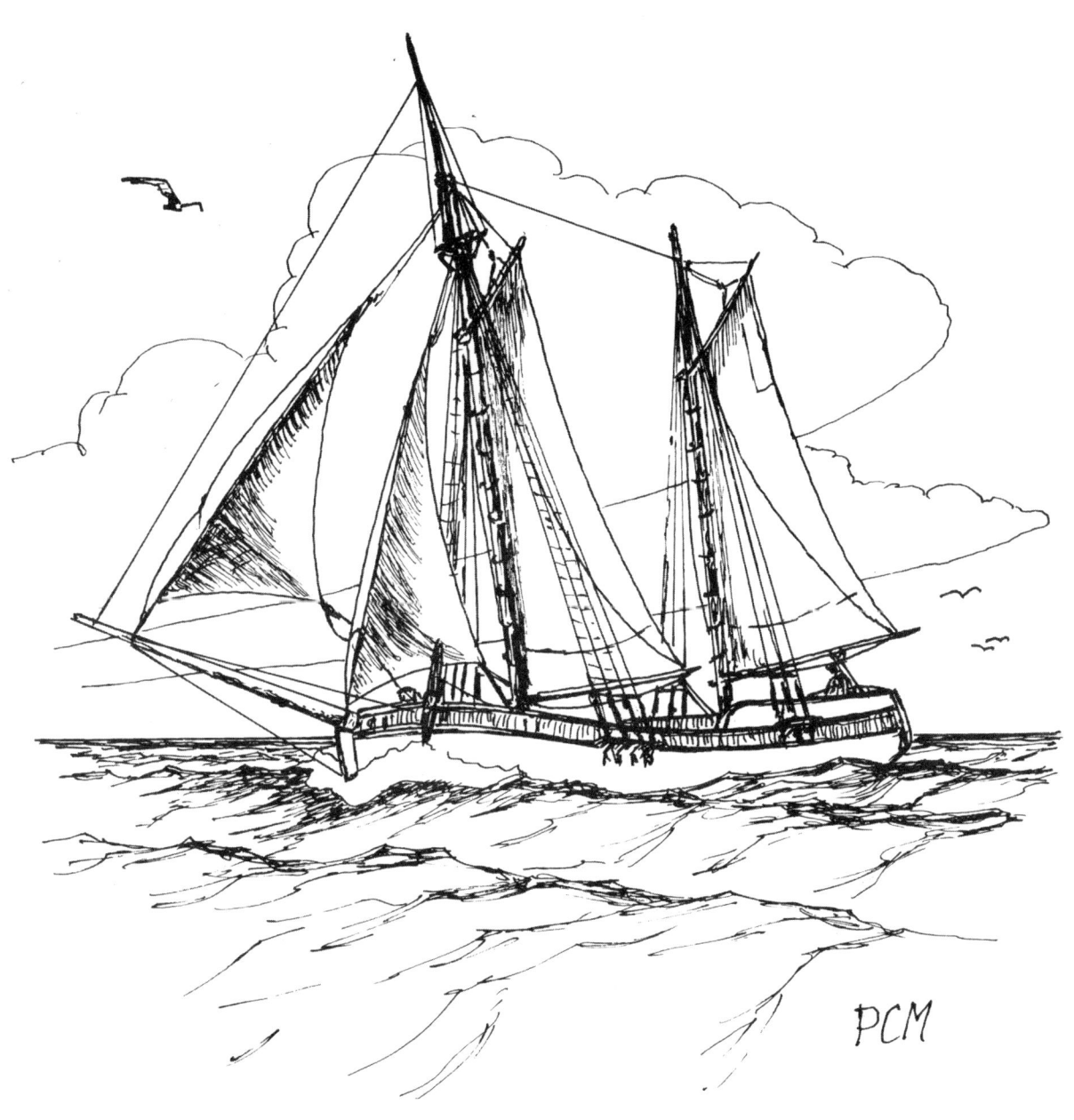

An American ketch, or "catch", used for fishing and cargo carrying in the 1700's. It was a possible forerunner to the schooner rig in this country. (Illustration used in *American Sailing Coasters of the North Atlantic*.)

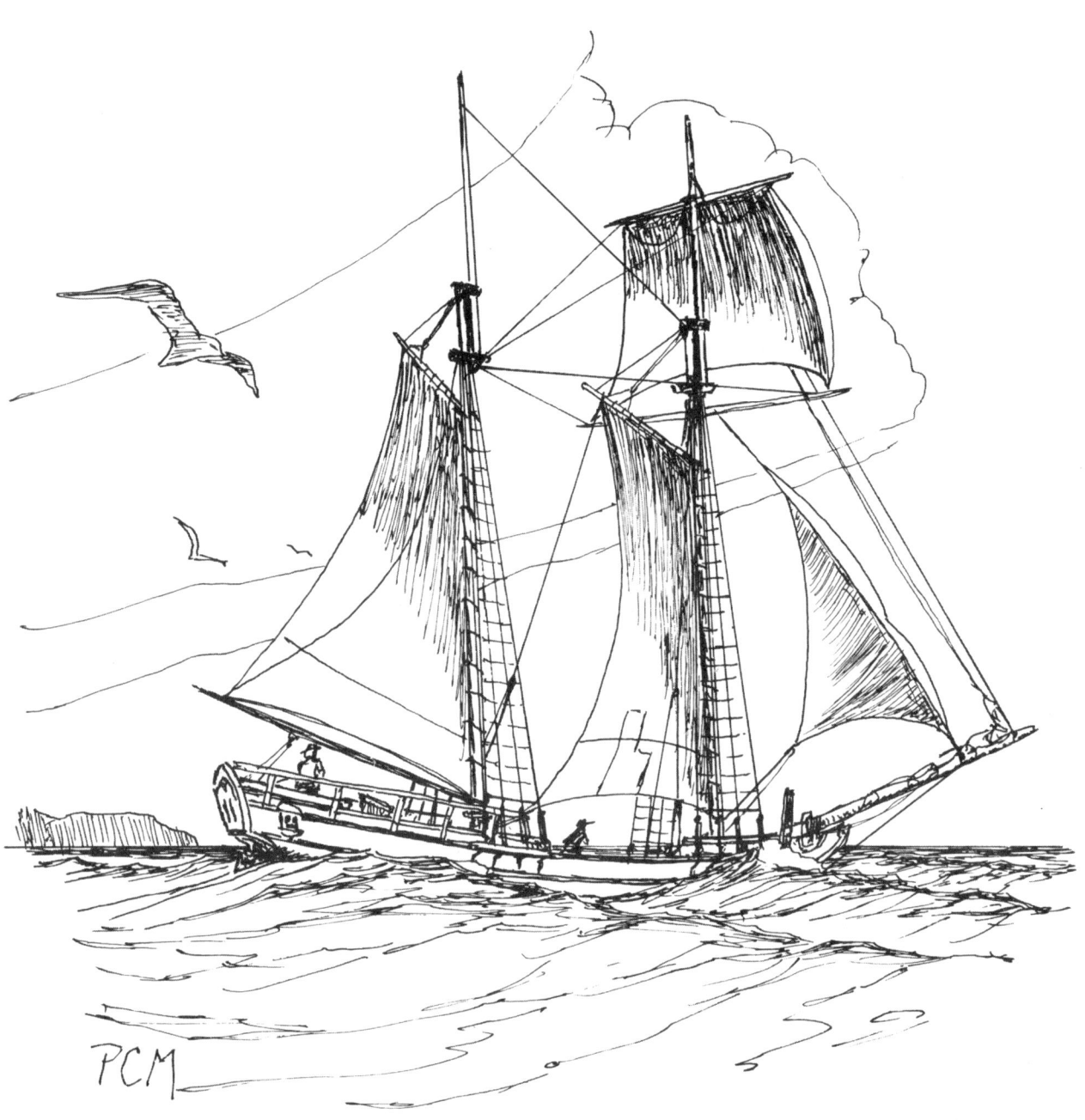

An American topsail schooner of the mid-1700's, with a square topsail rigged on the fore topmast. Vessels such as this one were employed in deep water as well as coastal trades. (Illustration used in *American Sailing Coasters of the North Atlantic*.)

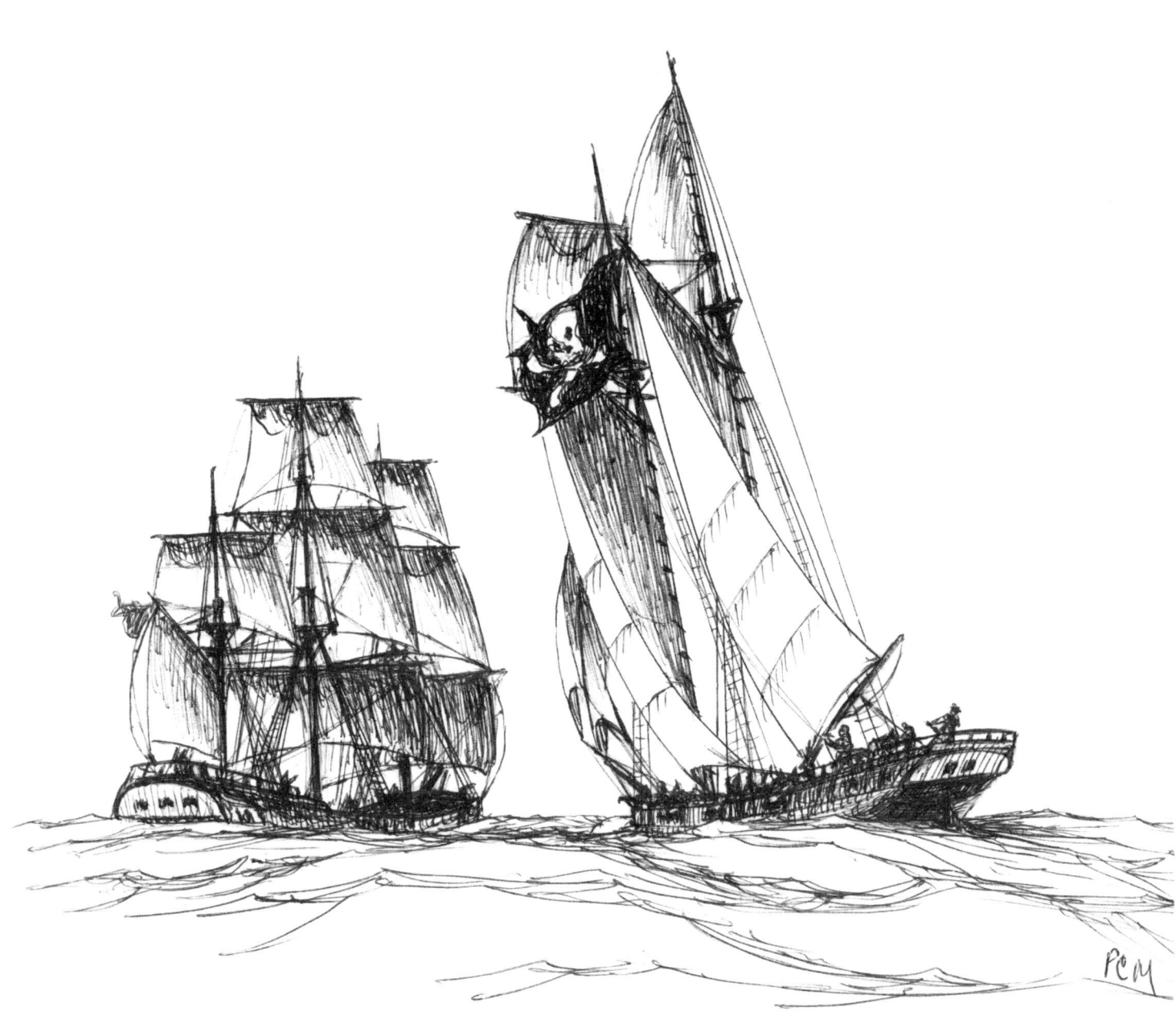

A pirate schooner overtakes a European merchant ship somewhere in the West Indies, circa 1800.

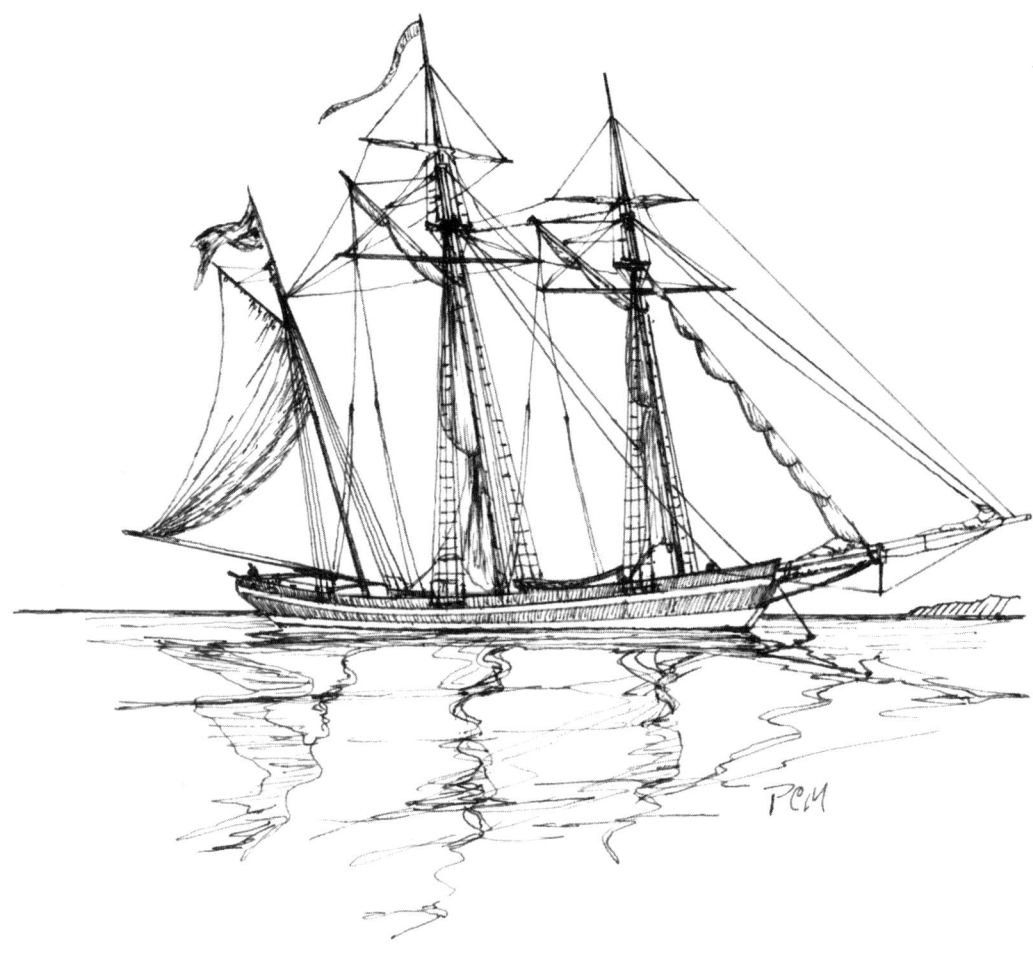

ABOVE: A three masted schooner fashioned along the "Baltimore Clipper" style. A few vessels, such as the one shown, were built in the Chesapeake Bay area around 1800. (Illustration used in *Four Masted Schooners of the East Coast*.) **BELOW:** A topsail schooner packet of the 1840's. This kind of vessel was often used to carry passengers on coastal trips. To be successful they had to be relatively fast. (Illustration used in *American Sailing Coasters of the North Atlantic*.)

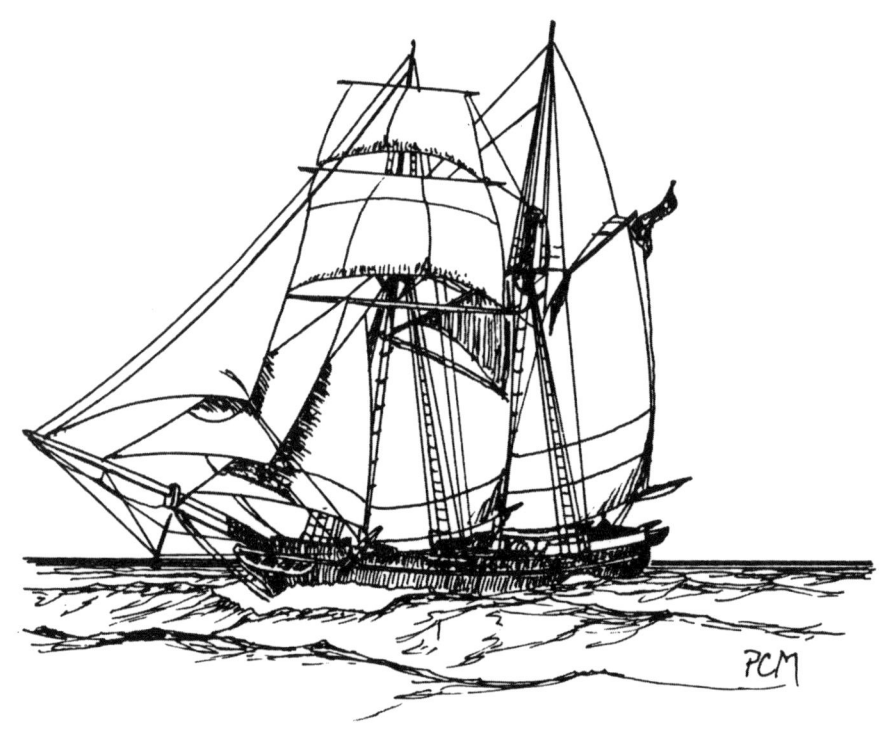

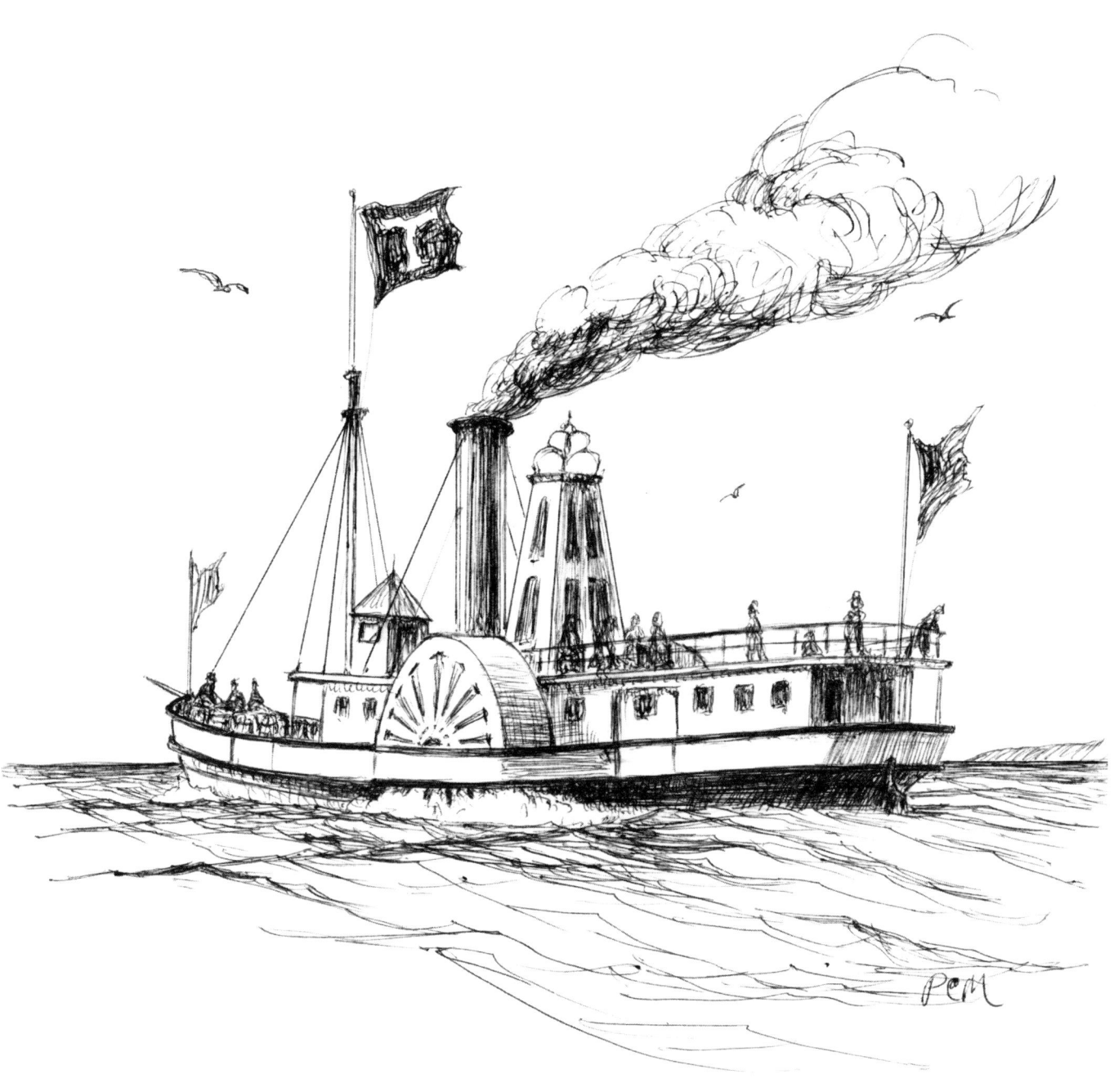

The little wood burning steamer "Telegraph". This staunch, early steamboat served as a passenger and freight packet between the mainland and the island of Nantucket from 1832 until 1858.

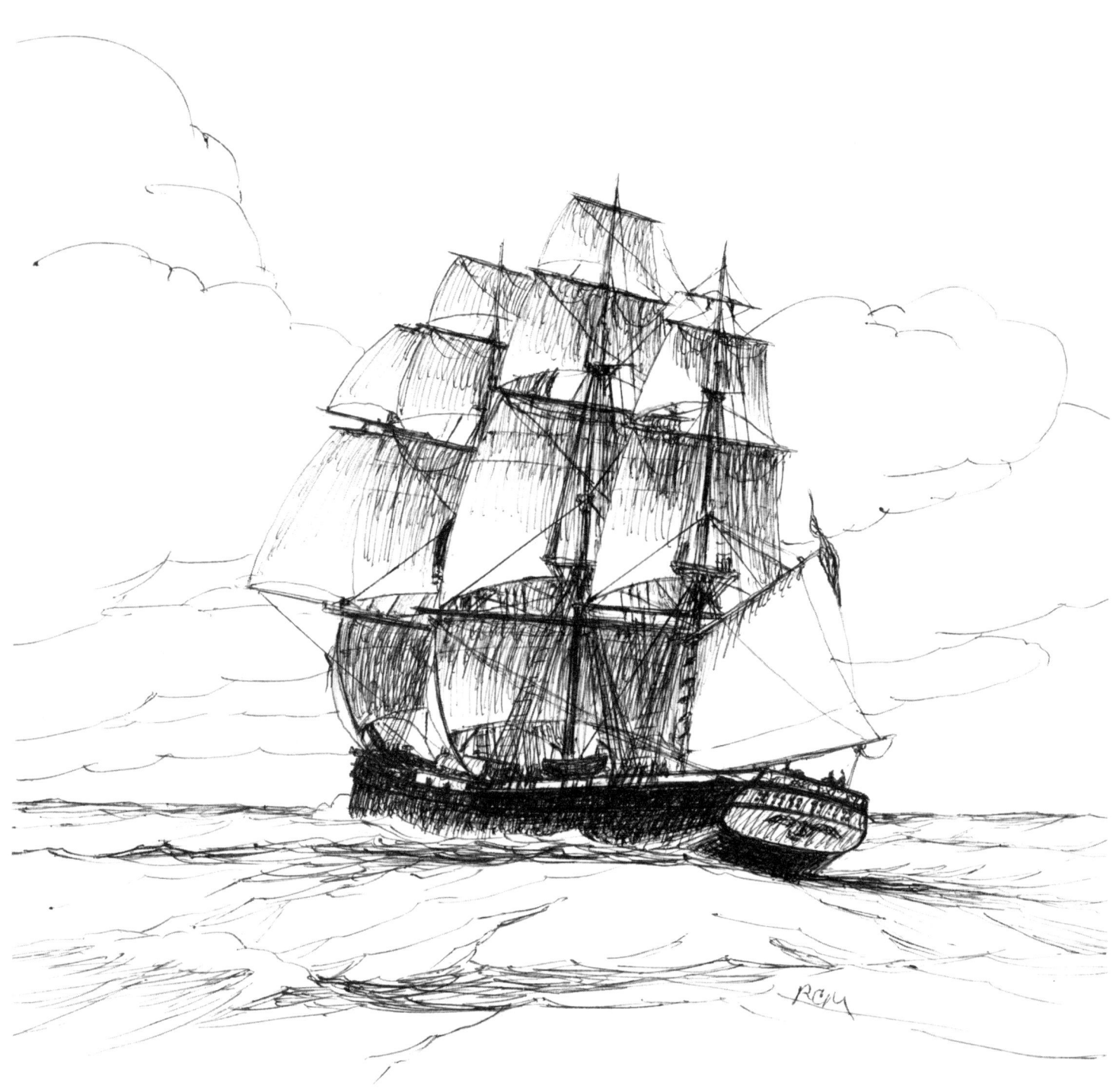

A Liverpool packet ship with "stunsails" set. Vessels such as these were the forerunners of our clipper ships and were in use during the 1840's.

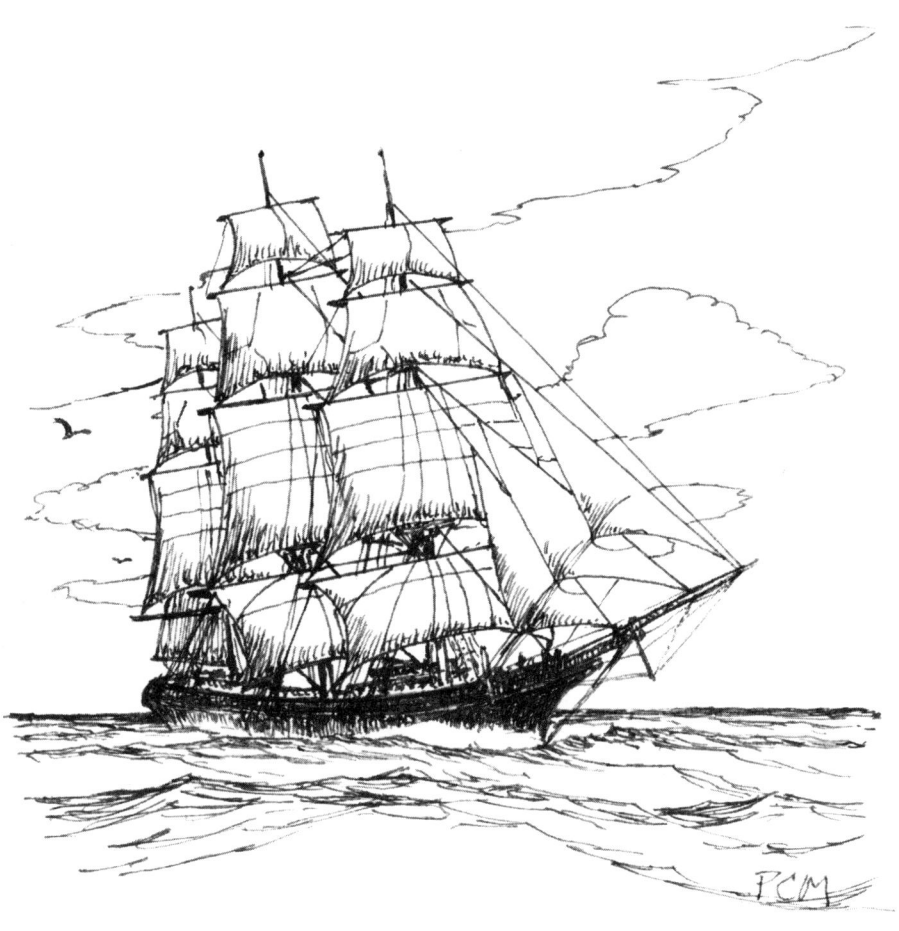

ABOVE: A small clipper ship of the 1850 period. (Illustration used in *Sea Yarns*, published by the Orleans Historical Society.) **BELOW:** The "Eckford Webb", built in New York in 1855, was a very fast three masted schooner and one of the earliest of these vessels to have three masts of equal height. (Illustration used in *American Sailing Coasters of the North Atlantic*.)

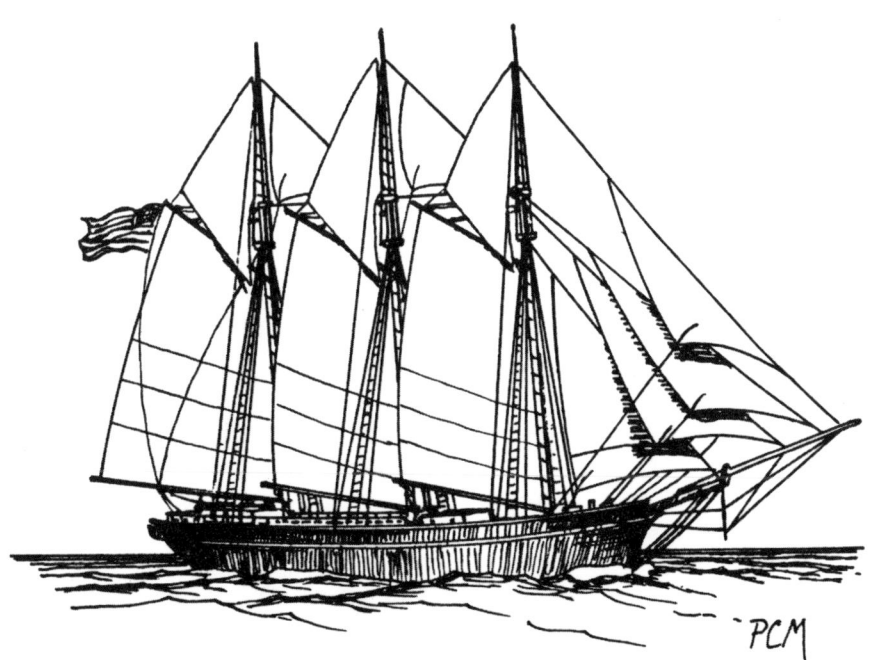

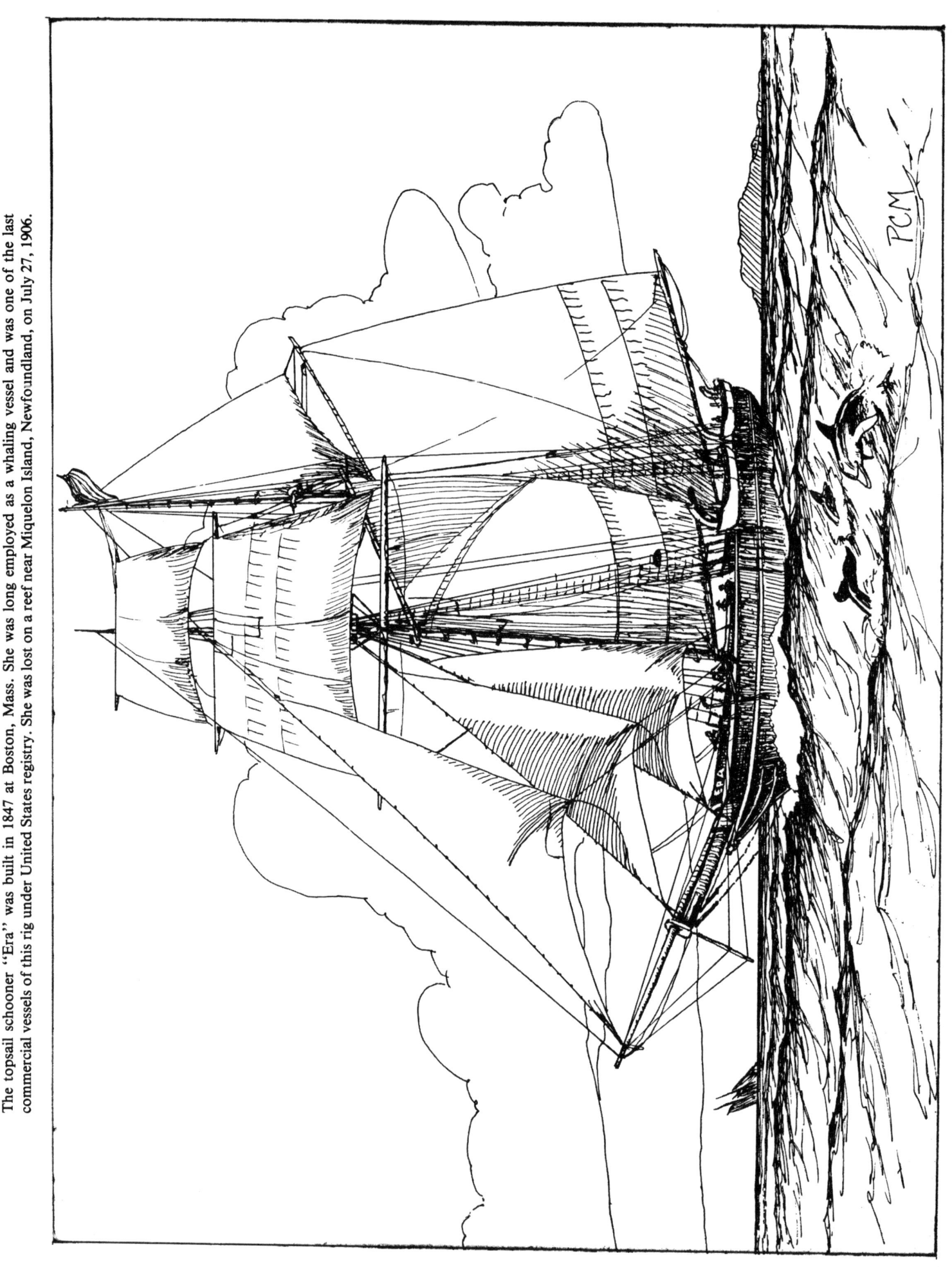

The topsail schooner "Era" was built in 1847 at Boston, Mass. She was long employed as a whaling vessel and was one of the last commercial vessels of this rig under United States registry. She was lost on a reef near Miquelon Island, Newfoundland, on July 27, 1906.

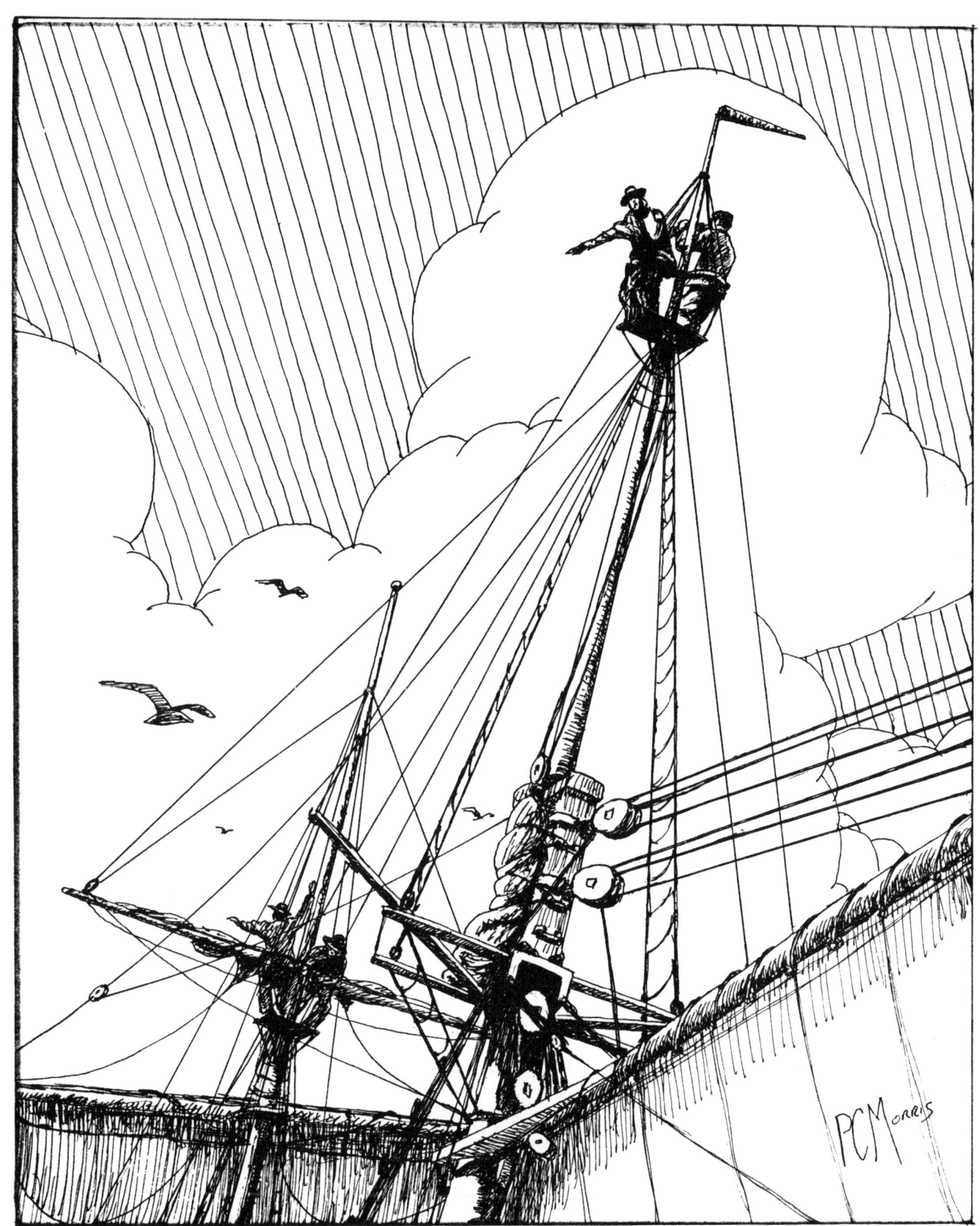

"Thar she blows", yell the men in the "hoops". They have just seen the spouts from a surfacing "pod" of Sperm Whales and are letting those down on deck know where the whales are located.

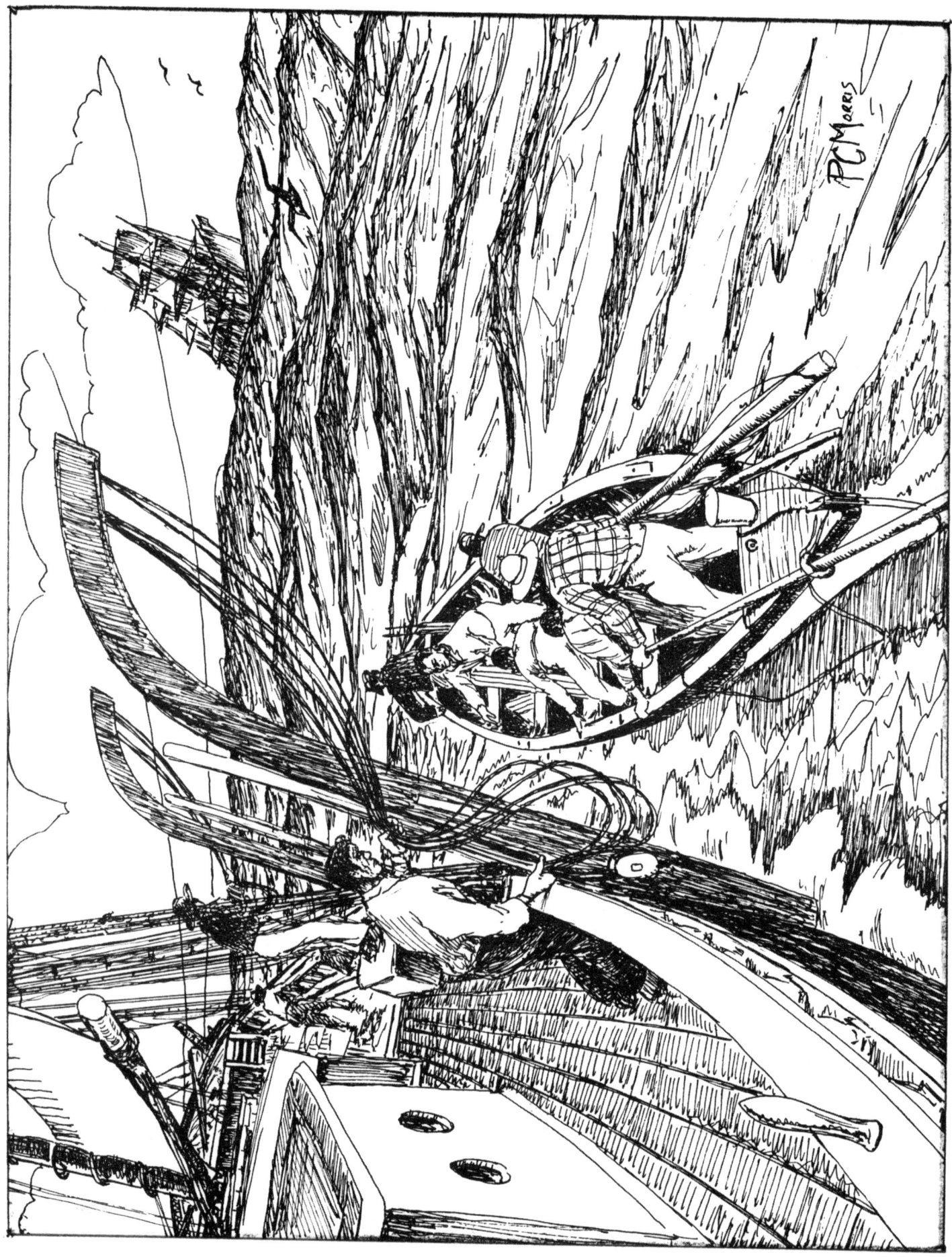

As quickly as possible after sighting the whales, the whale boats were lowered away to give chase. Each boat was manned by six men.

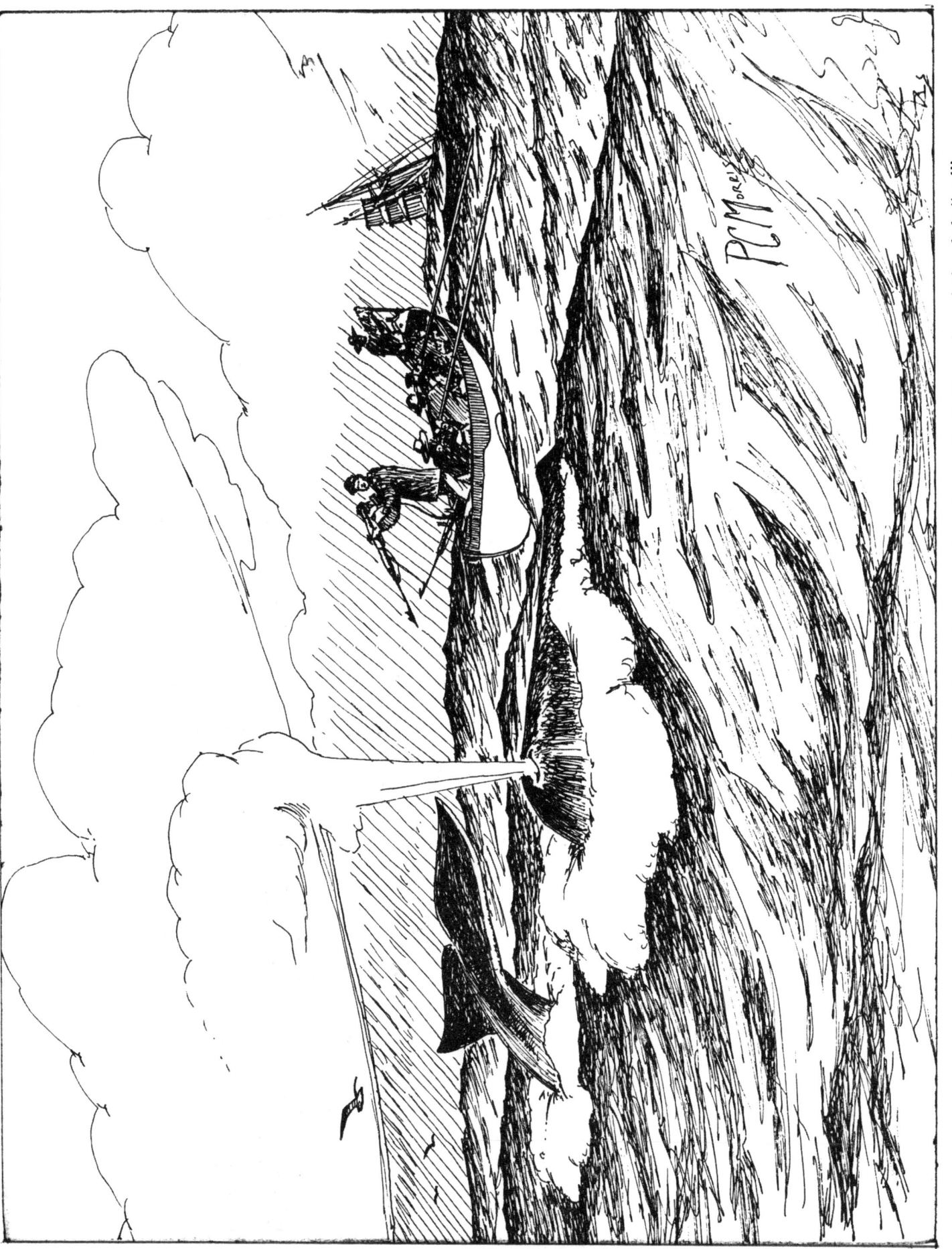

The whale boat tries to get close to the spouting whales. Should these huge animals become "gallied", or alarmed, the whole "pod" would sound. When within striking distance, the harpooner is told to stand up and get ready with his harpoon.

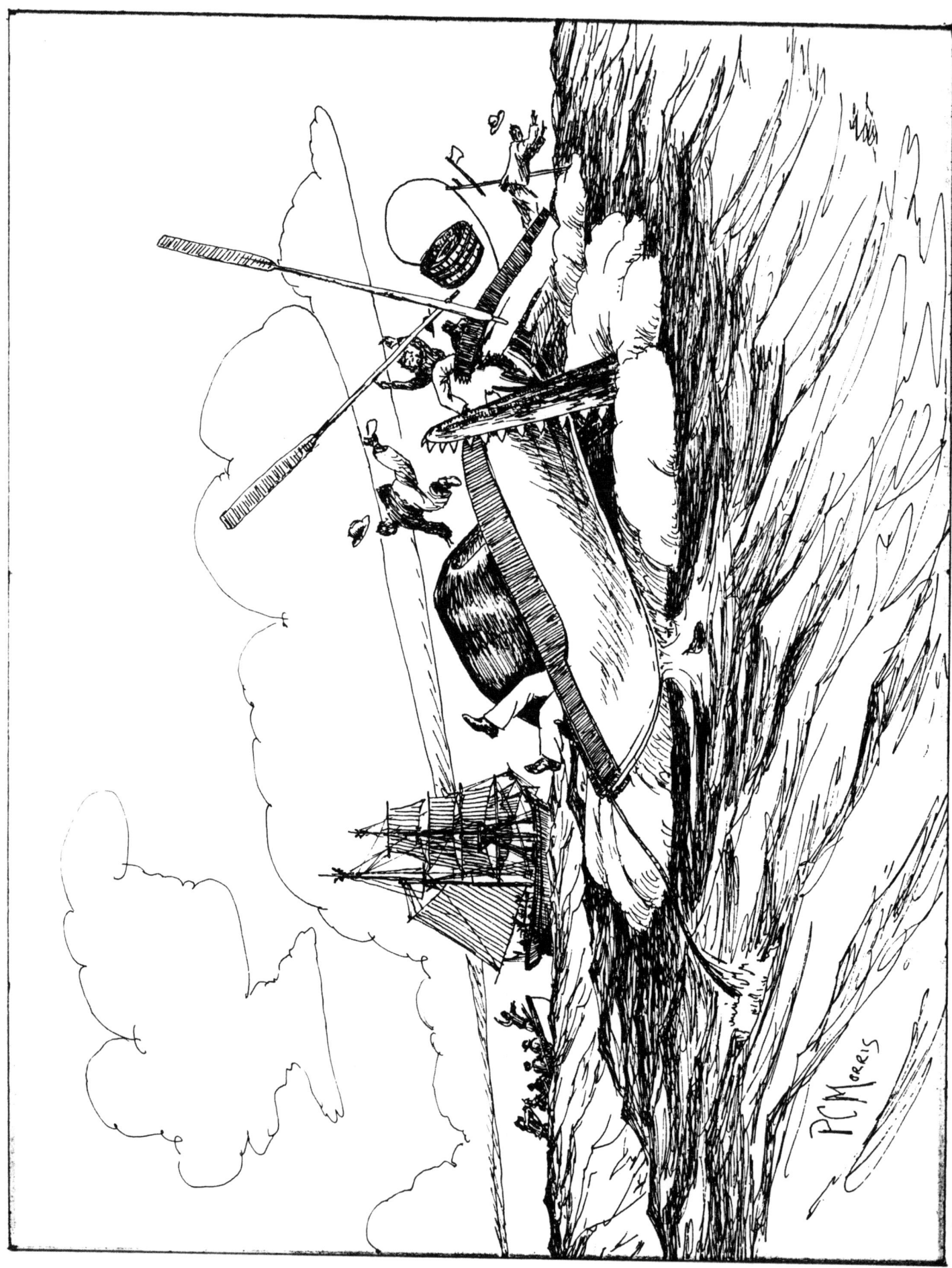

A bull Sperm Whale often turned upon the boat that had harpooned it. This could result in a smashed boat and injured whalemen.

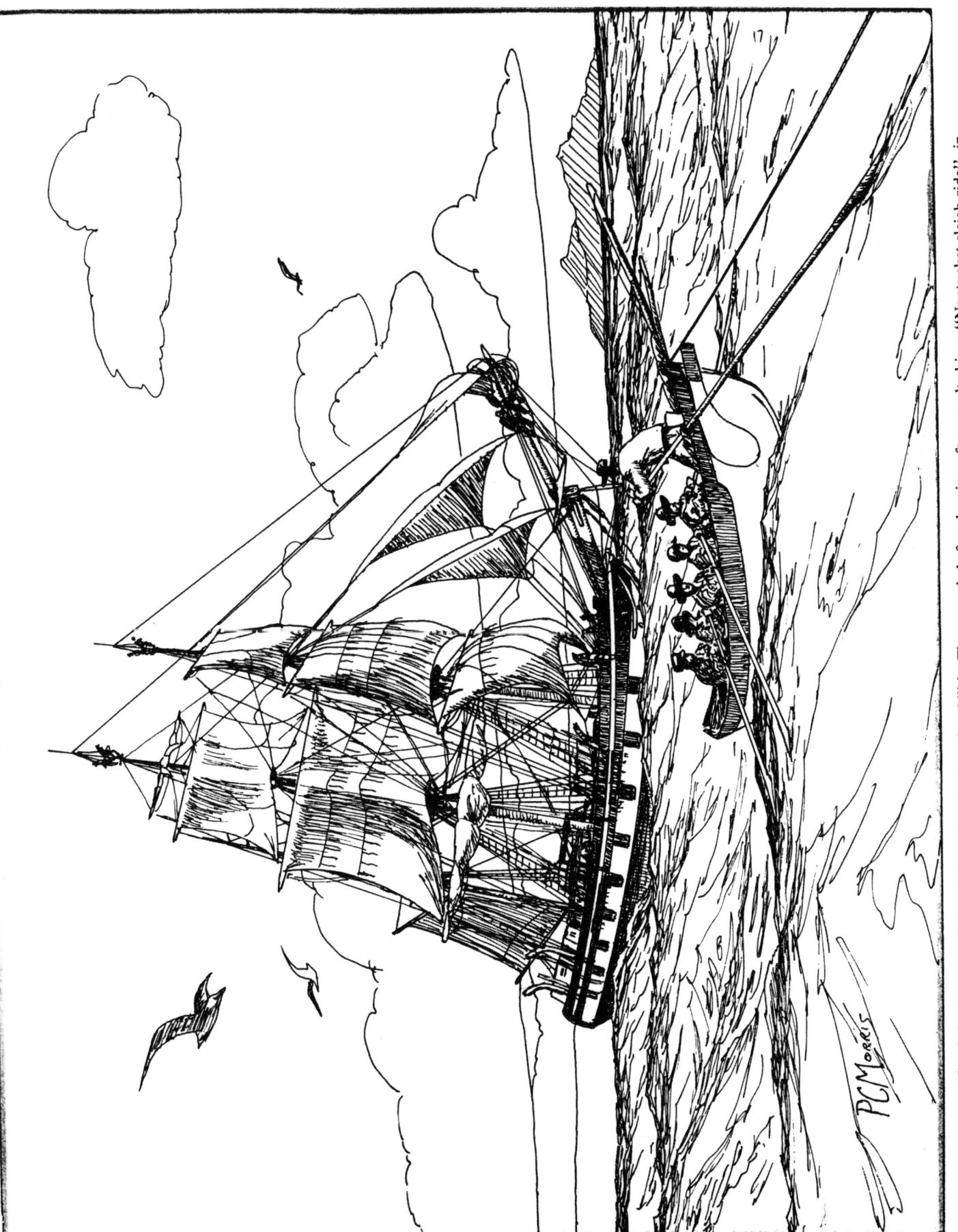

After being harpooned the whale had to be lanced to kill it. The struggle before lancing often resulted in a "Nantucket sleigh ride", in which the whale towed the whale boat far from its mother ship. The dead whale then had to be towed back to the ship for cutting in. Here, a bark, similar to those sailing in the early to mid-1850's, heaves to in preparation toward getting the whale made fast alongside.

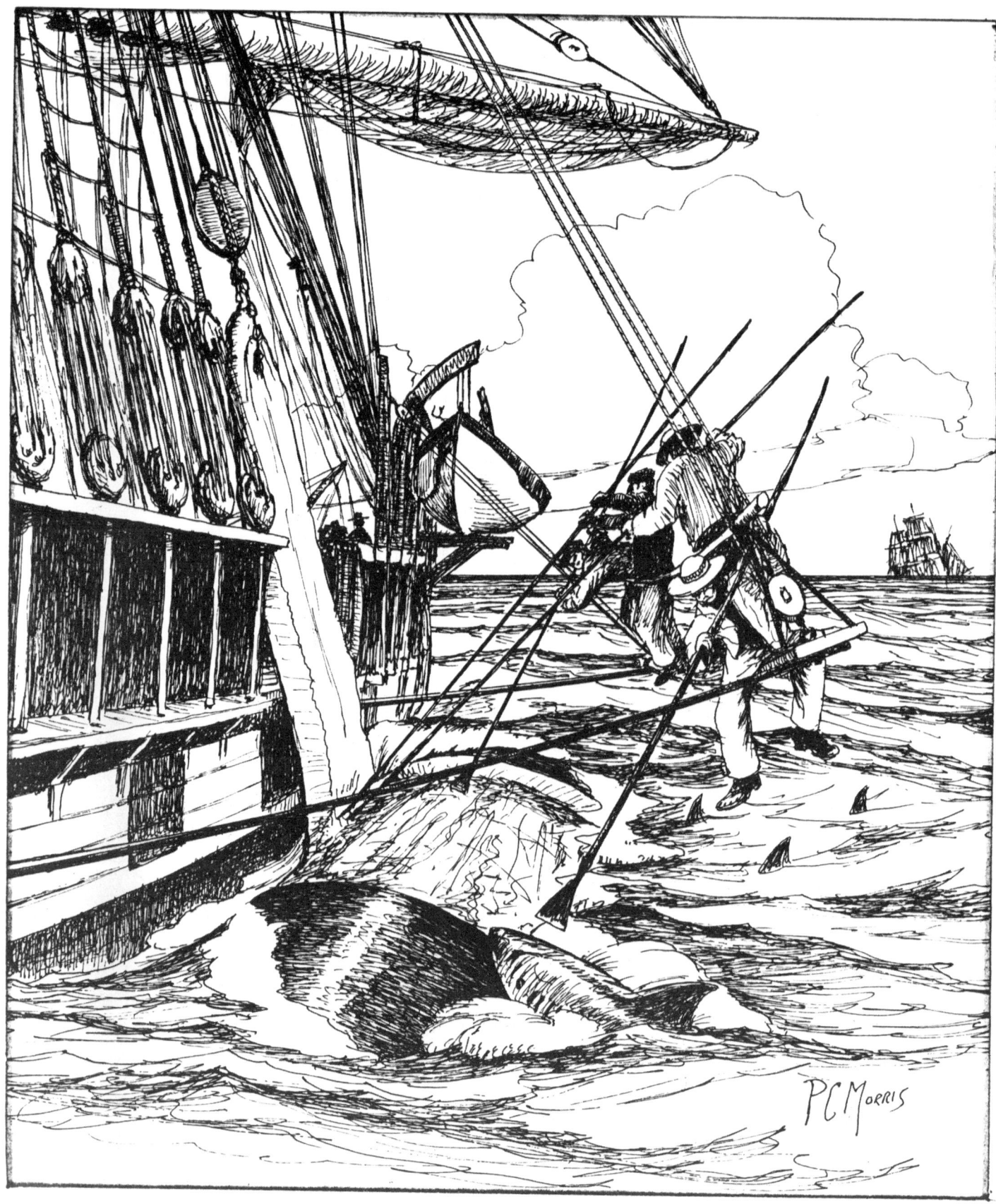

Cutting in was always done on the starboard, or right side, of a whale ship. Here is shown a great "blanket piece" as it was cut from the whale's carcass. It is slowly hoisted aboard where it will be cut up and "tried out" for its oil.

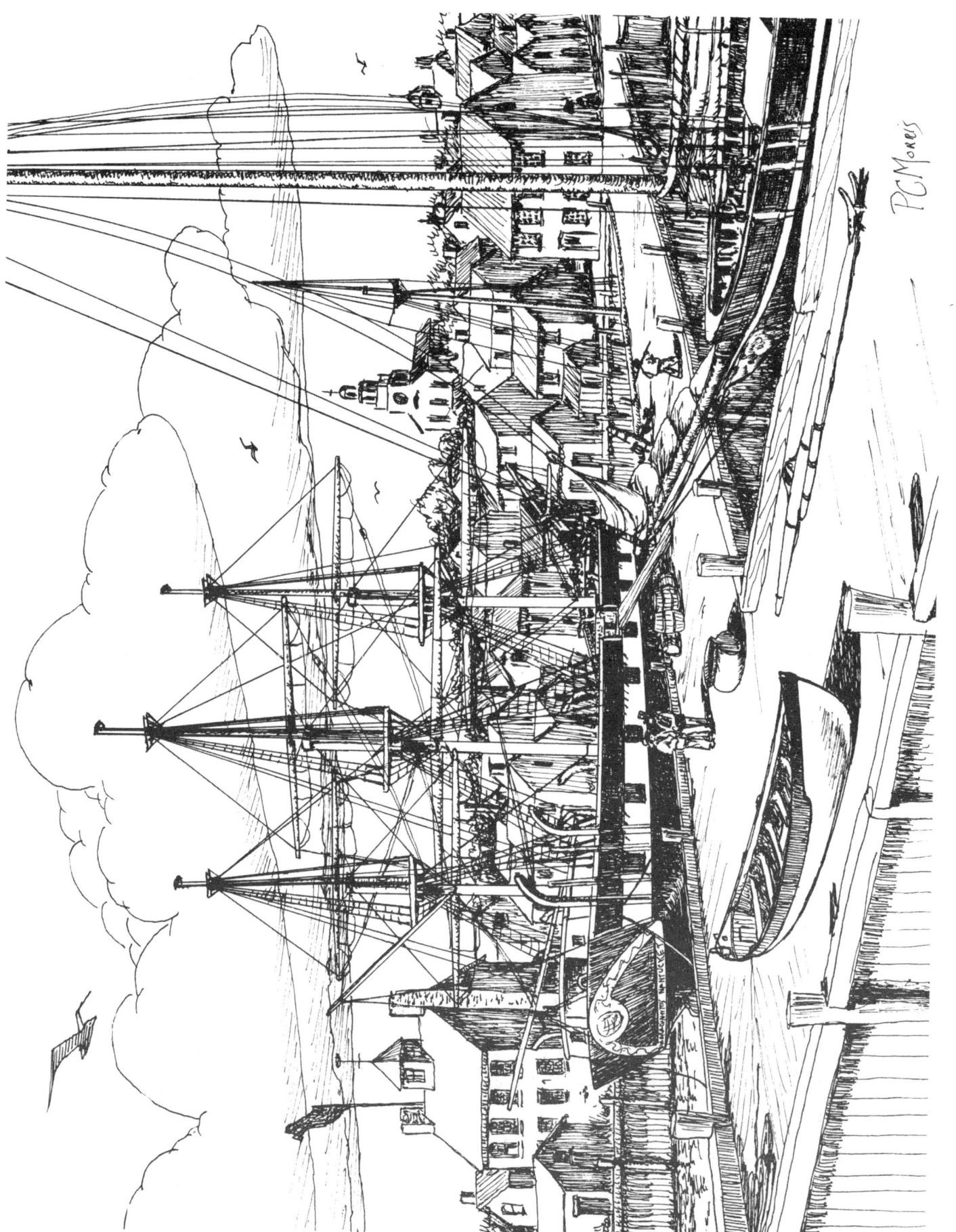

A whale ship that has returned to Nantucket rests at Straight Wharf. It is being refitted for another long voyage to distant seas. Many whaling voyages lasted three or four years.

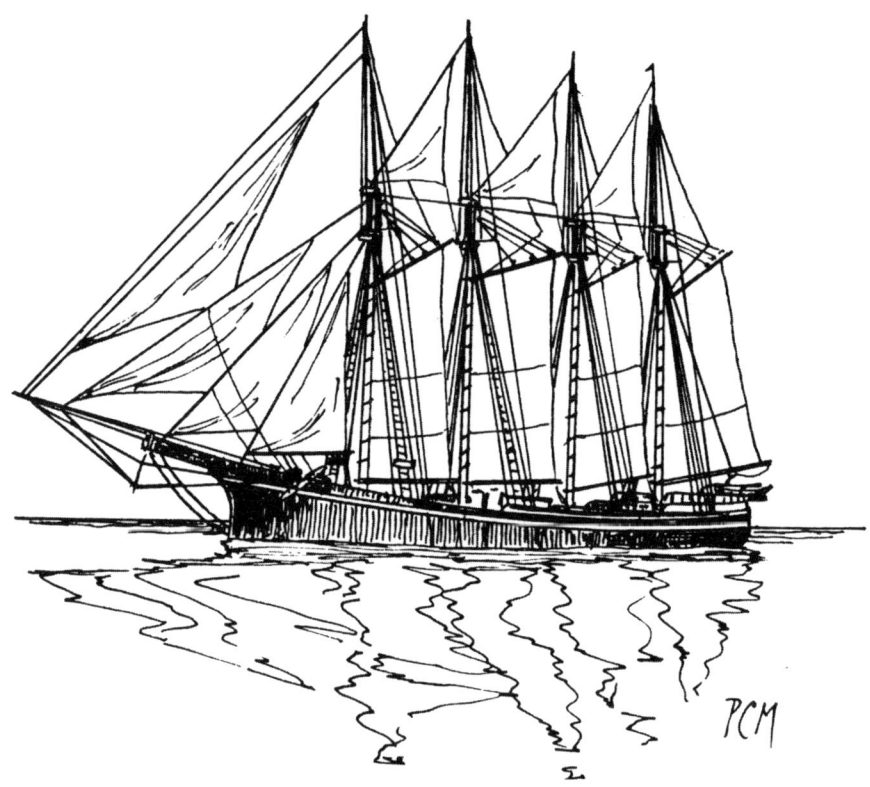

ABOVE: The "Weybosset" was the first four masted schooner to operate on our east coast. She was rebuilt as a schooner from a former steamboat in 1879. (Illustration used in *American Sailing Coasters of the North Atlantic*.) **BELOW:** Coastal schooners and "the steamer" tied up at Nantucket during the 1870's. When the whaling business transferred to New Bedford, economics on Nantucket slowed to a great extent. (Illustration used in *Four Masted Schooners of the East Coast*.)

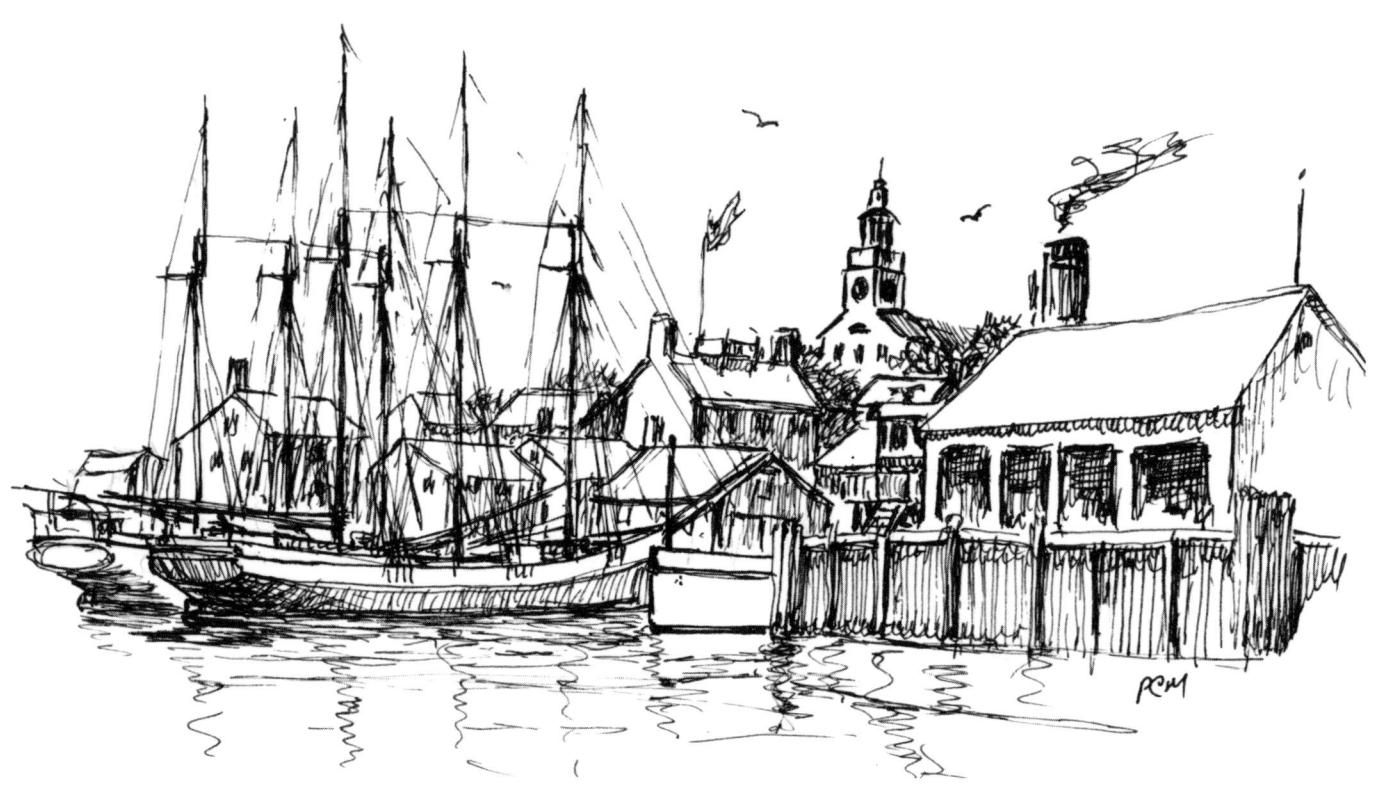

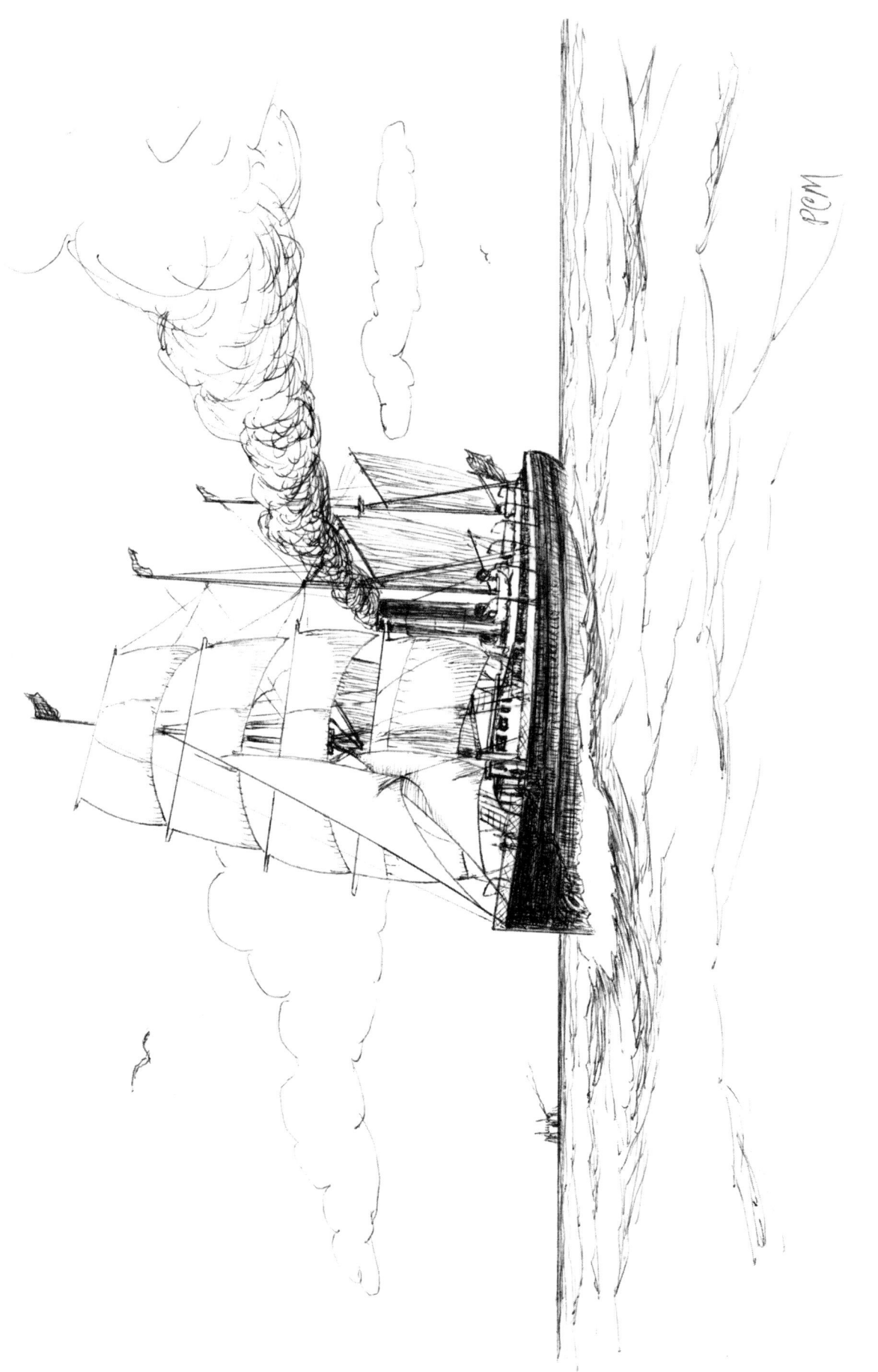

The mid to late 1800's saw many oceangoing steamships built with fairly large sailing rigs. Some of these auxiliaries were rigged as plain ships or barks, while others carried rigs that were somewhat unusual. Here is shown the "City of Rio de Janeiro", an iron steamer built in Chester, Pennsylvania in 1878. She was launched with a modified barkentine rig and was intended to operate between New York and Brazil.

The big "down east" ship, "Benj. F. Packard" was built in Bath, Maine in 1883. She was typical of many of the latter day square rigged vessels built in this country. She was intended as a deep water cargo carrier and earned for herself the reputation for being a "rough" ship as far as the treatment of her crew was concerned. The "Packard" lasted until 1939, when she was towed from her berth at Playland Park, Rye, N.Y., and scuttled off of Eatons Neck in Long Island Sound.

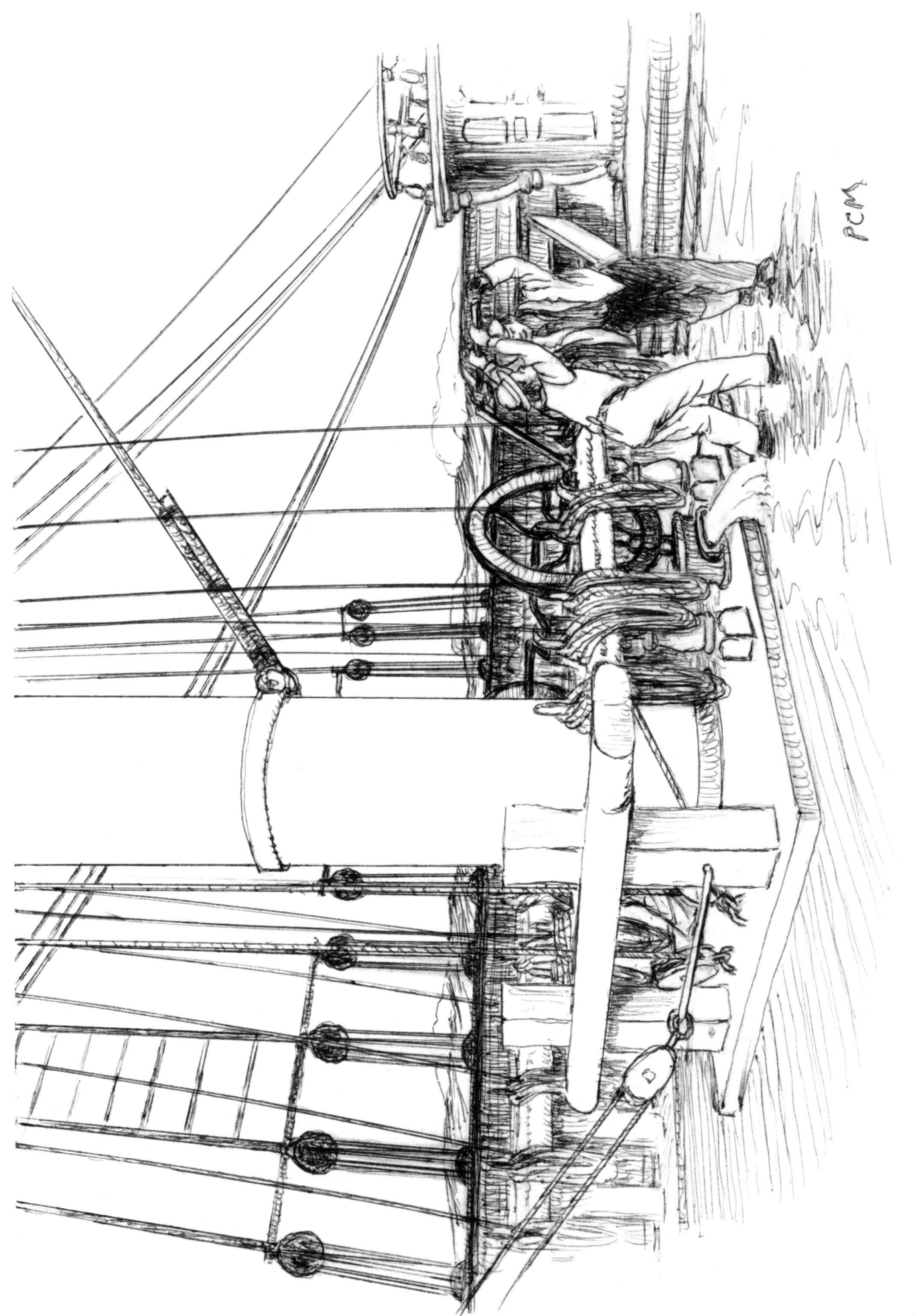

"I'm gonna try a farm next," says Jack to Jimmy. All wooden ships leaked to some extent. During and after a "blow" a trick at the pumps could prove to be a back breaking job on an older vessel.

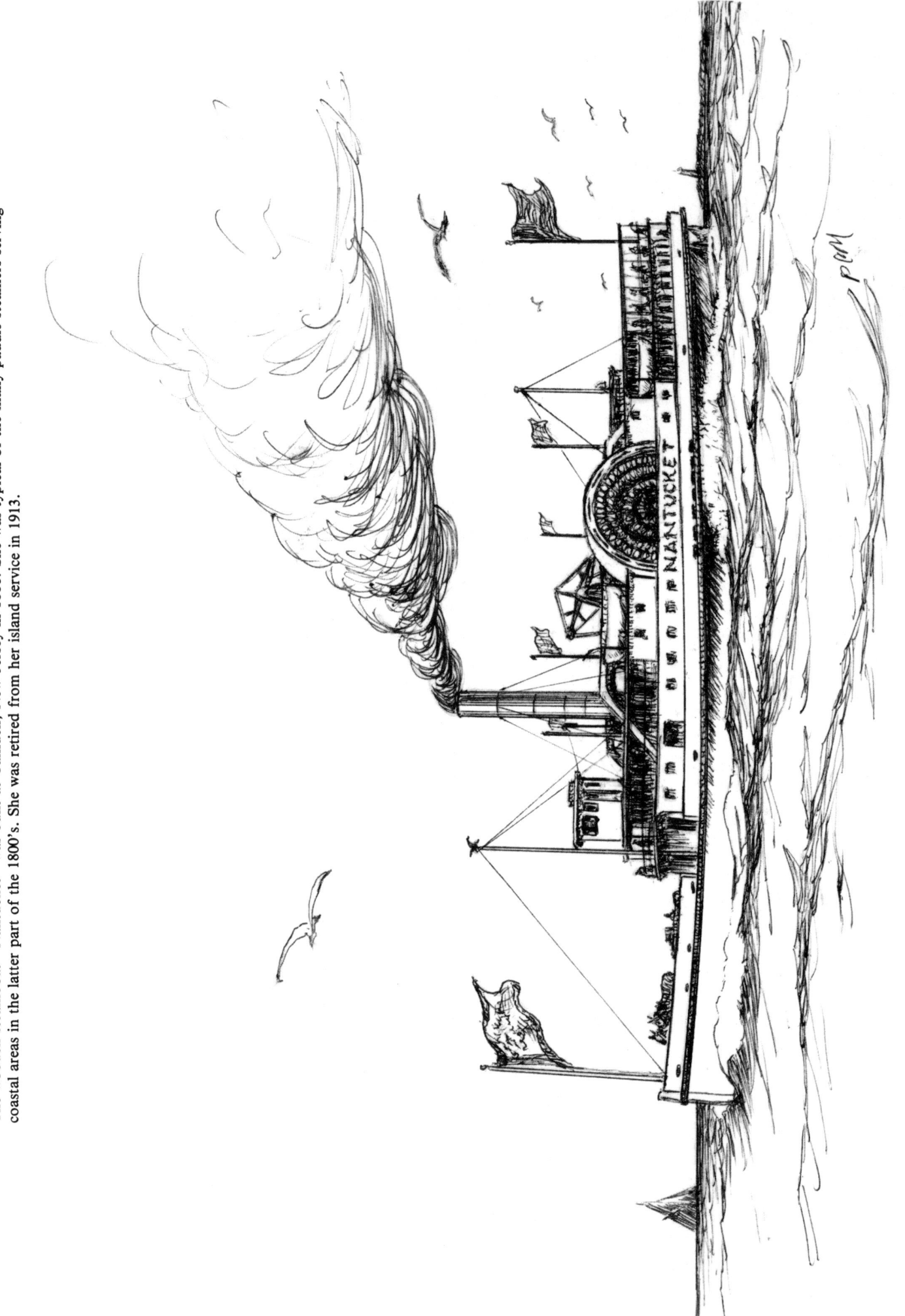

The wooden steamboat "Nantucket" was built at Camden, New Jersey in 1886. She was typical of the many paddle steamers serving coastal areas in the latter part of the 1800's. She was retired from her island service in 1913.

ABOVE: Wooden shipbuilding went on all along our eastern coast, but was especially common in New England. Here are shown the frames of a wooden sailing vessel as they await the outside planking. A great majority of the cutting and construction was done with hand tools.
BELOW: Plans, such as we think of them today, were not used in early shipbuilding. Instead a "lift model" was carved, such as the one shown. From this were taken the measurements necessary to form the frames of future sailing vessels. (Illustrations used in *Four Masted Schooners of the East Coast*.)

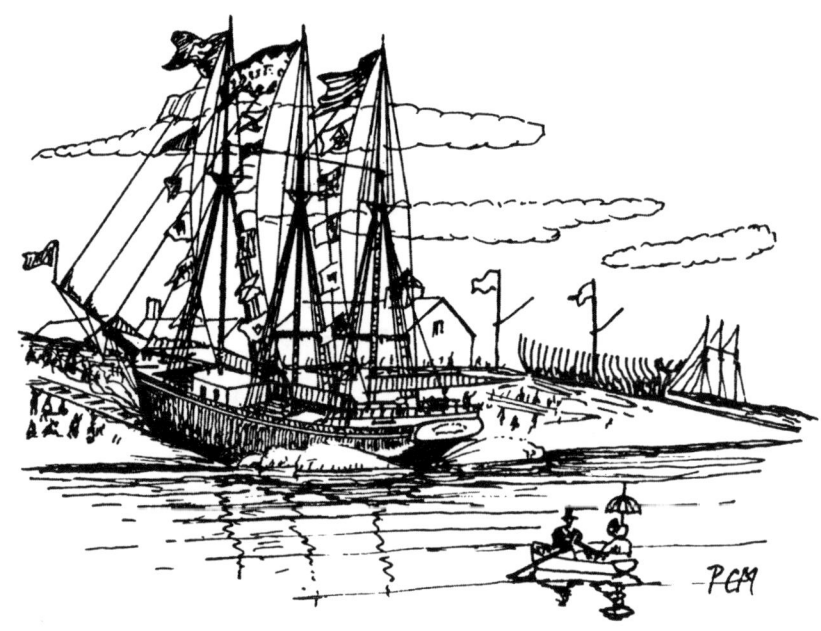

ABOVE: The launching of any large vessel was a big event back in "the old days". People would come to the shipyard from miles around to watch the new vessel as she slid into the water. (Illustration used in *American Sailing Coasters of the North Atlantic*.)
BELOW: Once the new vessel was launched, as soon as possible she would be made ready for sailing. She was then towed from the place of her building to the open sea where she cast off the tug and sailed away to an uncertain career. (Illustration used in *Four Masted Schooners of the East Coast.*)

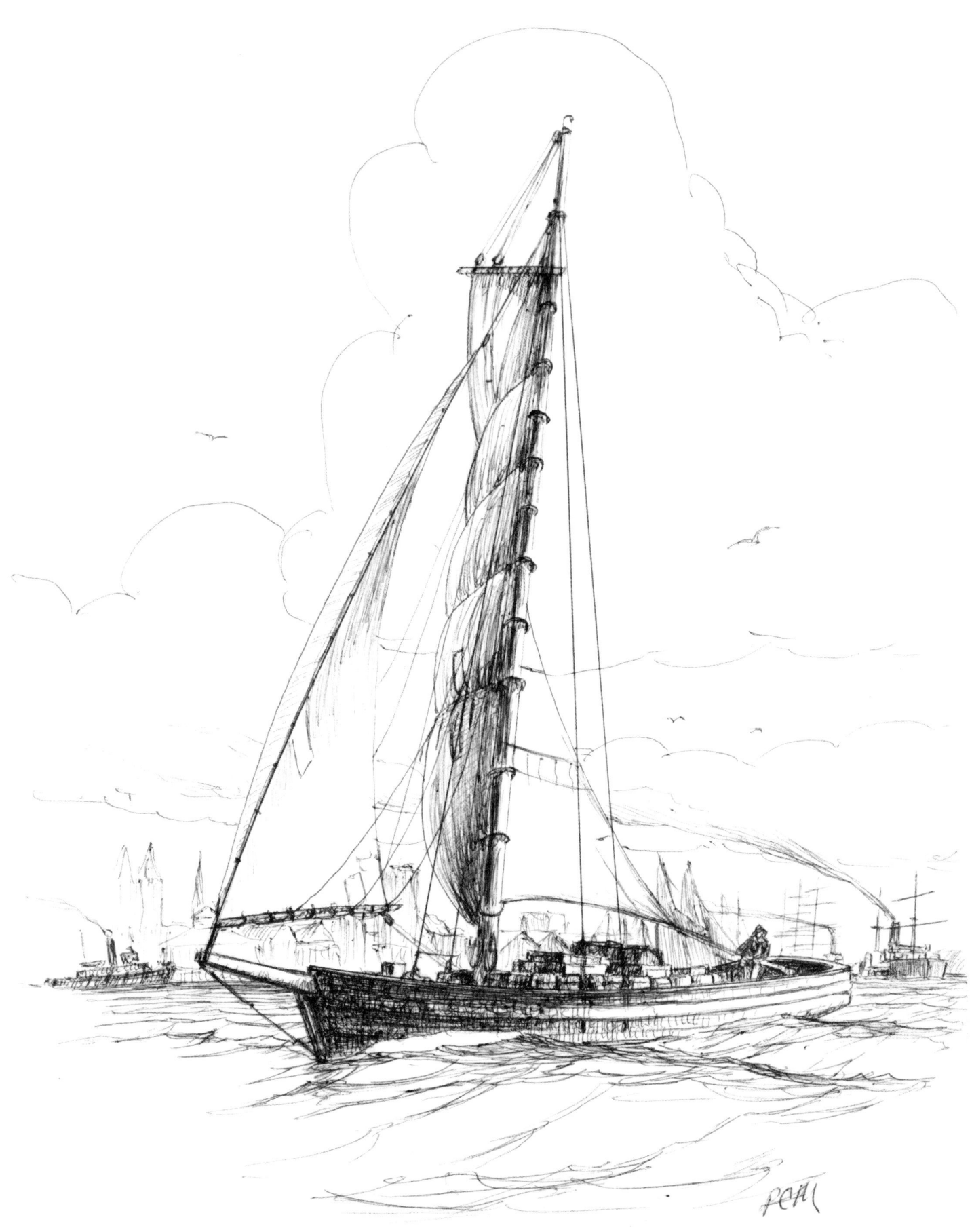

A New York sailing lighter, such as the one shown, was used to carry cargo from one pier to another and sometimes to larger vessels at anchor. These little work horses were used in and around New York harbor for a very long time. Some were still in use in the early 1900's.

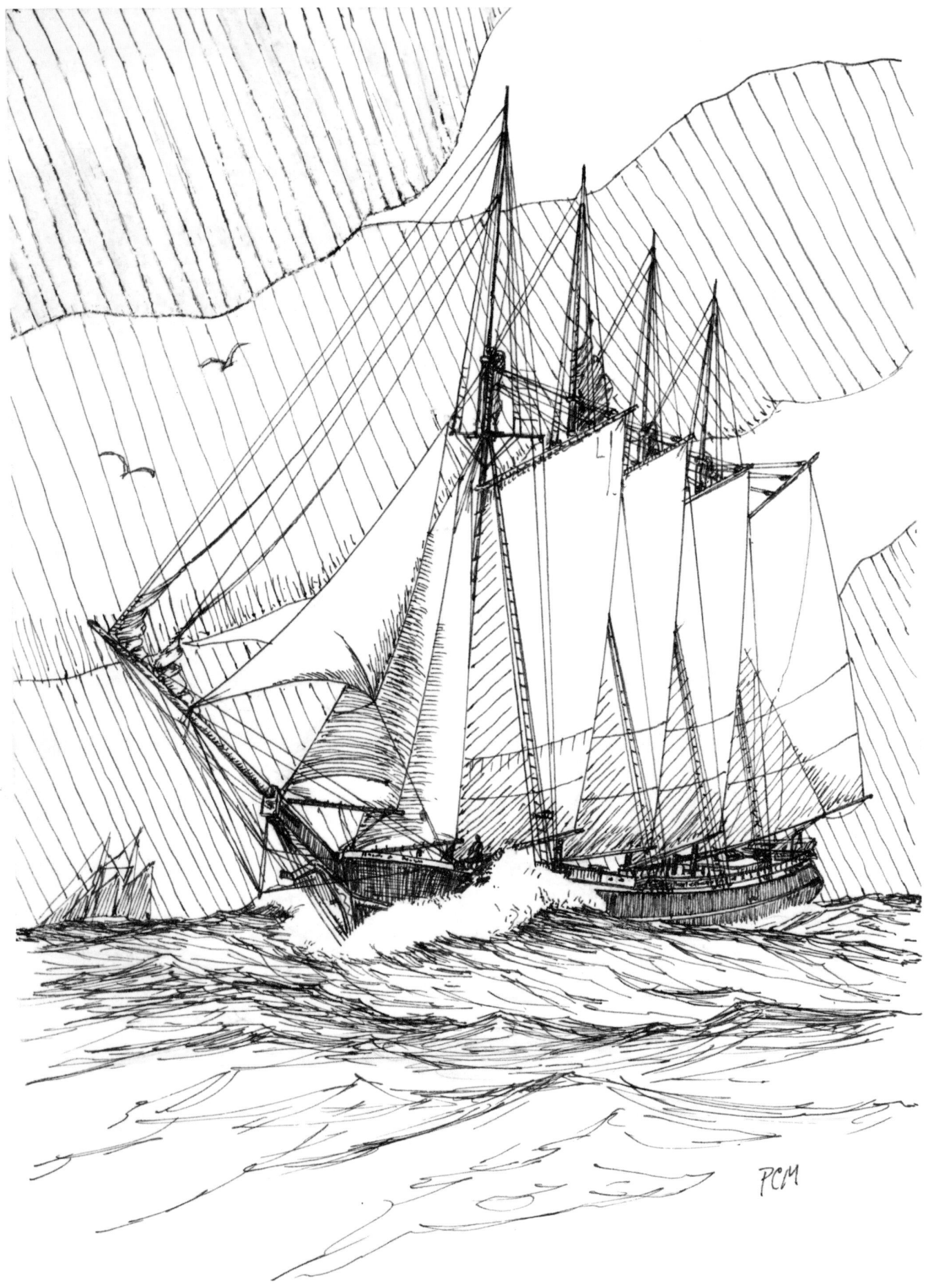

A big four masted schooner, fully loaded, heads northward through heavy seas with her cargo of coal. (Illustration used in *Four Masted Schooners of the East Coast*.)

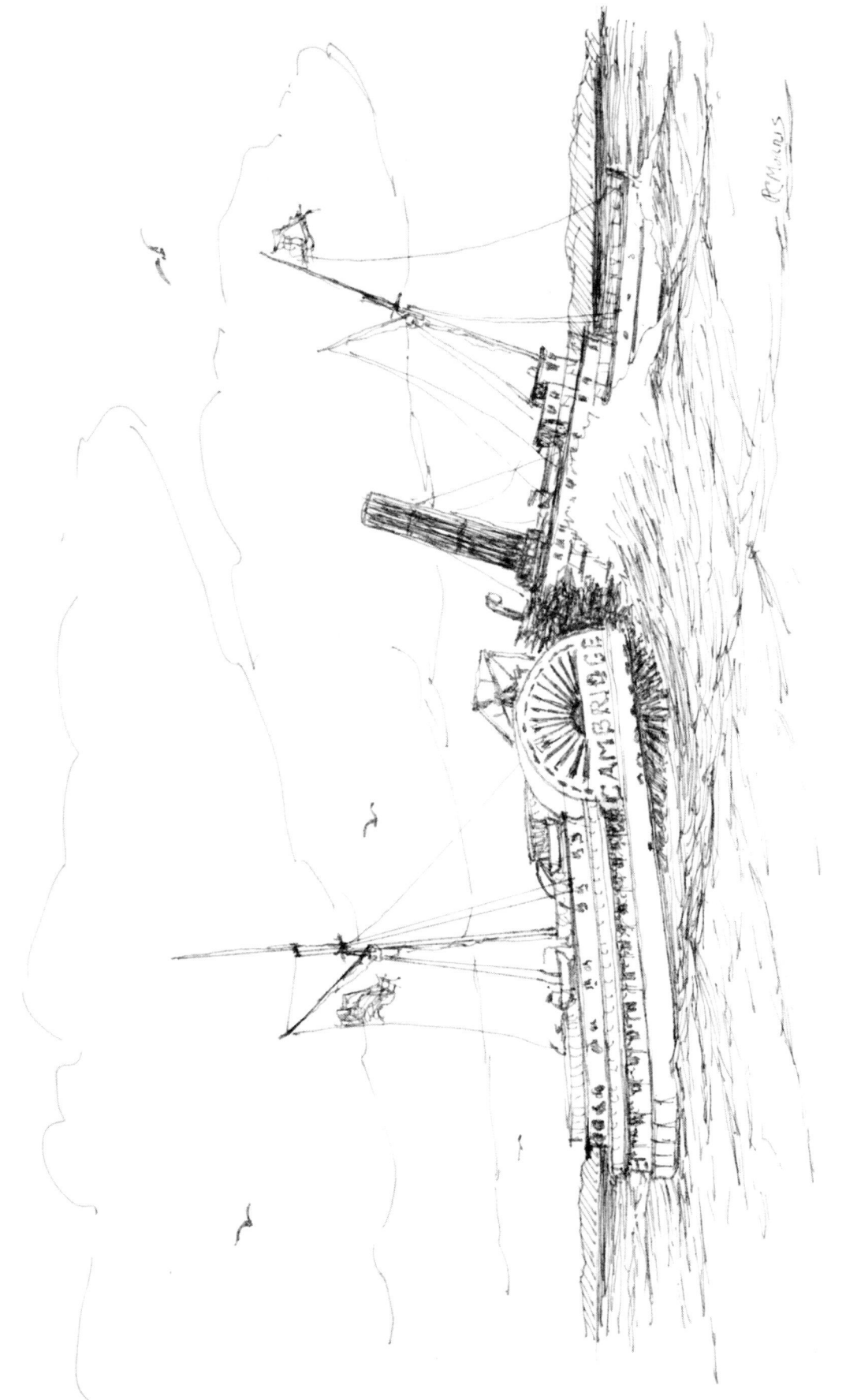

Many of the steamers that were employed in the late 1800's met fates that were sometimes violent. Here is a view of the paddle steamer "Cambridge", just after breaking in half. She had stranded on a rocky ledge off of Maine on Feb. 10, 1886, and was a total loss. (Illustration used in *Shipwrecks Around Maine*.)

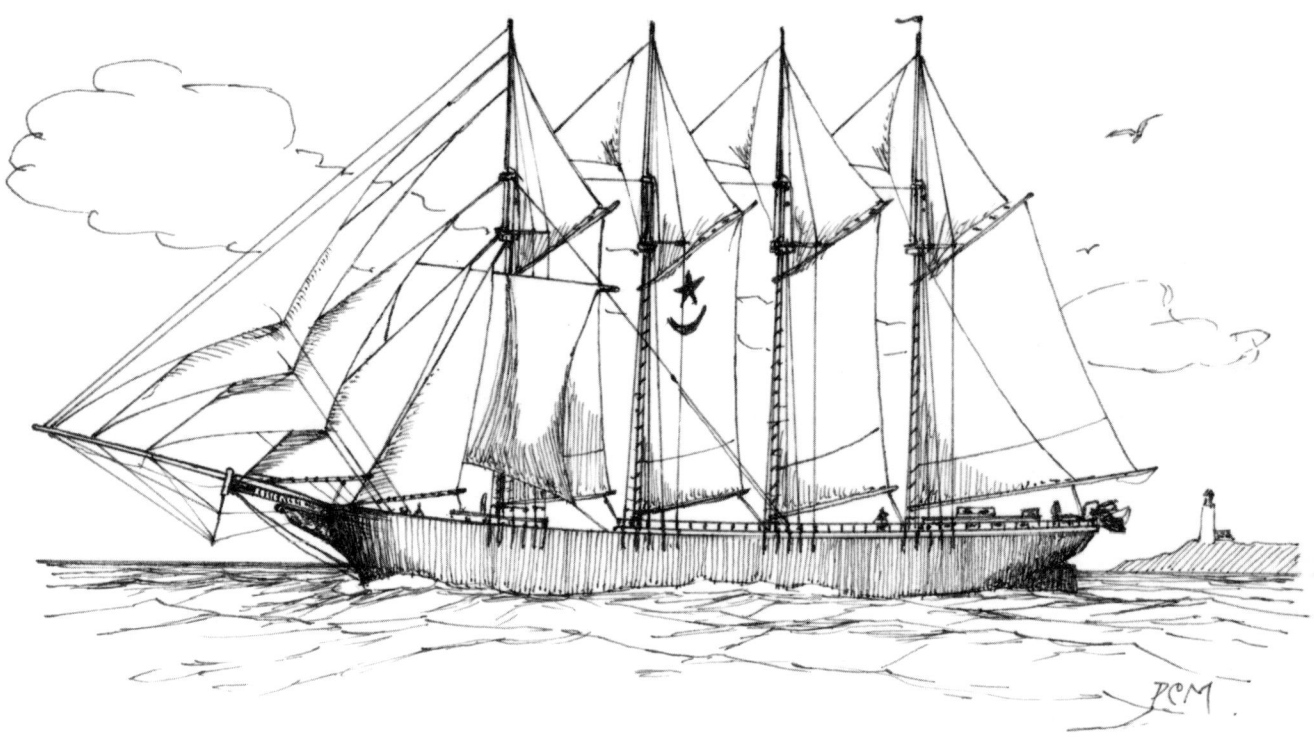

ABOVE: The four masted schooner "Louise H. Randall" was built in Boston in 1892. She was unusual as an eastern coasting vessel in that she was rigged with a yard on her foremast. **BELOW:** Although strongly built, the "Louise H. Randall" didn't last very long. On Nov. 27, 1893, she was lost off of the coast of Long Island, N.Y. Her crew was saved after enduring severe hardships while lashed to the rigging. (Illustrations used in *Four Masted Schooners of the East Coast*.)

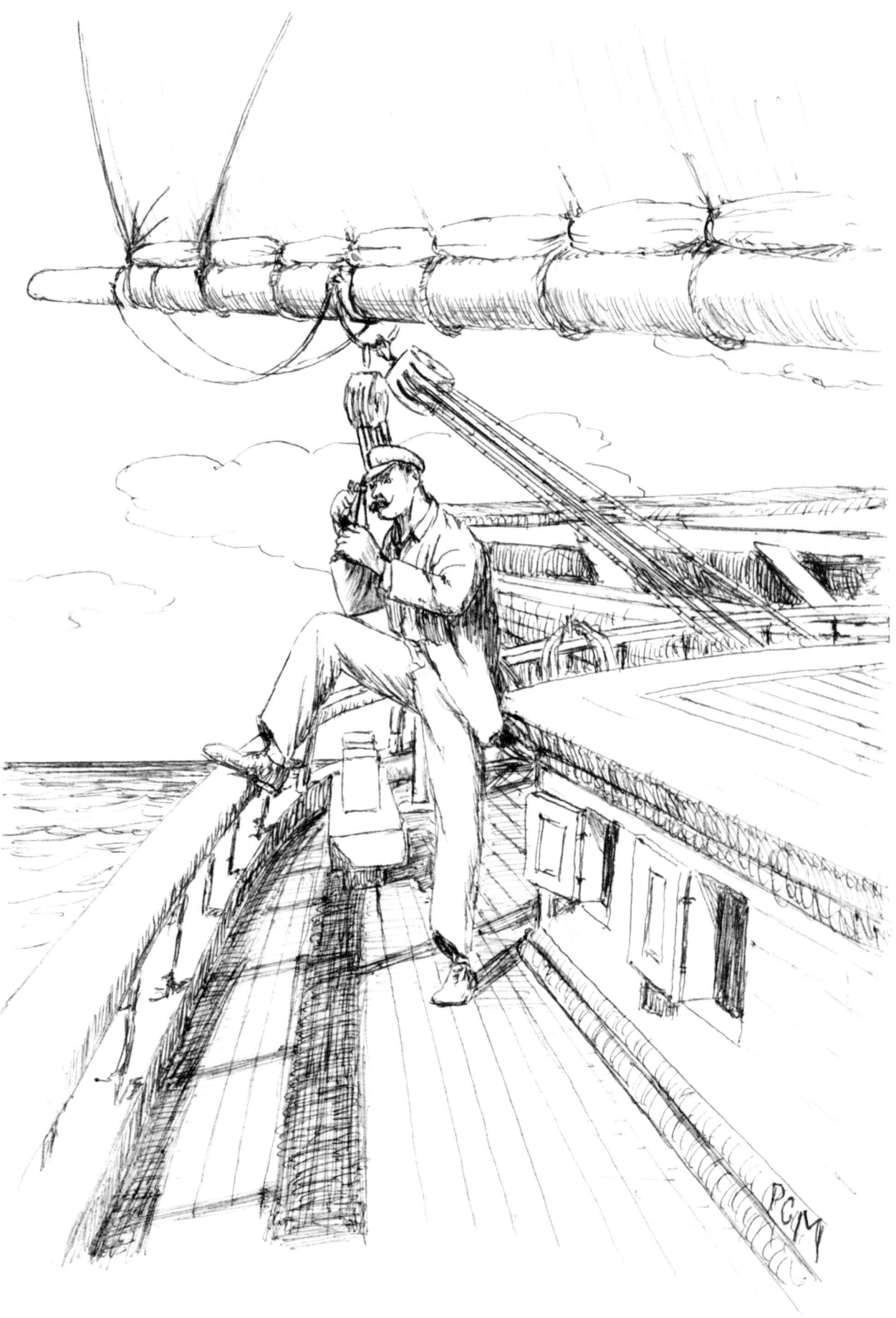

The "old man" shoots the sun. Coastal sailing was still tricky back around the turn of the Twentieth Century and the better a captain was at navigation, the better were his chances of success and survival.

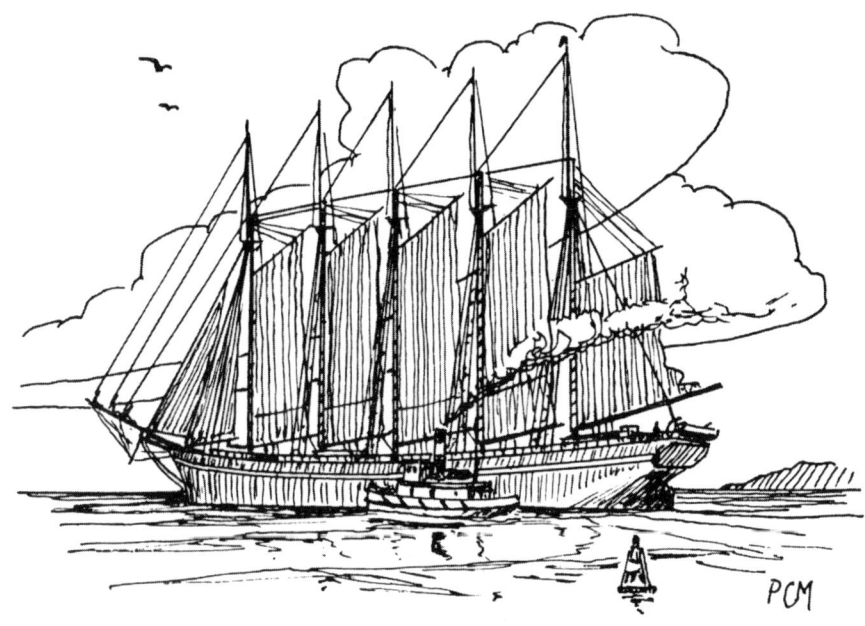

ABOVE: More five masted schooners began to appear in the late 1890's, as the demand for larger hulls arose. Here a big one is shown as it prepares to cast off its tug and head out to sea. **BELOW:** A "trick at the wheel". All sailors were expected to use one hand for the ship and one hand for themselves. They were also expected to be able to steer a straight course. This required two hands most of the time. (Illustrations used in *American Sailing Coasters of the North Atlantic*.)

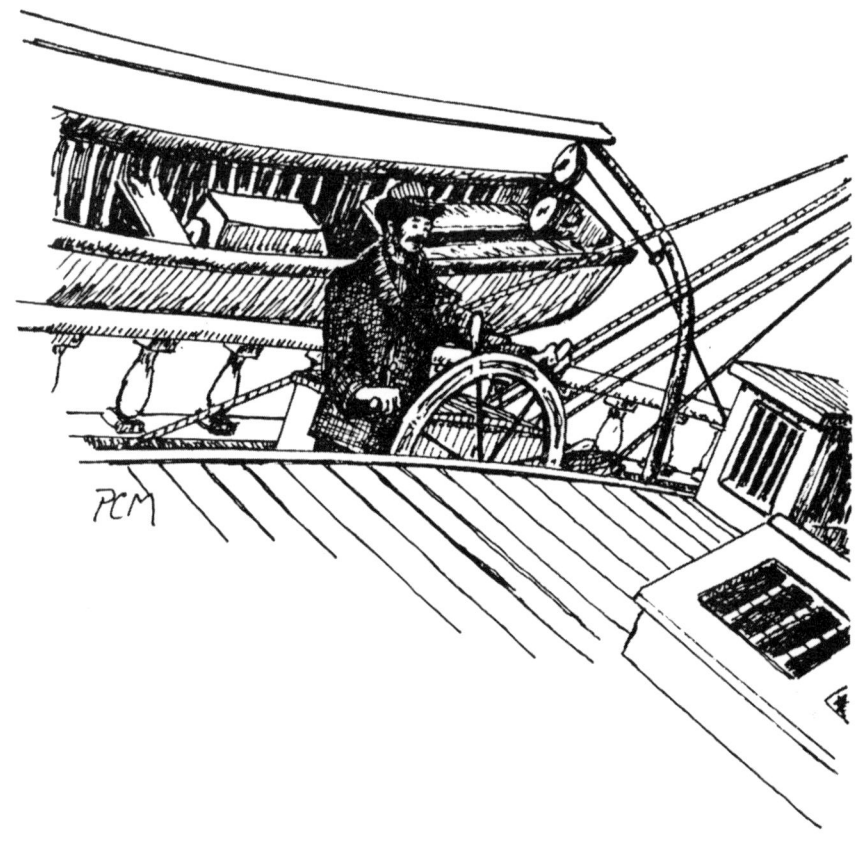

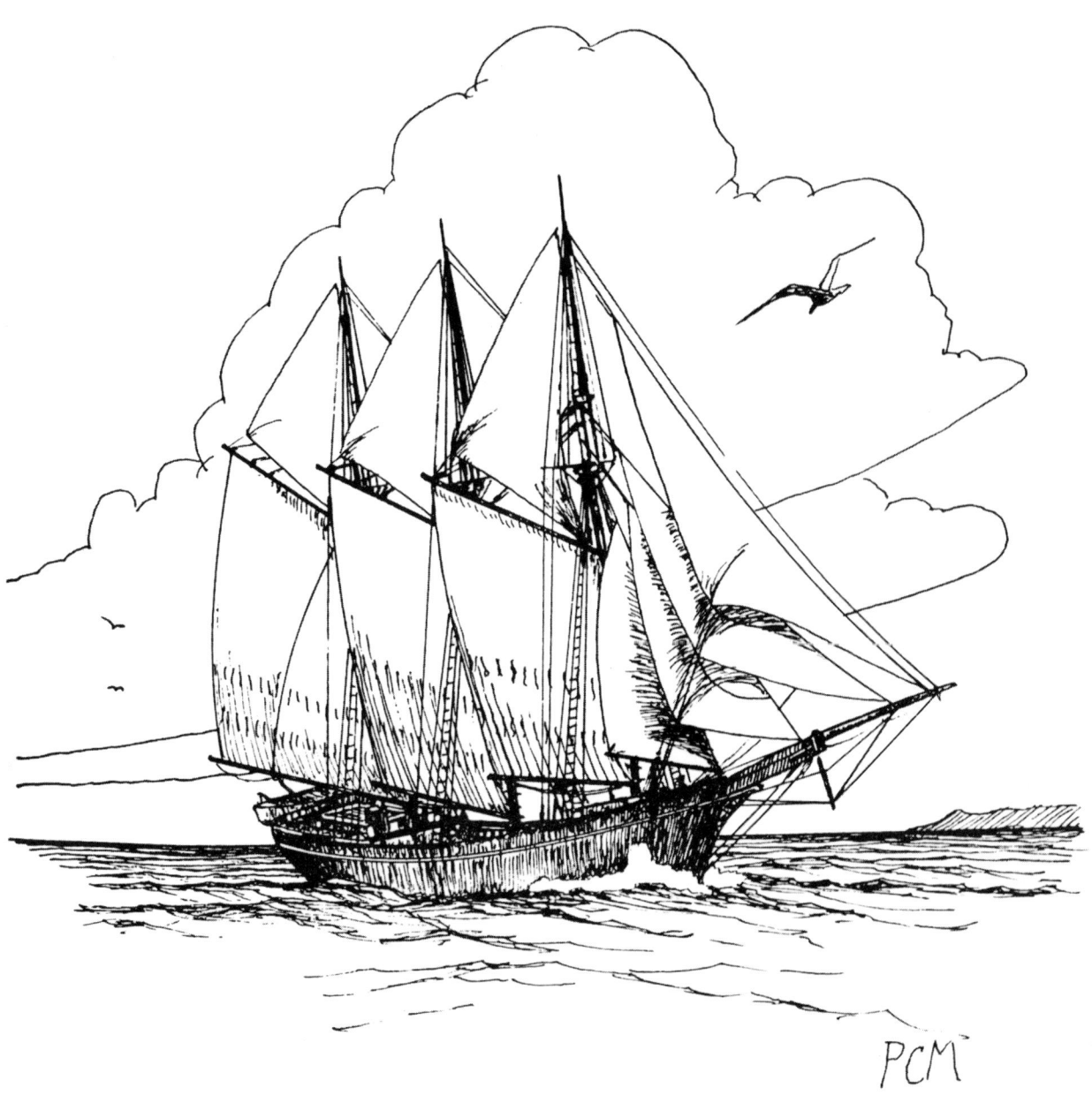

A three masted schooner of the 1890's. There were literally hundreds of these vessels busily engaged in carrying bulk cargoes along our coastline. The one pictured here is sailing "light", or without cargo. She might possibly have a centerboard, which would greatly assist her when sailing without much depth in the water. (Illustration used in *American Sailing Coasters of the North Atlantic*.)

A tug hauls a "bunched up" tow of coasting schooners to port in a Maine river. Wood, coal, ice, fertilizer, stone and all sorts of bulk cargoes were carried on coastal routes. (Illustration used in *Shipwrecks Around Maine*.)

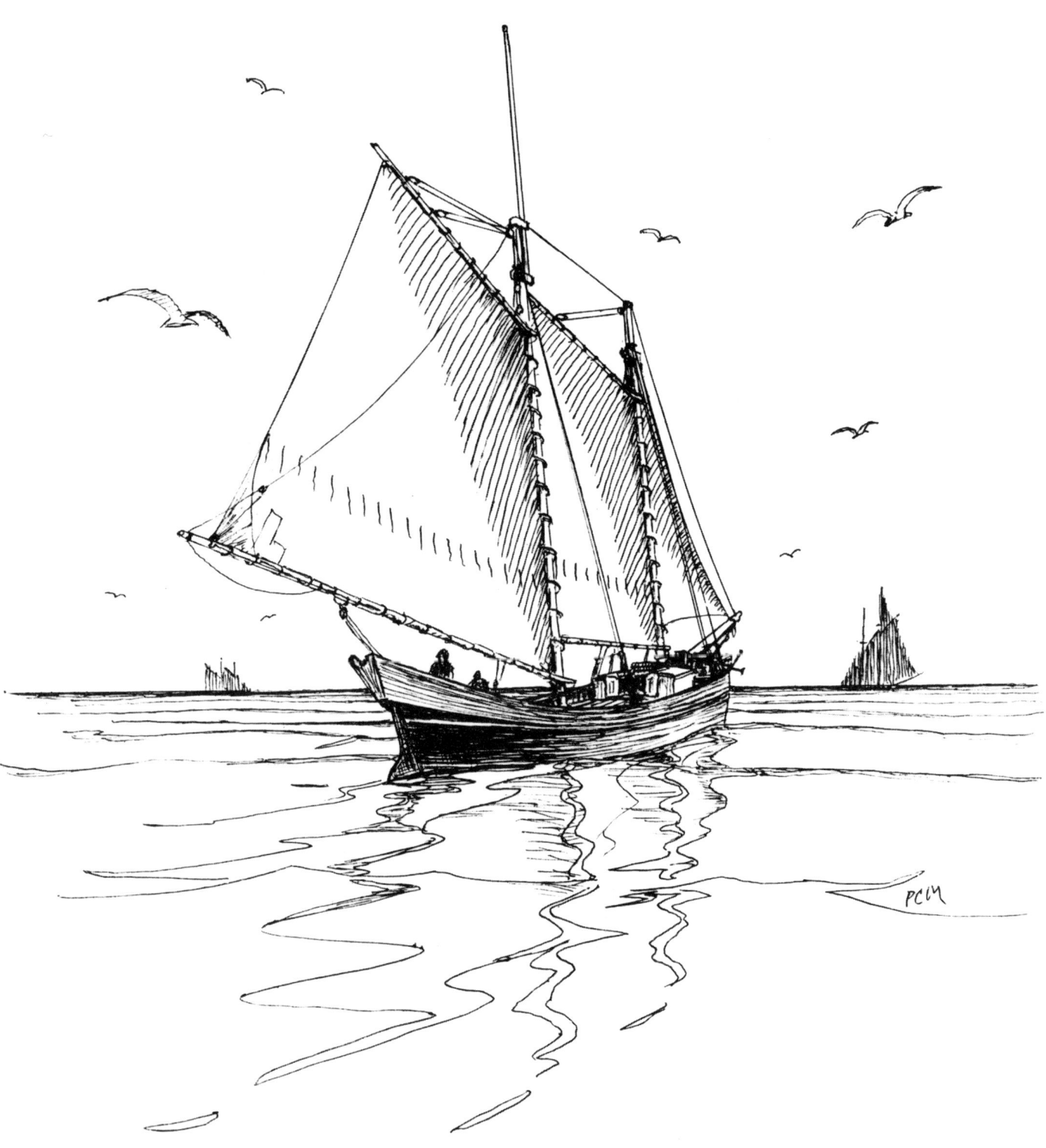

A fishing pinky awaits a breeze as she heads out to the fishing grounds to do some hand lining. Pinkies were built both in New England and Canada during the 19th Century.

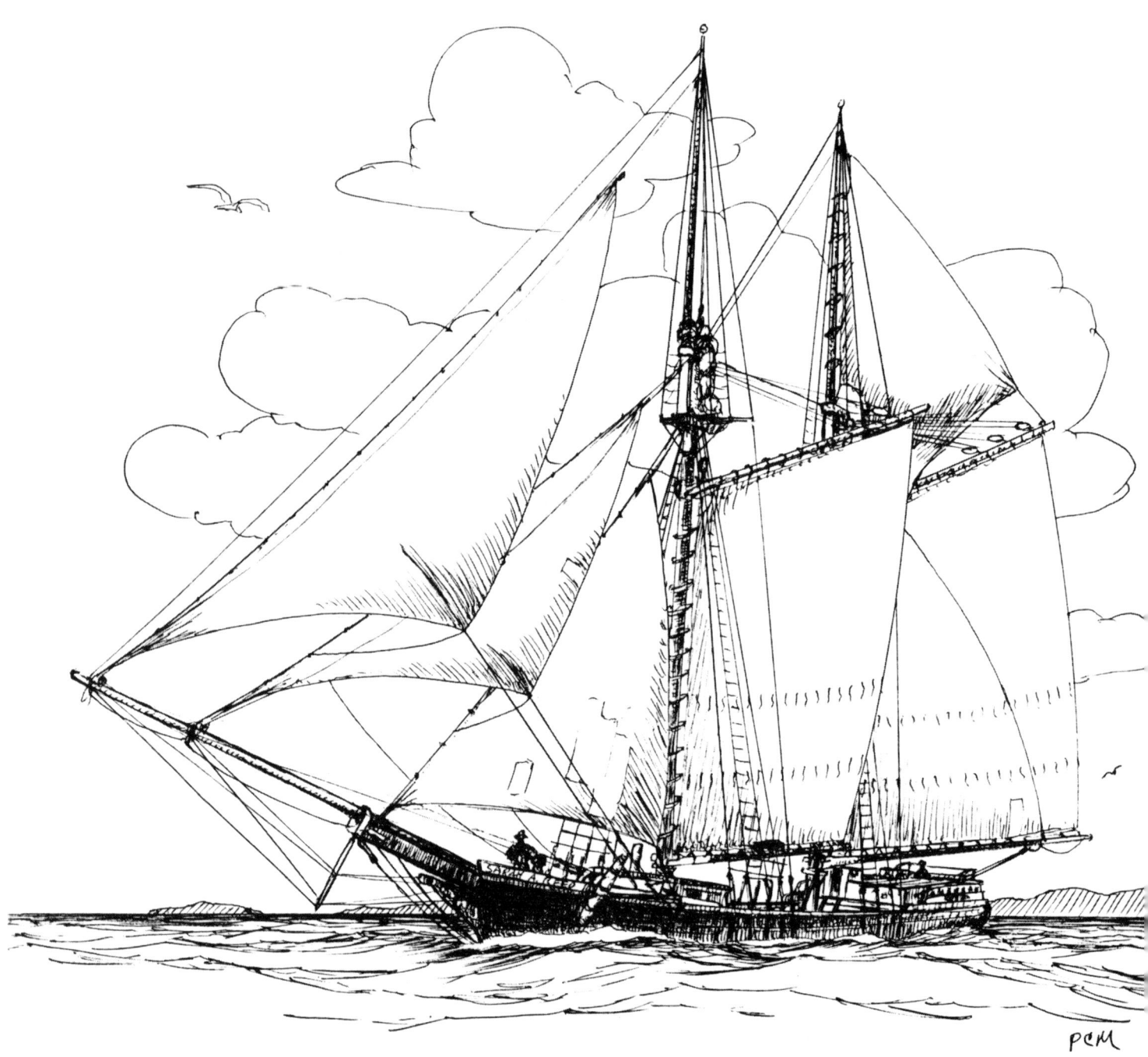

The two masted cargo schooner "Sara A. Reed" rolls along, fully loaded. She was built in Calais, Maine in 1868 and lasted a very long time. She was finally abandoned by her owners on May 13, 1919.

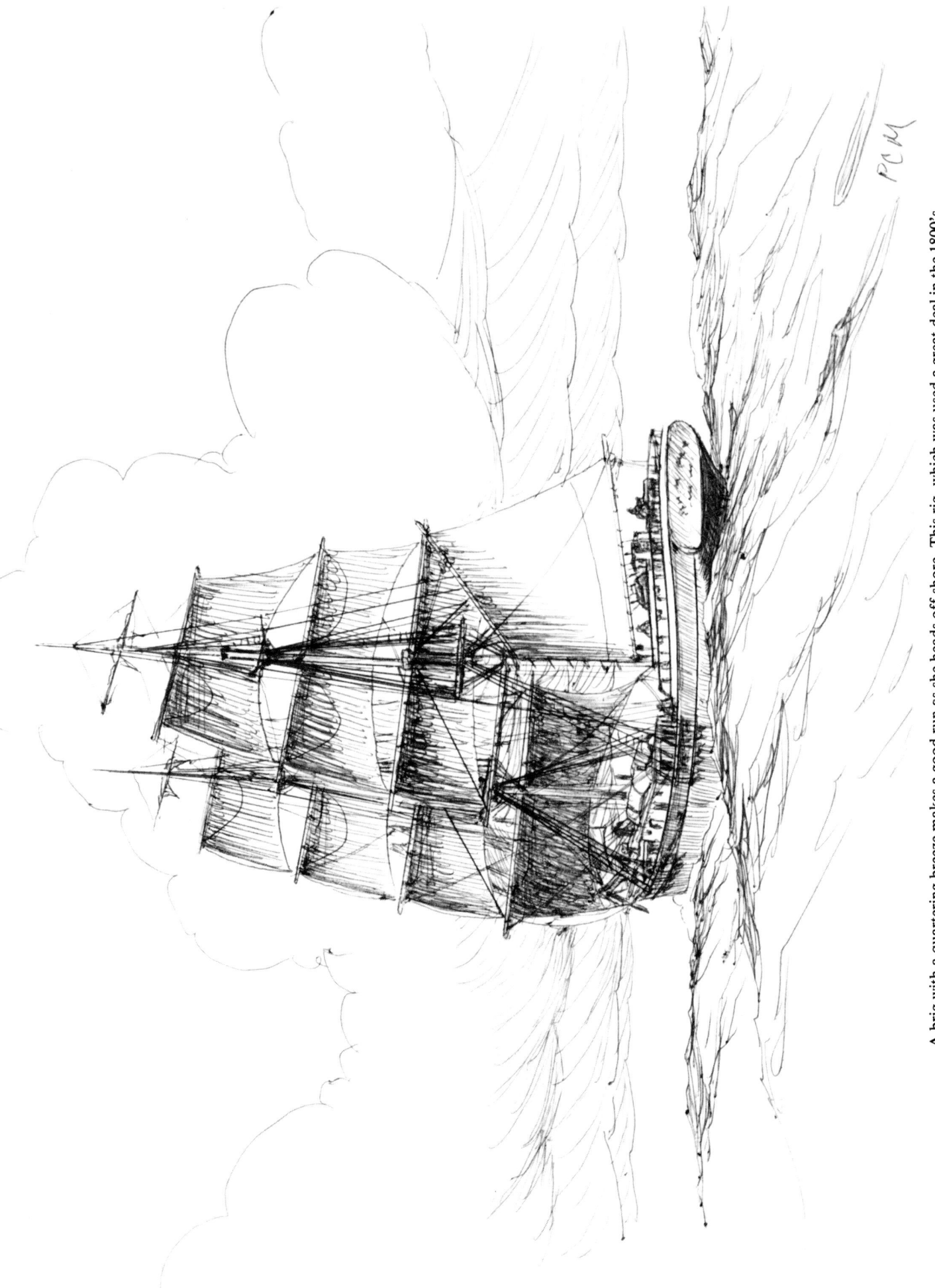

A brig with a quartering breeze makes a good run as she heads off shore. This rig, which was used a great deal in the 1800's, fell from favor in the latter part of that century and by 1900 there were not a great many to be seen.

ABOVE: The use of schooner barges came into heavy usage in the latter part of the 1800's. Schooner barges were towed by tugs, but did set some sail to assist in their operation. Here is the "Delaware", a schooner barge that was converted from a steamer in 1895. (Illustration used in *Schooners and Schooner Barges*.) **BELOW:** Wrecks were a common occurrence in the 1800's. Coasting vessels were lost every year in fairly large numbers. Here is a two masted schooner ashore and beyond help. (Illustration used in *American Sailing Coasters of the North Atlantic*.)

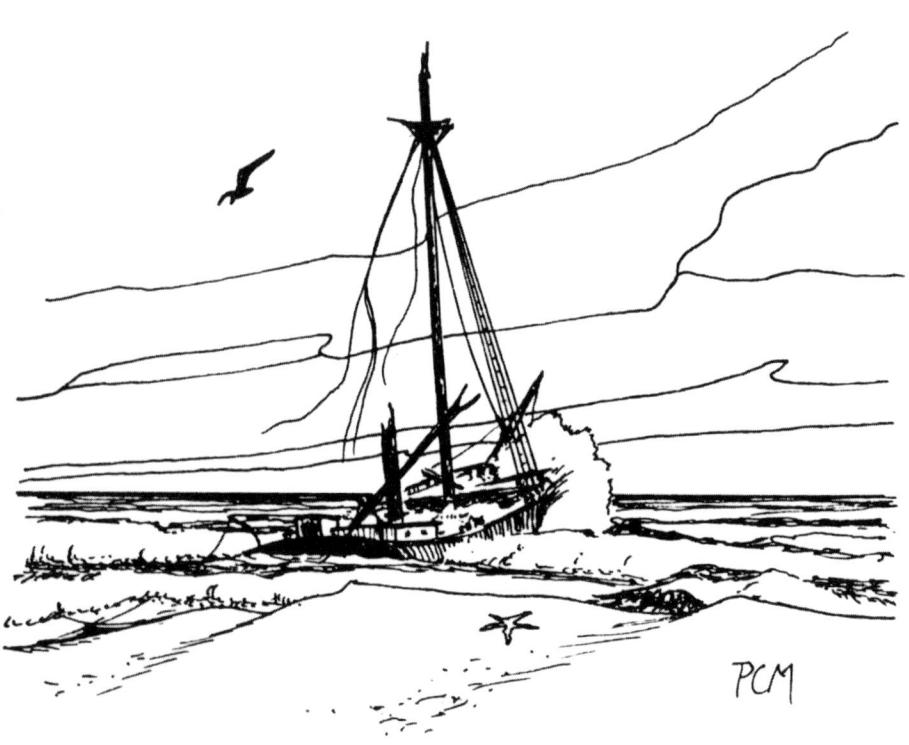

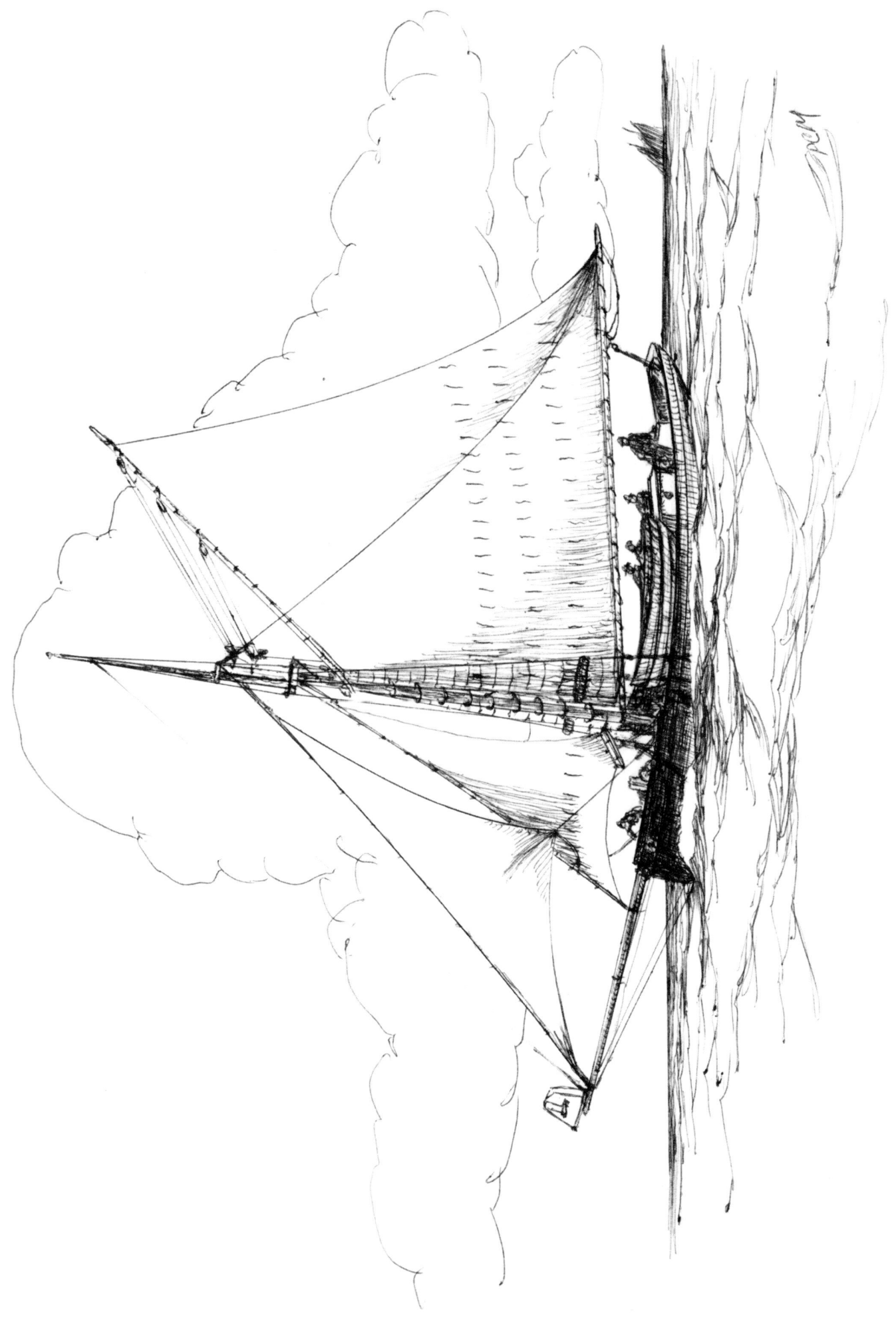

A Gloucester "sloop boat", the "Vesta" was built in 1898. With her dories on deck and a swordfishing pulpit rigged on the bowsprit, this little vessel is ready to catch codfish or the occasional "Broadbill". Sloops were used in the fishing industry more than is generally realized today. This plumb stemmed fisherman later had an engine installed and lasted until listed as abandoned by her owners in 1941.

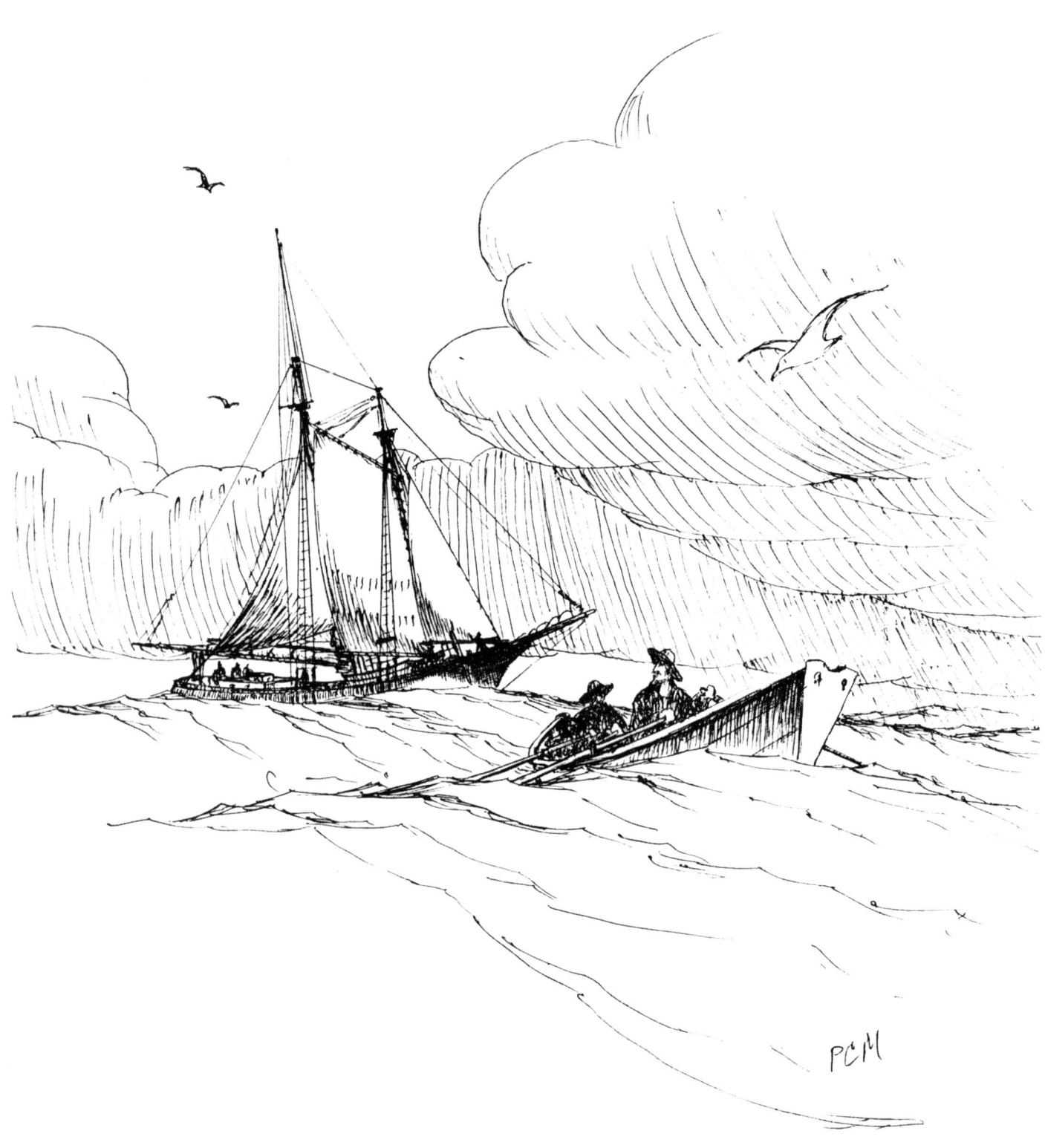

Two dory mates head back to their schooner before "it comes on to blow". They'll probably have a mug up of coffee or tea before going back out to set their tubs of trawl in better weather. Fishing was a dangerous profession back in the days of the schooner fleets and the yearly losses of life were often much too high.

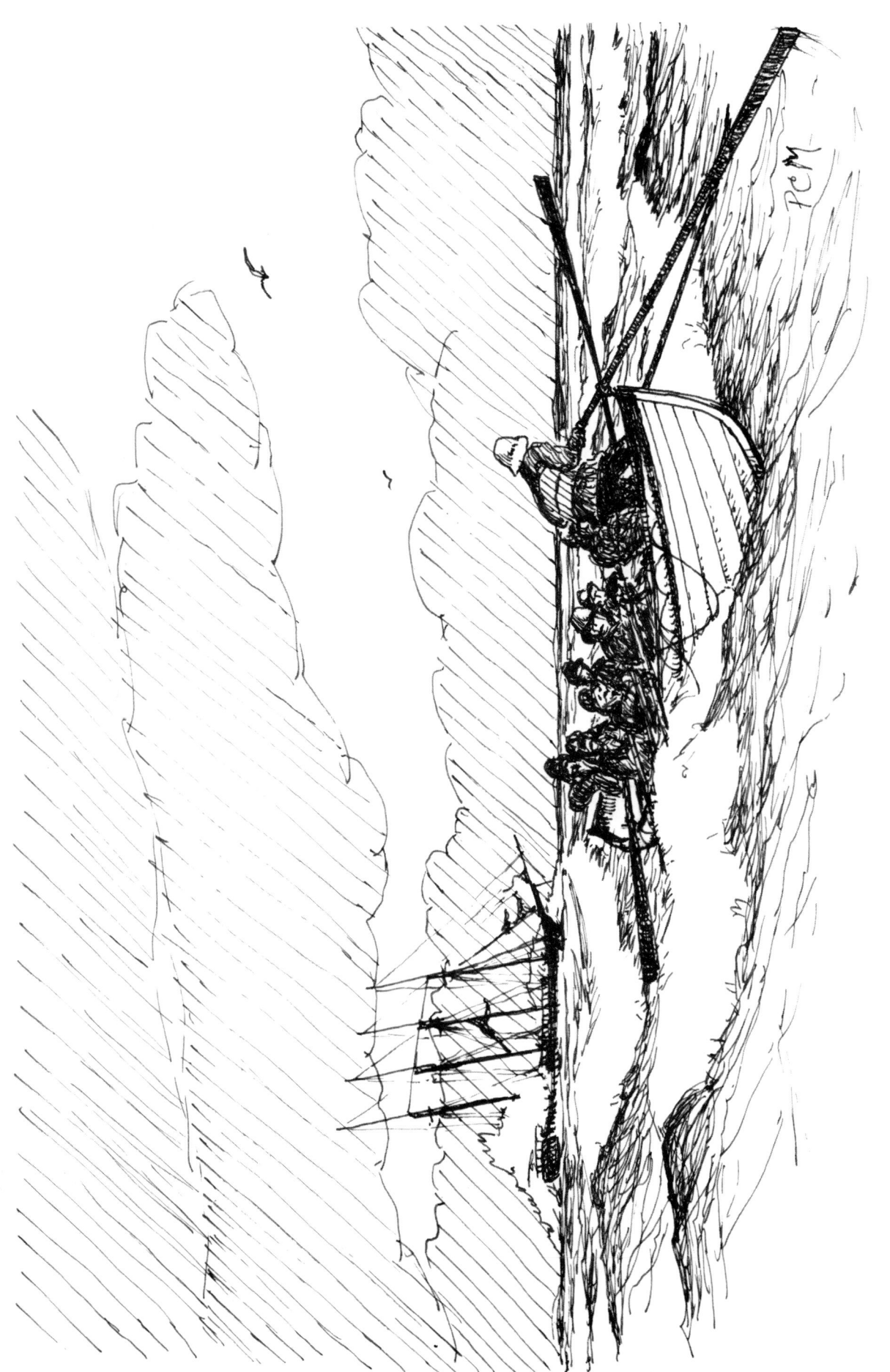

A four masted schooner is shown aground off Cape Cod and the brave men in the U.S. Lifesaving Service have launched their surfboat to go to the rescue. The Lifesaving Service was organized in the 1870's and saved hundreds of lives and countless dollars in property value. (Illustration used in *Shipwrecks Around New England*.)

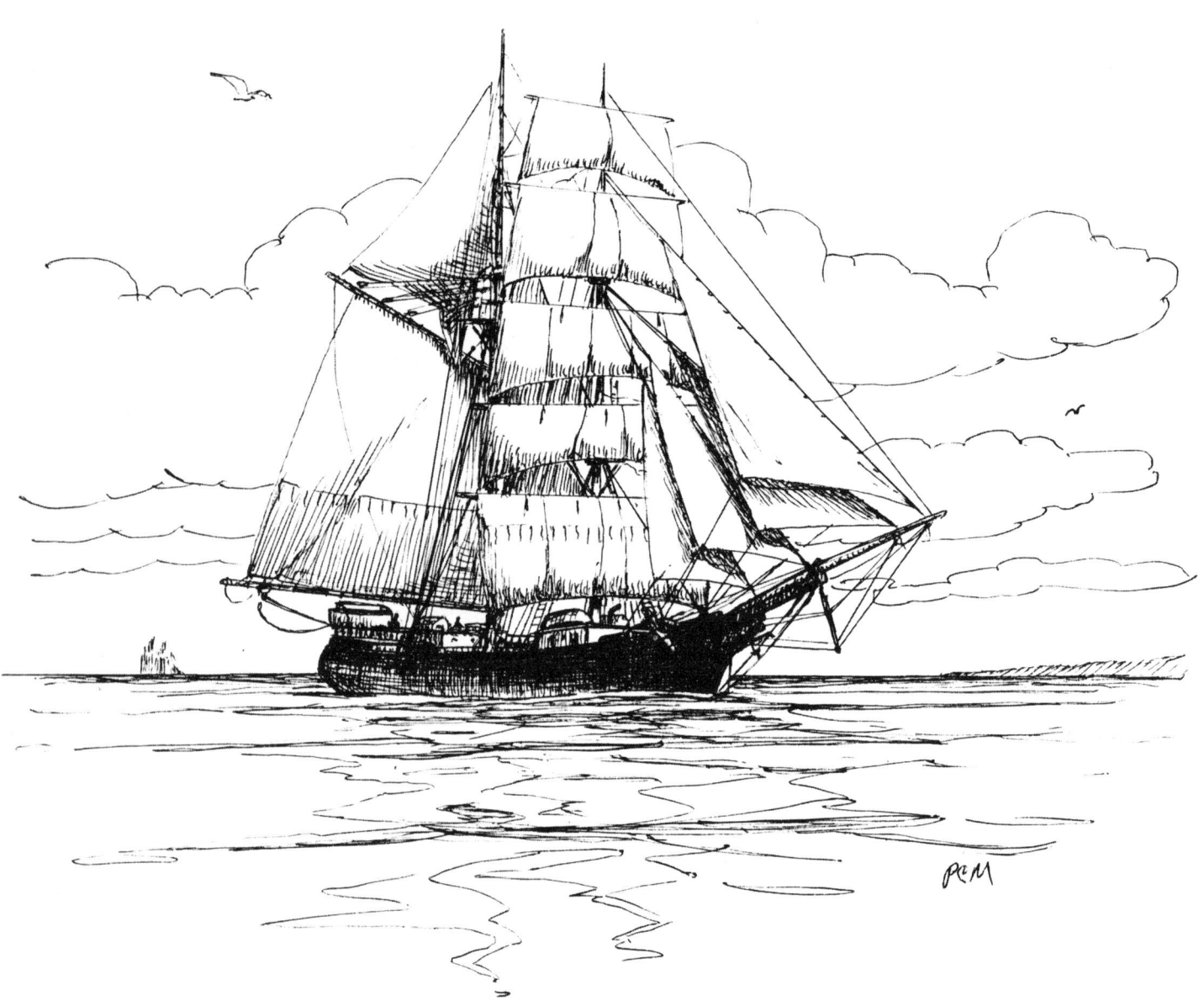

A hermaphrodite brig, commonly referred to as a brigantine in later days, is shown starting to pick up a breeze after laying becalmed a few miles off shore.

A big, wooden, six masted schooner sails along shore with a good quartering breeze. Coal was the principle cargo carried in these very large schooners. During World War One however, other bulk cargoes were carried and some of the big schooners made deep water passages.

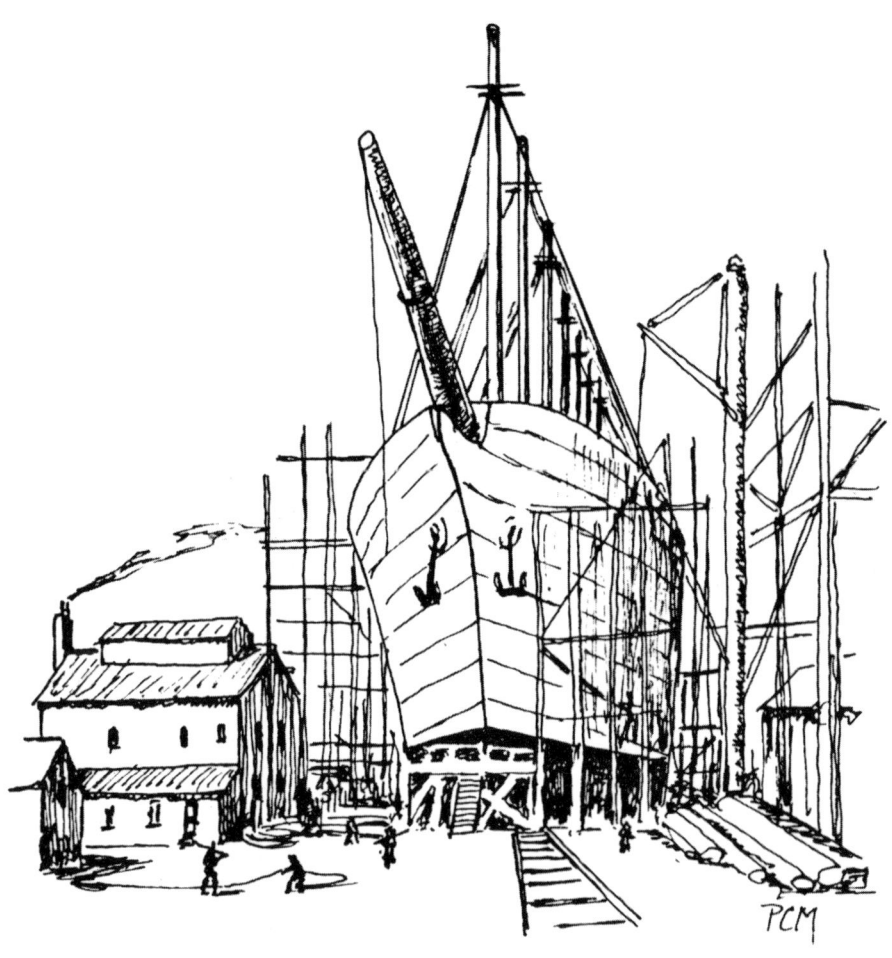

ABOVE: The "Thomas W. Lawson" was built of steel in 1902 at Quincy, Massachusetts. She was the only seven masted coasting schooner to be built and lasted only five years. (Illustration used in *American Sailing Coasters of the North Atlantic*.)
BELOW: Painting the scroll work on the bow of a large vessel. (Illustration used in *Four Masted Schooners of the East Coast*.)

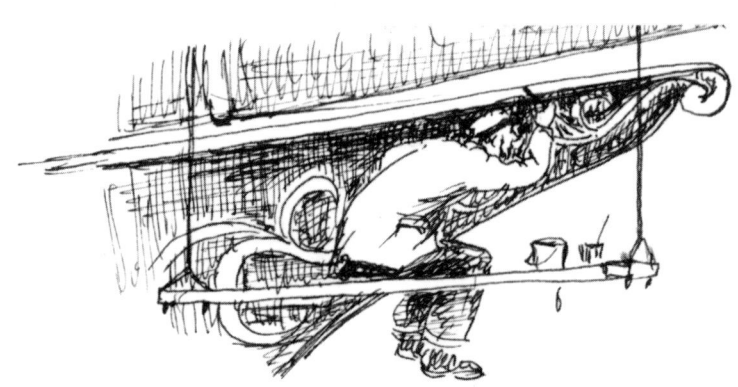

One of the great tragedies suffered by the Life Saving Service occurred on March 17, 1902, off Monomoy Island, Cape Cod. Seven men from the service and five men from the schooner barge "Wadena" were drowned when the lifesavers' surf boat overturned in rough water. Only one man, Surfman Seth Ellis, was rescued. This was accomplished when Captain Elmer F. Mayo was able to row to the overturned surfboat in a dory. Mayo was able to get Ellis into the dory and safely negotiate the breaking surf and land on the beach. (Illustration used in *Shipwrecks Around Cape Cod.*)

ABOVE: Schooner barges not only stranded, but many broke loose from their tug and were blown out to sea. The "Cardenas" was at sea for almost a month after parting her towing hawser in 1902. She was finally picked up by the same tug she had broken away from weeks earlier. The small sails on the barge were of great help in this and similar cases. (Illustration used in *Schooners and Schooner Barges*.)
BELOW: A deck capstan used for warping and hauling heavy lines. (Illustration used in *Four Masted Schooners of the East Coast*.)

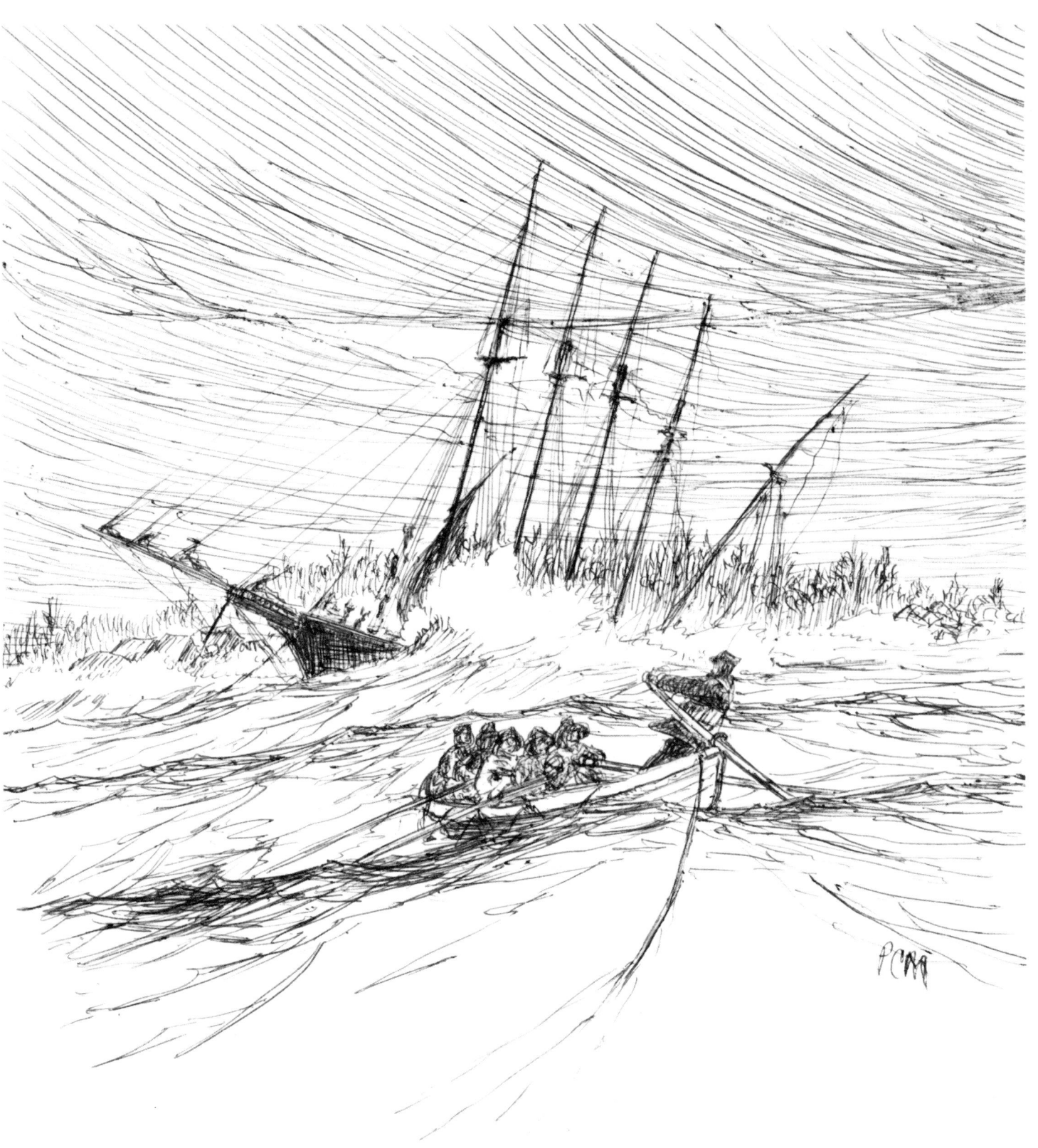

Many coasting vessels were forced ashore due to unfavorable weather. The big, five masted schooner "Washington B. Thomas" dragged her anchors and went ashore on the Maine coast on June 12, 1903. The wife of Captain William J. Lermond was drowned. Lifesavers from Cape Elizabeth managed to remove Captain Lermond and his crew from the doomed schooner after battling terrible weather conditions. (Illustration used in *Shipwrecks Around Maine*.)

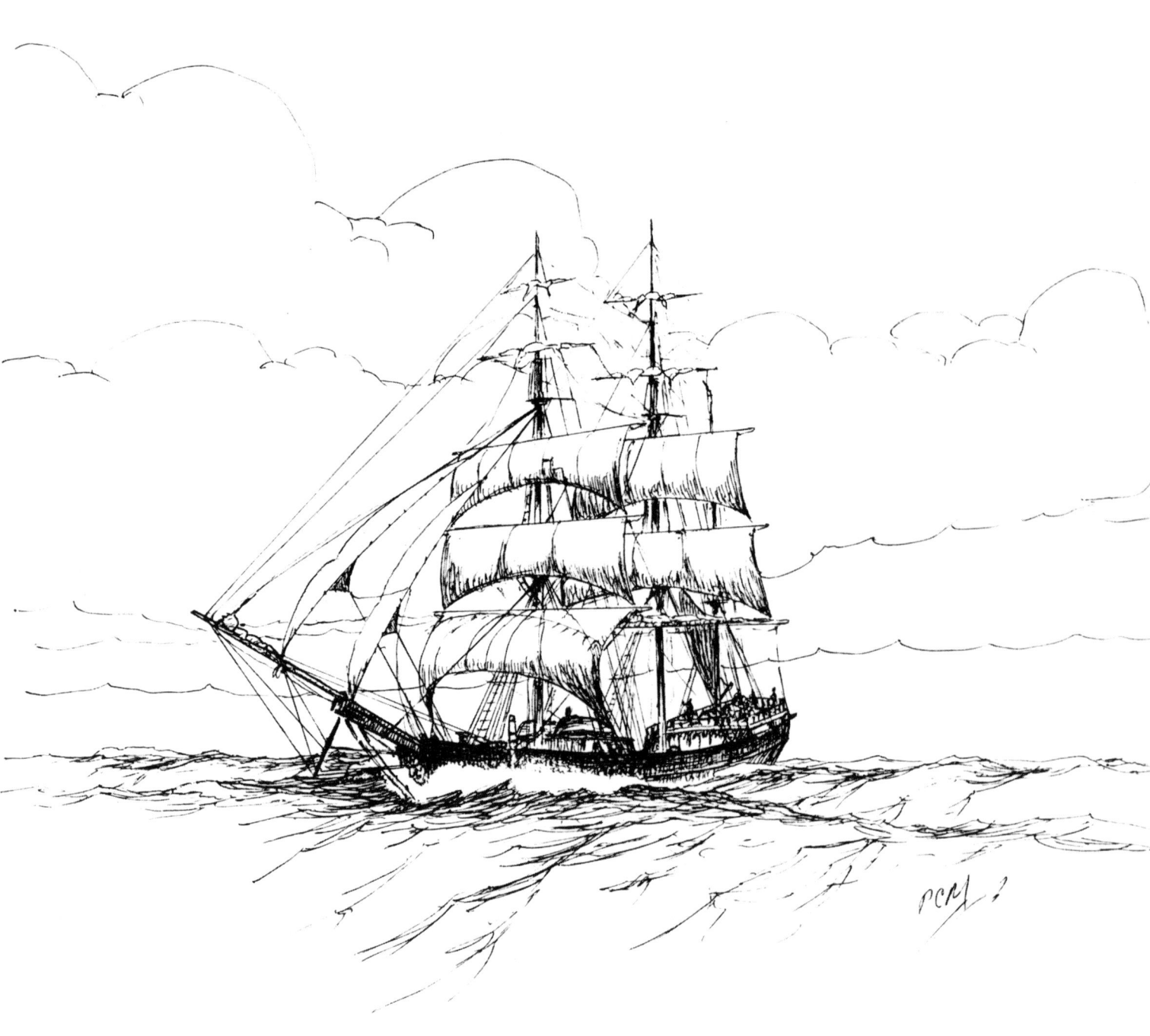

A "bluenose" bark runs before a strong wind and rolling sea. These wooden, deep water vessels were often seen sailing along our coastline.

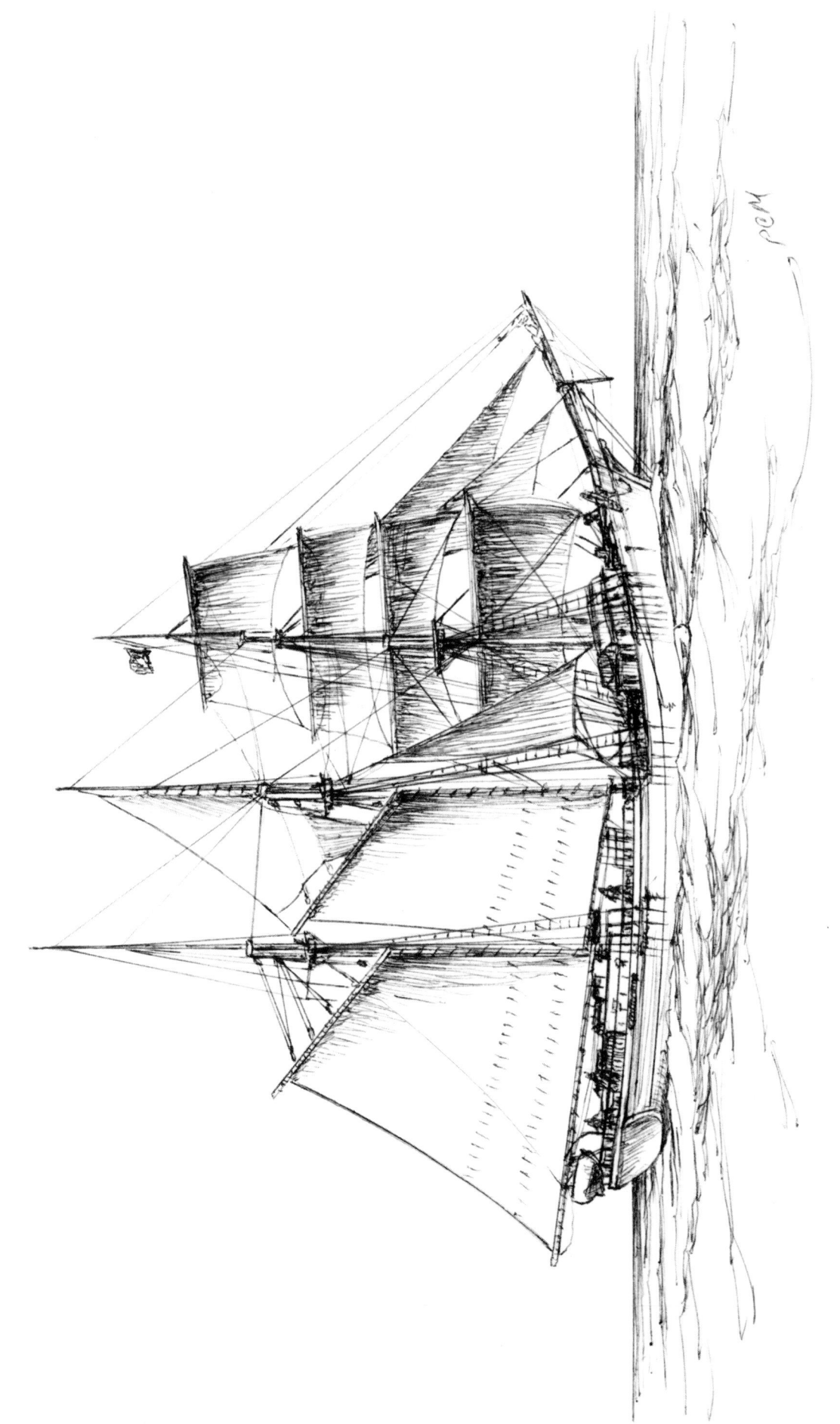

The Canadian barkentine "Annie Smith" was built at Liverpool, Nova Scotia in 1899. She is shown as she heads into the port of New York with the signal requesting a pilot flying from her foremast.

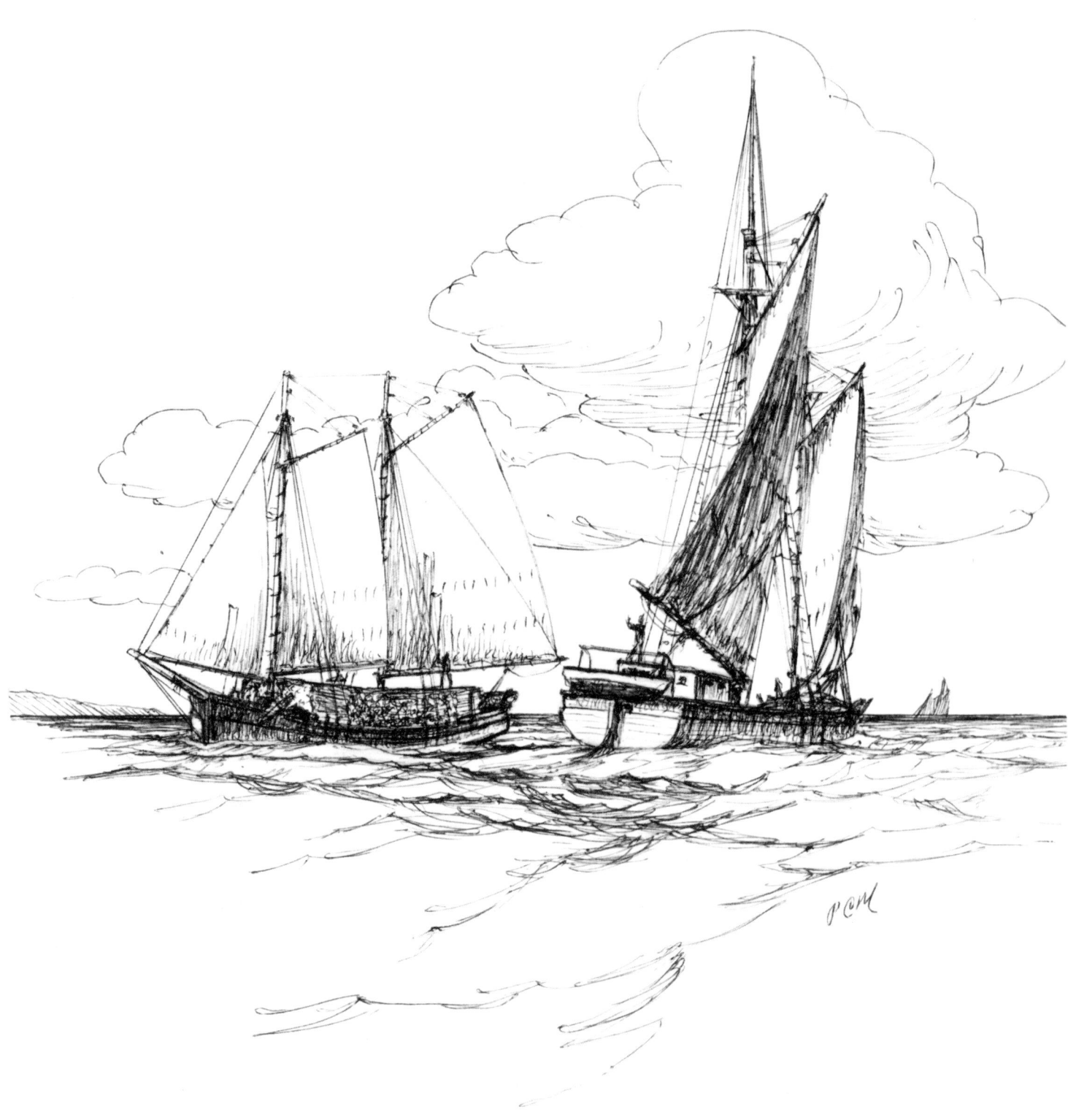

Two "Johnny Woodboats" pass each other off of the entrance to Penobscot Bay, Maine. The "Lillie G.", on the left, is loaded with kiln wood and headed into the port of Rockland. The "Eskimo", on the right, is empty and is heading back to her home port of St. John N.B., where she will load more wood. During the late 1800's these little schooners carried thousands of cords of firewood to the lime kilns in Rockland and Rockport.

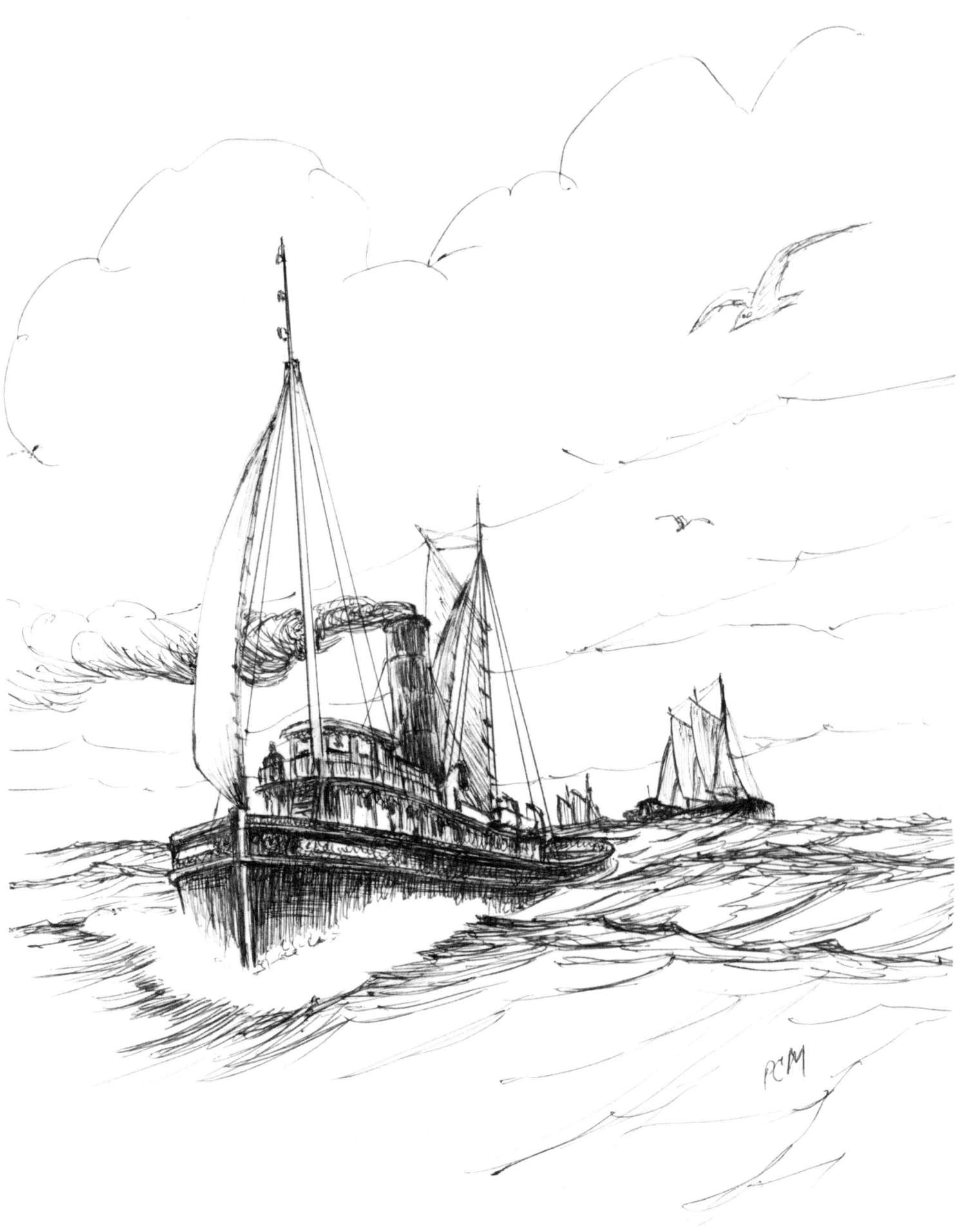

One of the big oceangoing tugs of the early 1900's labors through heavy seas with its tow of schooner barges loaded with coal. Tugs as well as barges often set sails to assist in their progress. In their competition with the large schooners, the tugs and barges eventually won the battle for dominance in this trade. The economics involved in operating tugs and barges produced larger profits than those of the sailing coasters. (Illustration used in *Schooners and Schooner Barges*.)

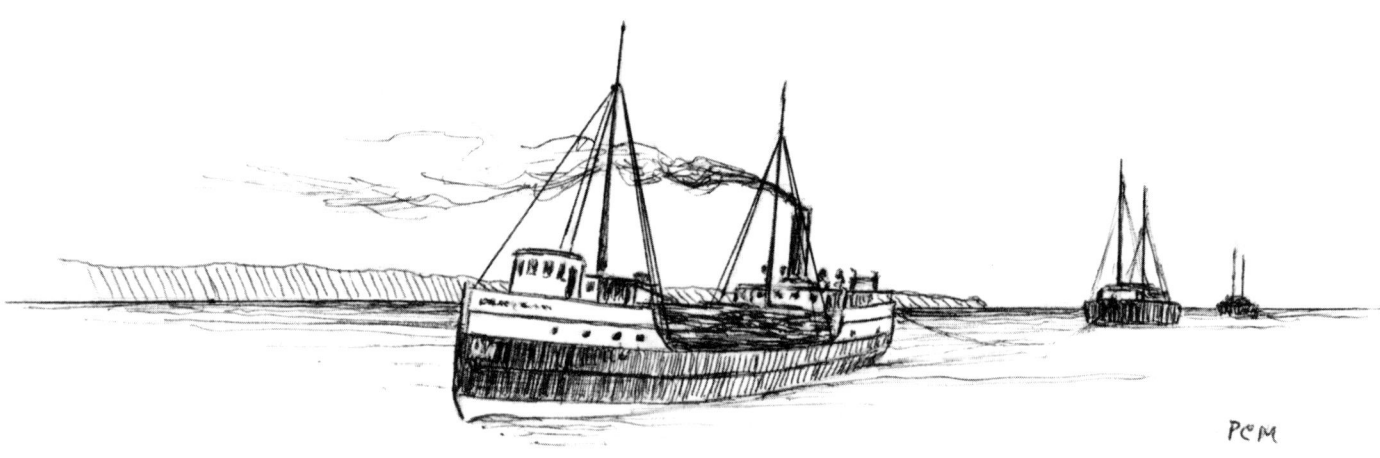

ABOVE: Following the Civil War, the successful towing of barges was demonstated on the Great Lakes. It continued as a practical way to move bulk cargoes into the 1900's. **BELOW:** Before 1908, the long tows traveling along our east coast posed a great threat to other shipping. There were far too many collisions and other accidents. In 1904, the lightship on Cross Rip in Nantucket Sound was struck three times in less than two months by passing tows. (Illustrations used in *Schooners and Schooner Barges*.)

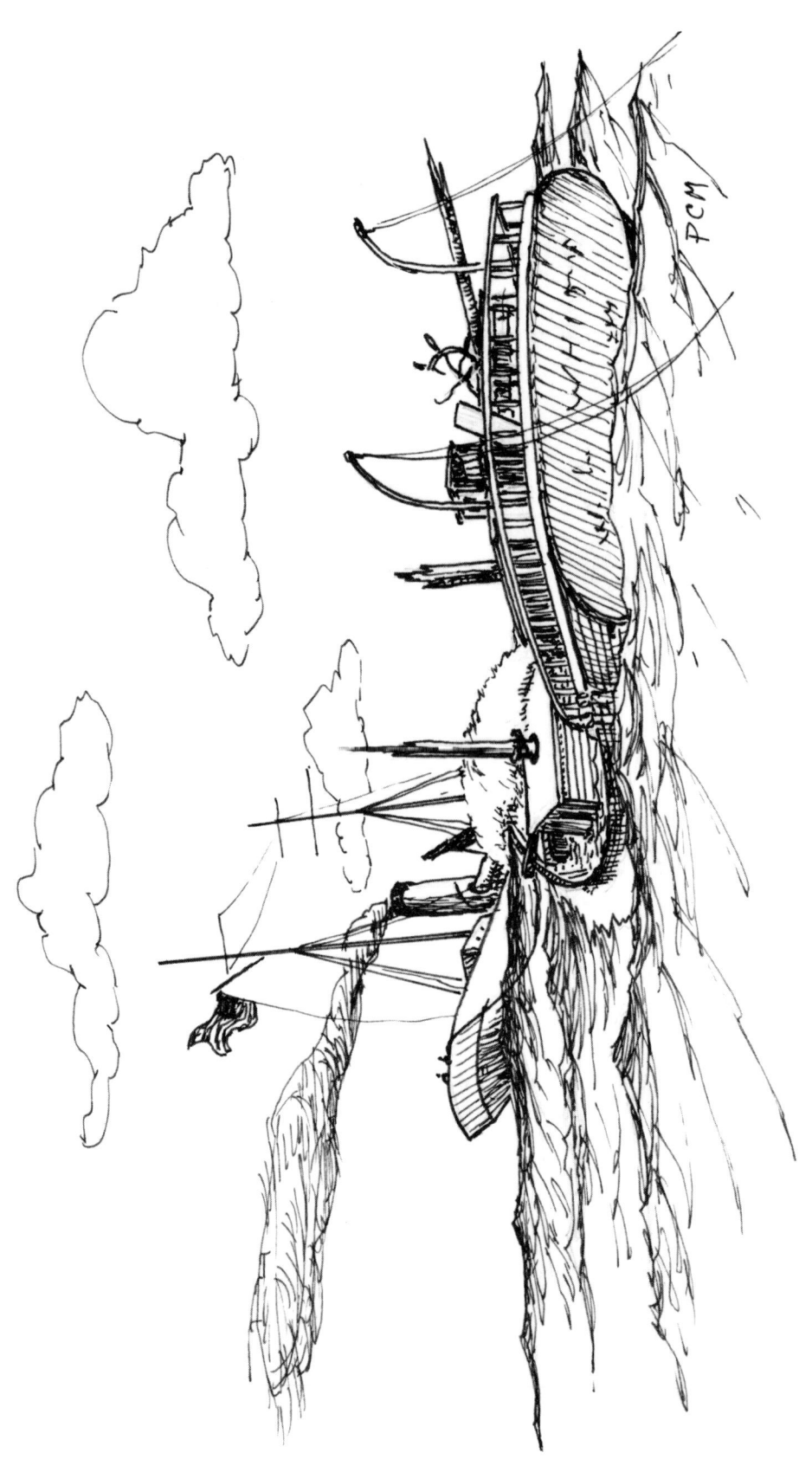

During the early 1900's the U.S. Revenue Service maintained cutters to enforce U.S. commercial policies on the high seas. One of their tasks was to search out and remove derelicts that were drifting around in our sea lanes. Many of these derelicts had been badly smashed by the elements and were a terrible threat to vessels encountering them in their path. Some derelicts, barely afloat, were blown up; others that could be salvaged were towed into port. (Illustration used in *Shipwrecks Around New England*.)

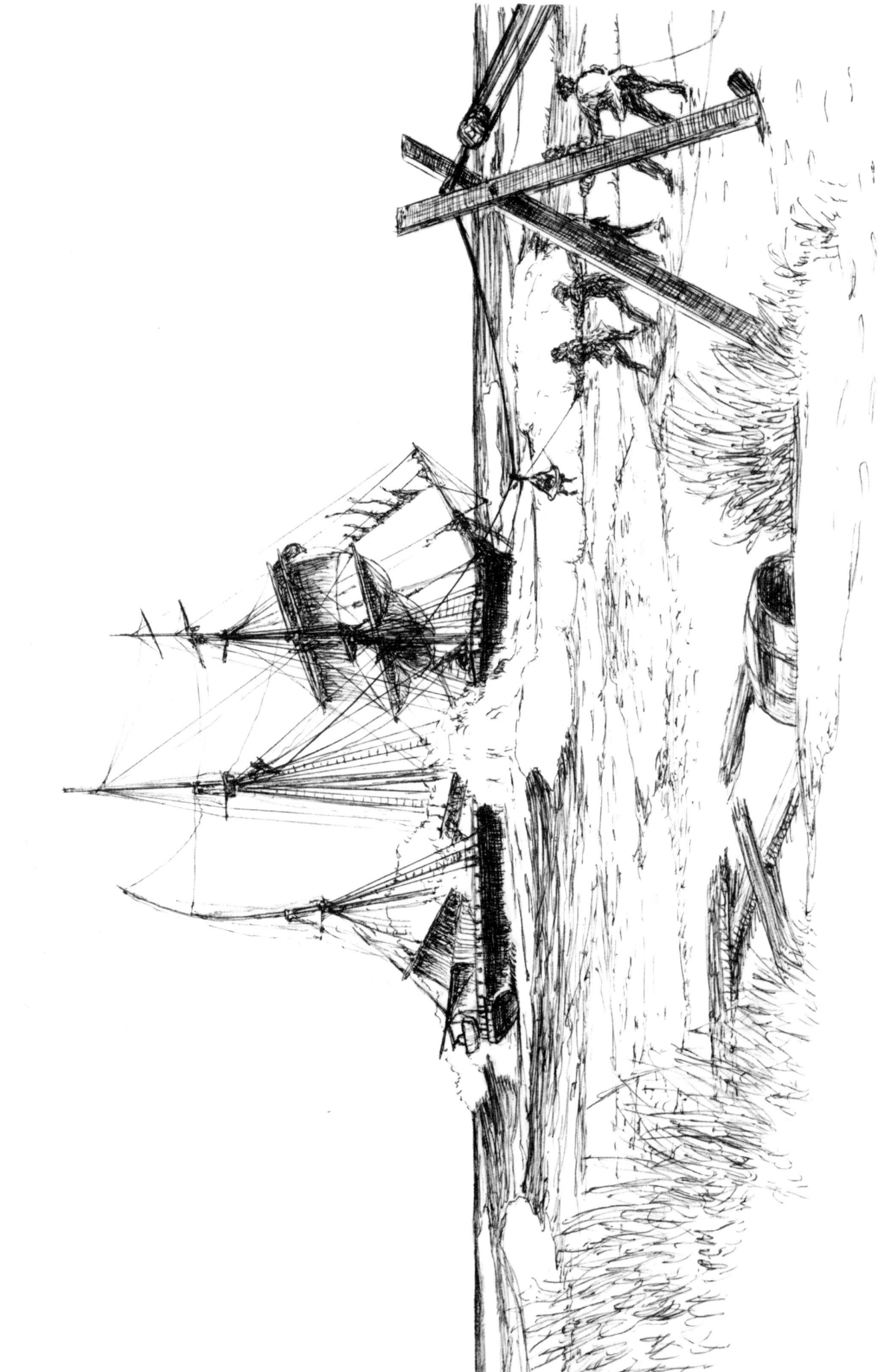

On March 27, 1913, the aging barkentine "Antioch" struck the shore near Squam Beach, New Jersey. The Lifesavers stationed there rescued the ten man crew with the breeches buoy apparatus and the old vessel soon went to pieces.

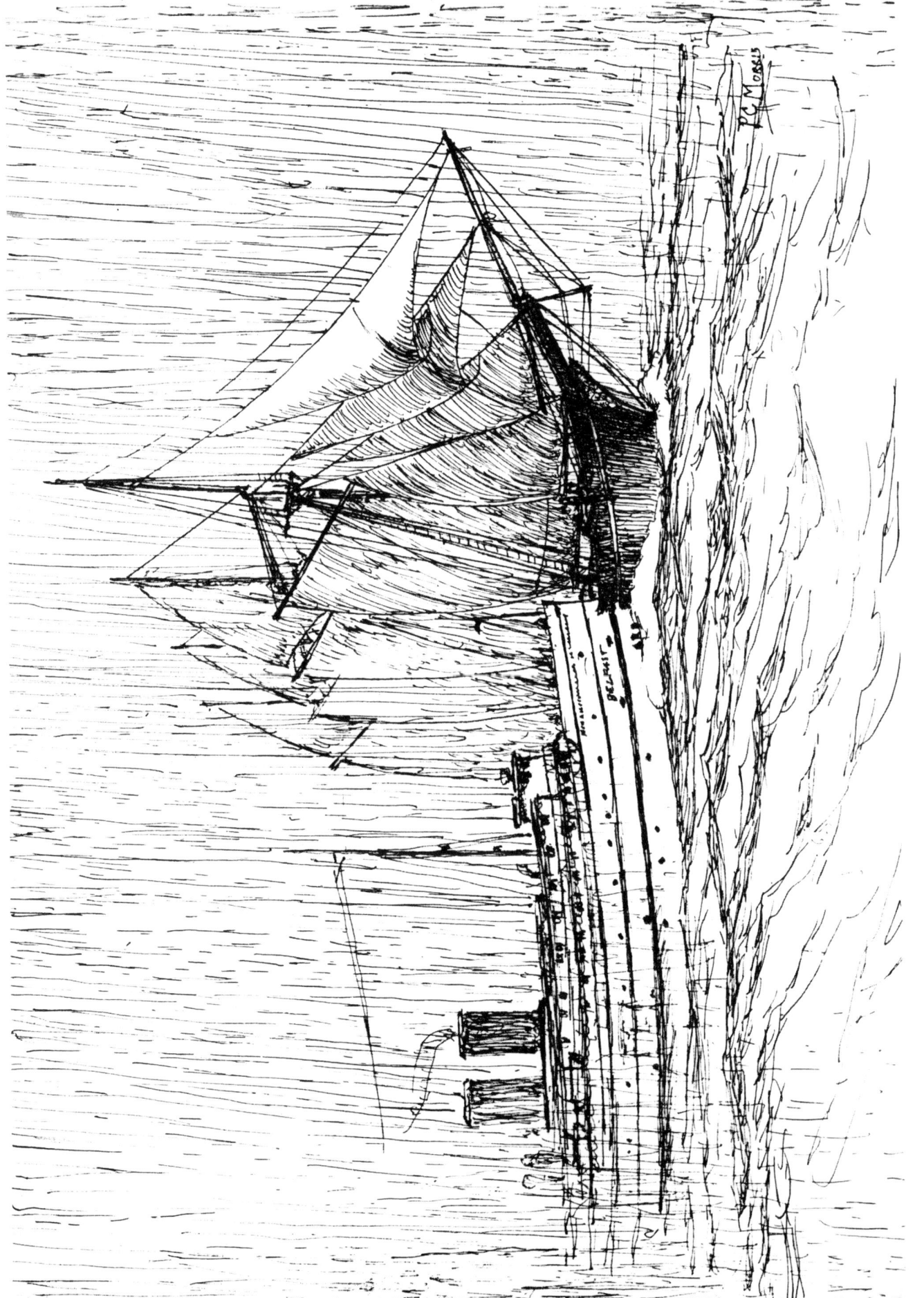

On Oct. 10, 1914, the Bangor to Boston steamer "Belfast" struck the four masted schooner "Alma E. A. Holmes" during a thick fog off of Bakers Island, Massachusetts. The Captain of the "Belfast" kept the steamers bow in the huge hole rammed in the side of the schooner until all of the crew were removed from the sailing vessel. After this he backed away and the "Alma E. A. Holmes", loaded with coal, sank like a stone. (Illustration used in *Shipwrecks Around Maine*.)

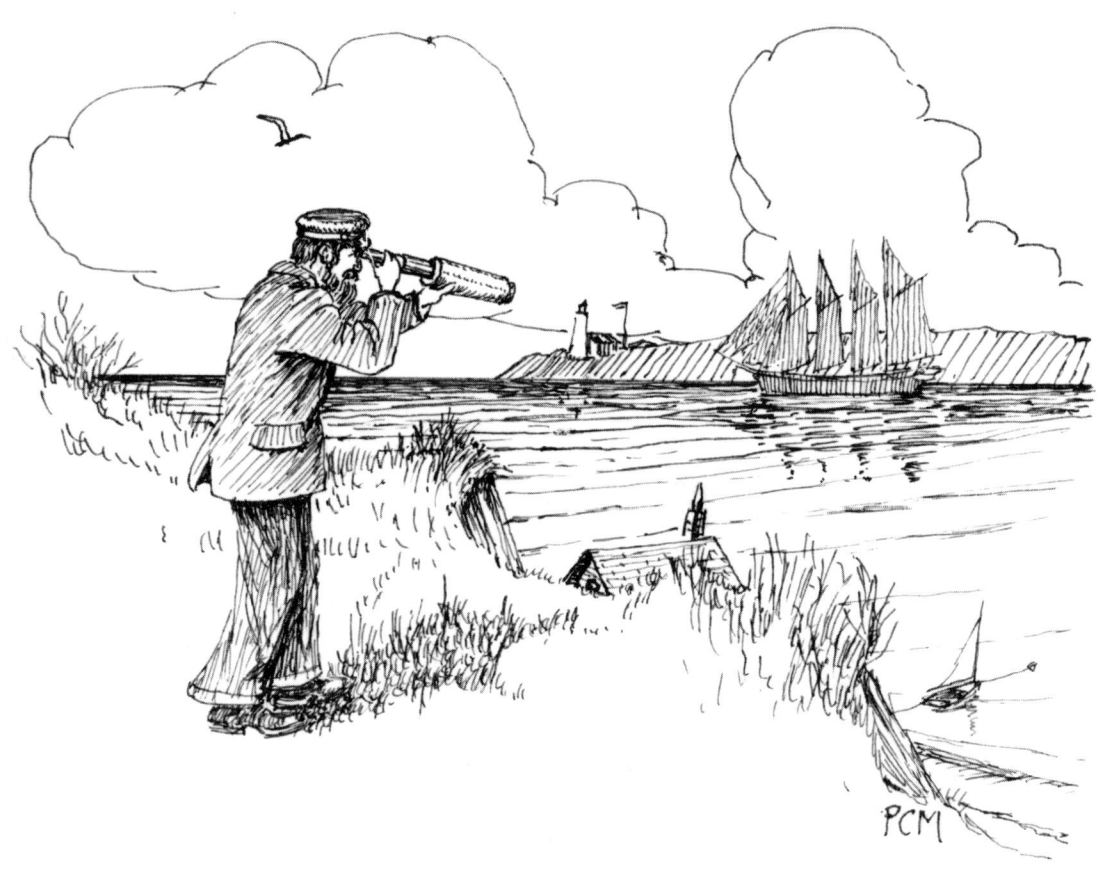

ABOVE: Many schooner operators kept company lookouts on the watch for the near arrival of their vessels. These men, many of whom were retired sea captains, were stationed near the approaches to major ports. When a company vessel was sighted heading in, the lookout would send a message ahead to the owners so that a tug could be dispatched to assist the quicker arrival of the vessel. (Illustration used in *Four Masted Schooners of the East Coast*.) **BELOW:** By the time World War One had broken out, schooners, schooner barges and steam colliers were all competing with one another for cargoes. (Illustration used in *Schooners and Schooner Barges*.)

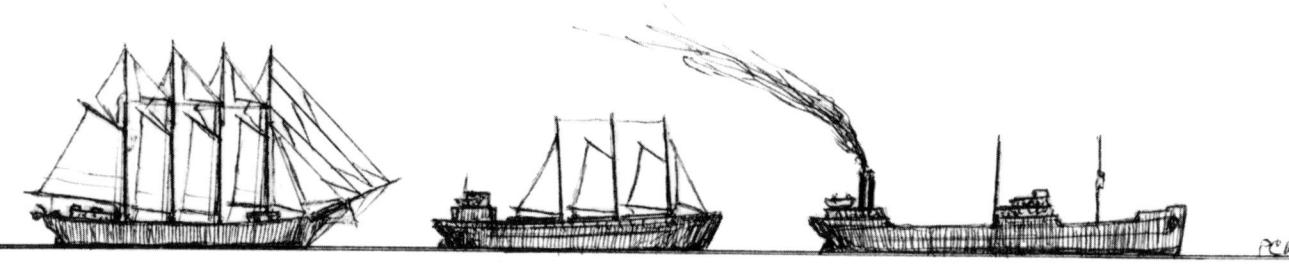

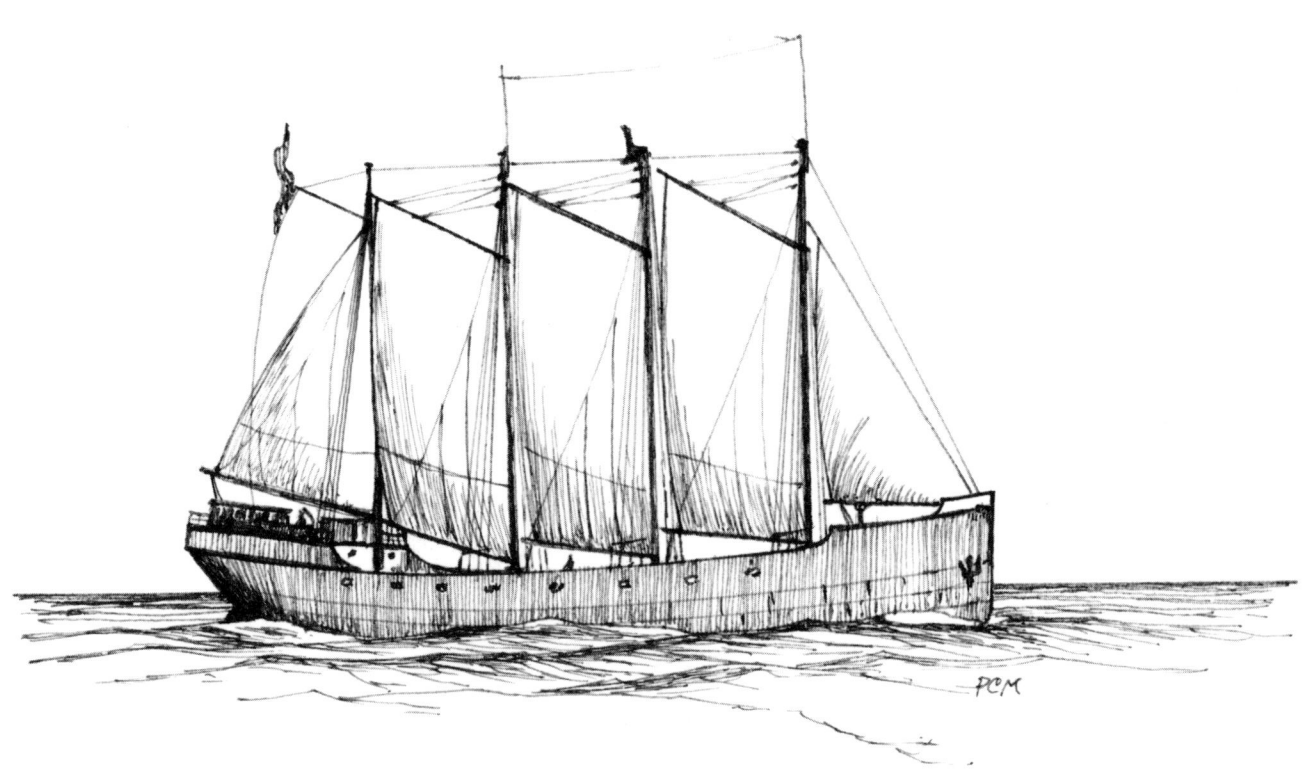

ABOVE: Some very strange looking craft were to be seen traveling along our coast during World War One. Not the least of these were the six steel auxiliary four masted schooners built in Toledo, Ohio in 1916. Their names all ended in "lite". Seen here is the "Starlite", which was sold to Argentina shortly after her launching. A sister ship, the "Daylite", was still afloat in the 1960's. (Illustration used in *Four Masted Schooners of the East Coast*.) **BELOW:** Tows of schooner barges continued during World War One and were seen almost on a daily basis near the approaches to our larger northeastern ports. (Illustration used in *Schooners and Schooner Barges*.)

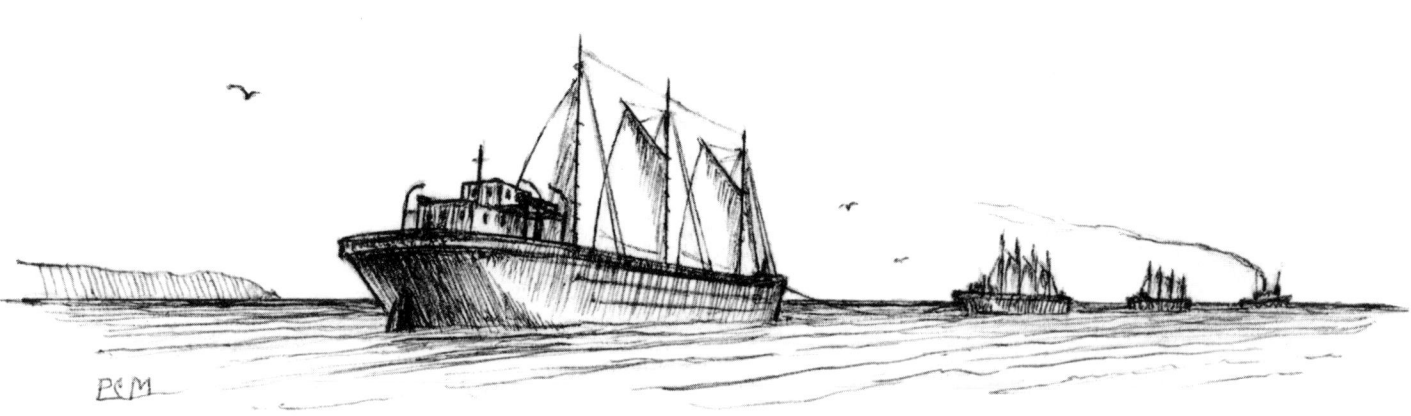

The coal loading docks at Norfolk, Virginia were huge affairs where train carloads of coal were pushed out onto the piers and their contents dumped into the holds of barges, schooners and steam colliers. Here is shown the schooner barge "George R. Stetson", of the Westmoreland Coal Company as she awaits a tow to the north. (Illustration used in *Schooners and Schooner Barges*.)

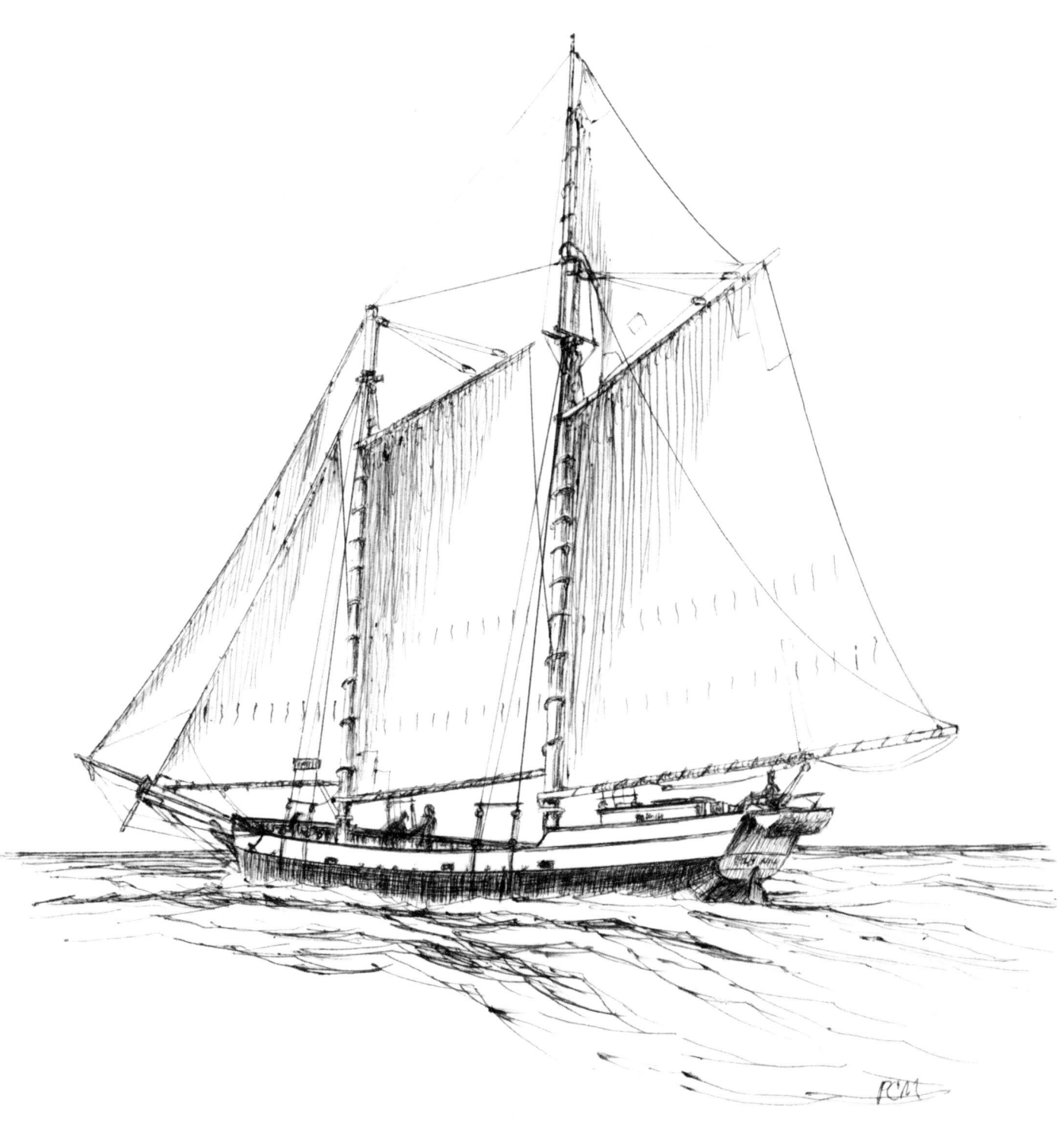

The ancient schooner "Polly", as she appeared around the time of World War One. She was a type of schooner that was referred to in early days as a "heel tapper". She was built in Amesbury, Massachusetss in 1805. Lasting an amazingly long time, she was finally abandoned by her owners at Quincy, Massachusetts in 1918.

Many of the old two masted schooners lasted a long time. A final stranding upon some wave washed shore was more than often the finishing chapter in a hard career. (Illustration used in *Shipwrecks Around Maine*.)

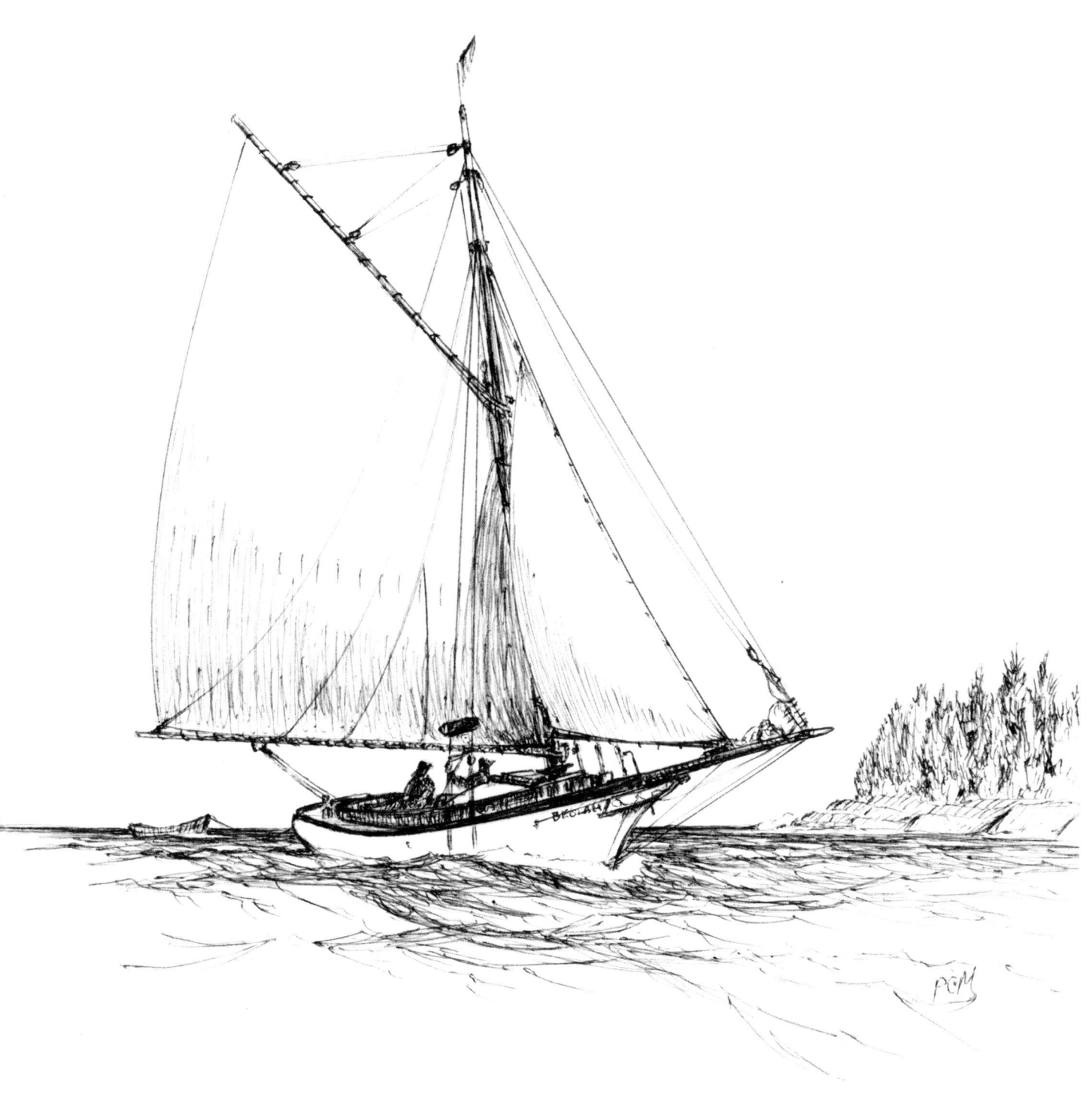

The Friendship sloop "Beulah" was built in Friendship, Maine in 1901. She is typical of a class of sloops built in that region of New England. Originally constructed as small fishing vessels, many of these sturdy craft were taken over by yachtsmen in later years. Some still survive and stand as tributes to their builders; one of whom was the well known Wilbur Morse.

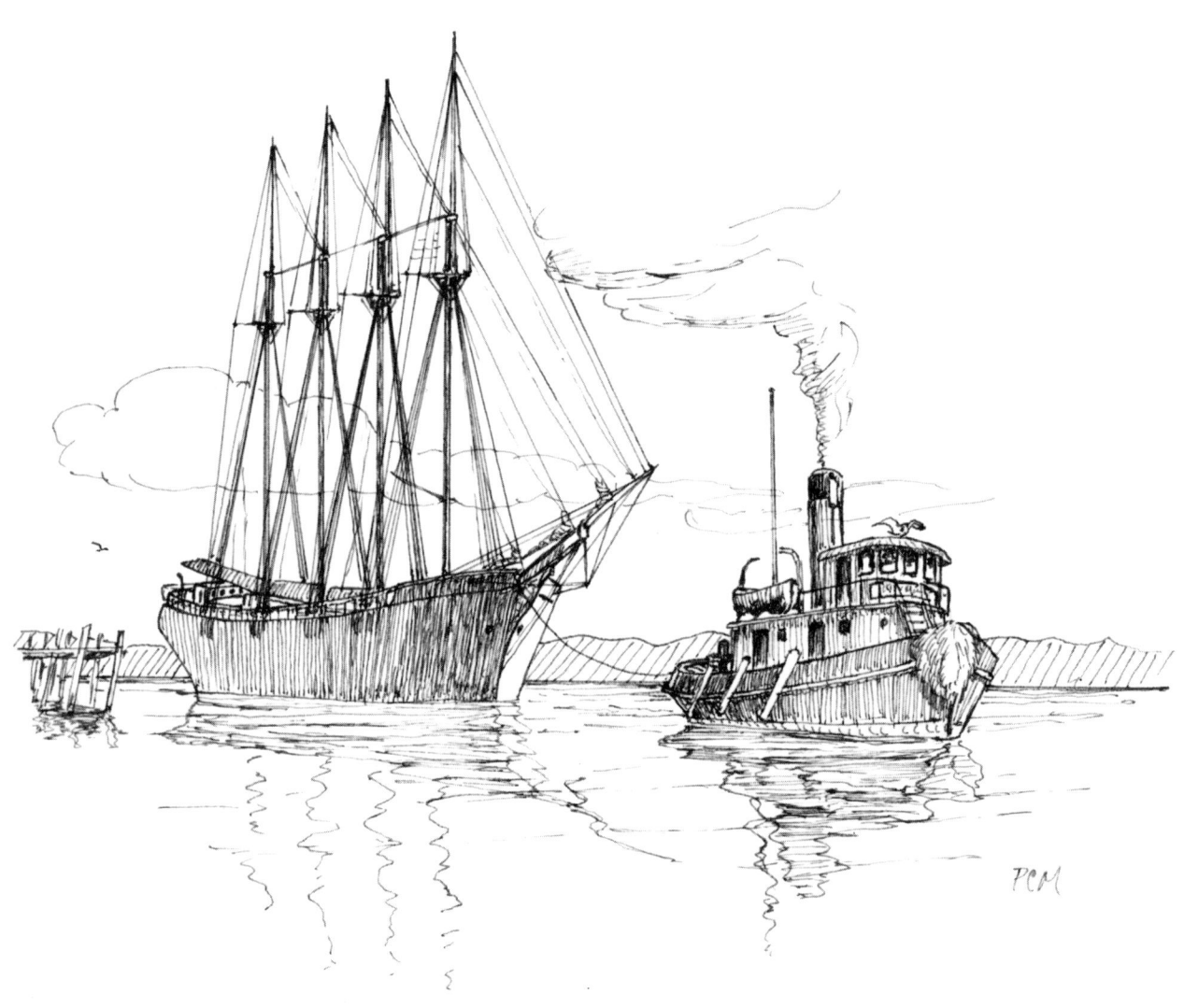

The four masted schooner "Anandale" was built in Sharptown, Maryland in 1919, and was one of the last of these east coast vessels built south of New England. The last eastern four masted schooner to be built was the "Josiah B. Chase", launched in 1921. (Illustration used in *Four Masted Schooners of the East Coast*.)

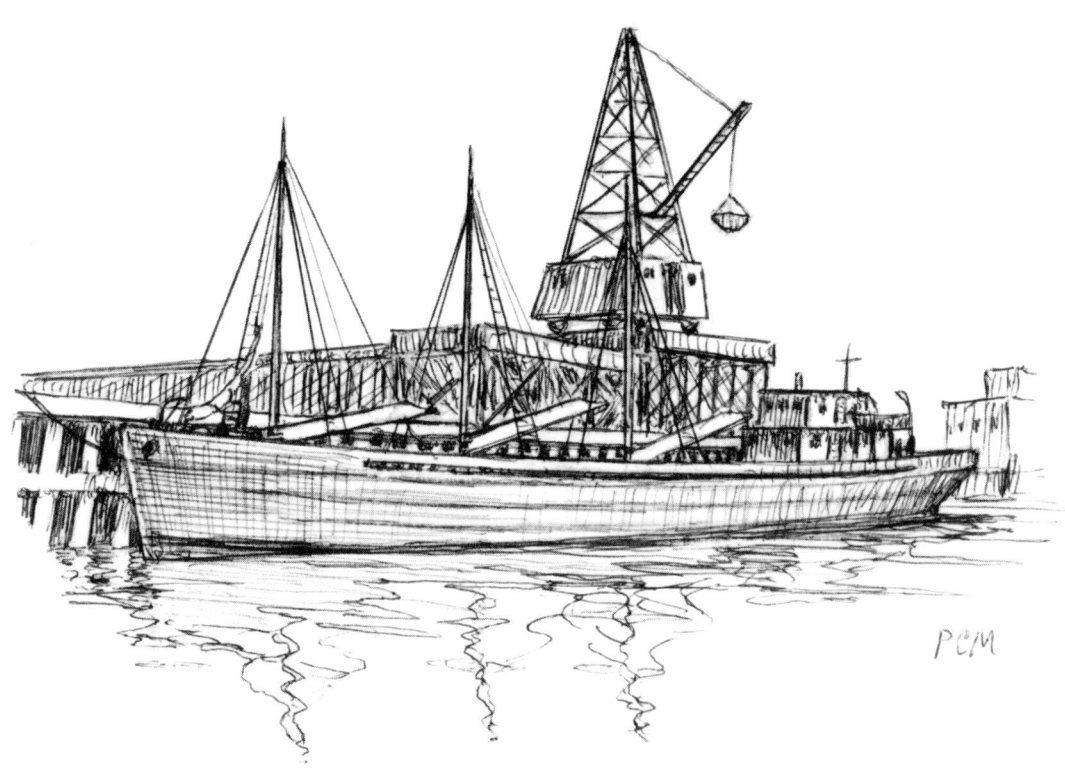

ABOVE: During the 1920's, coal still came into New England industrial ports in large amounts. However, after unloading at a port such as Boston, or Portland, many schooner barges returned to the coaling ports with empty holds. **BELOW:** One of the largest and longest lasting of the schooner barges was the steel, five masted "Dykes", built in 1919. Although stripped of her masts in the 1930's, she was still in commission in the late 1950's. (Illustrations used in *Schooners and Schooner Barges*.)

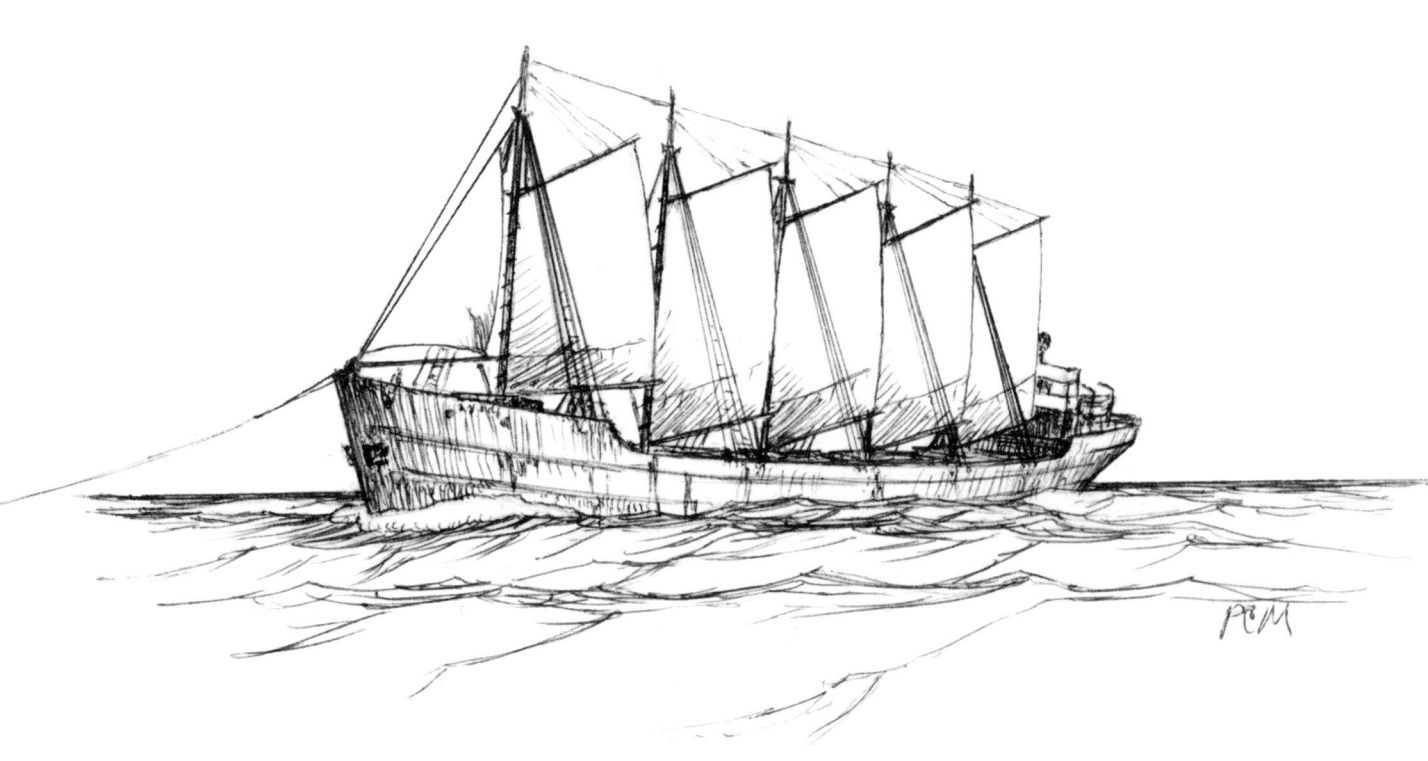

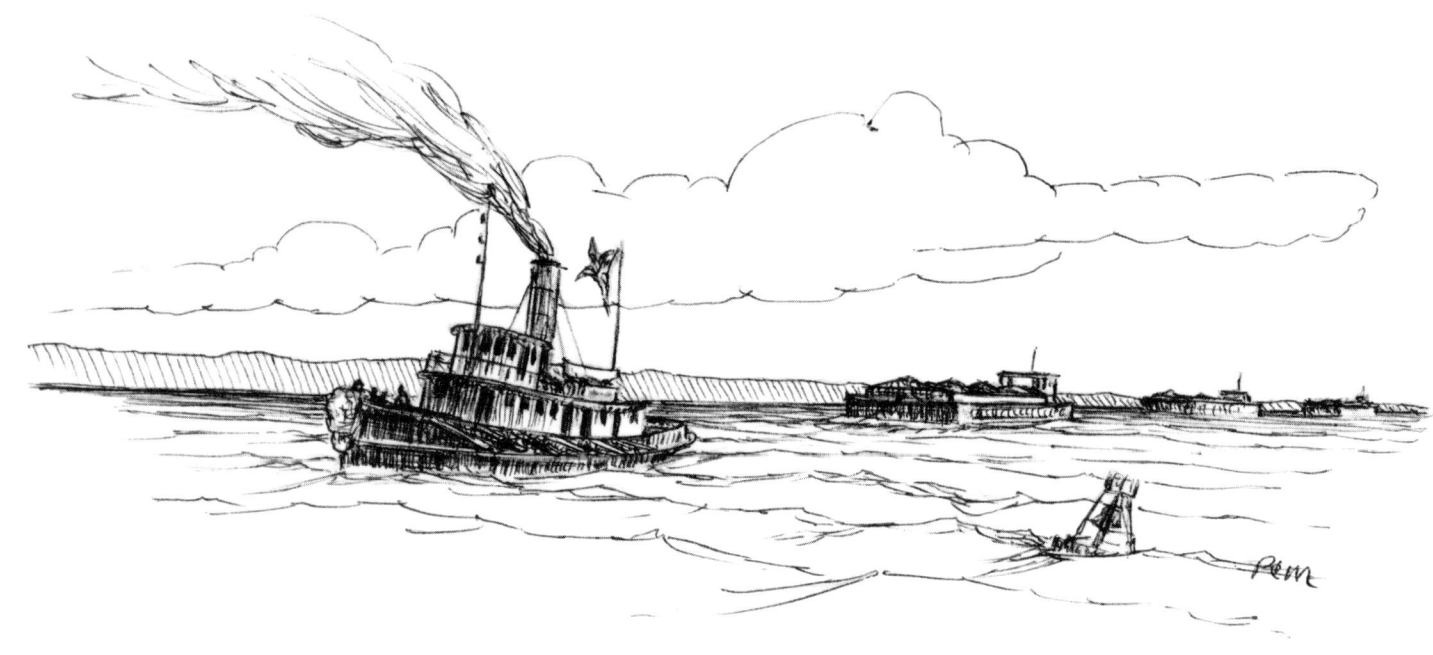

ABOVE: A tug and a tow of box barges proceeds through Long Island Sound in the 1920's. (Illustration used in *Schooners and Schooner Barges.*) **BELOW:** All during the late 1920's and 1930's, schooners that were unable to find work were hauled into quiet harbors where they slowly went into disrepair. These layups often became permanent and some of these quiet harbors turned into ship graveyards. (Illustration used in *American Sailing Coasters of the North Atlantic.*)

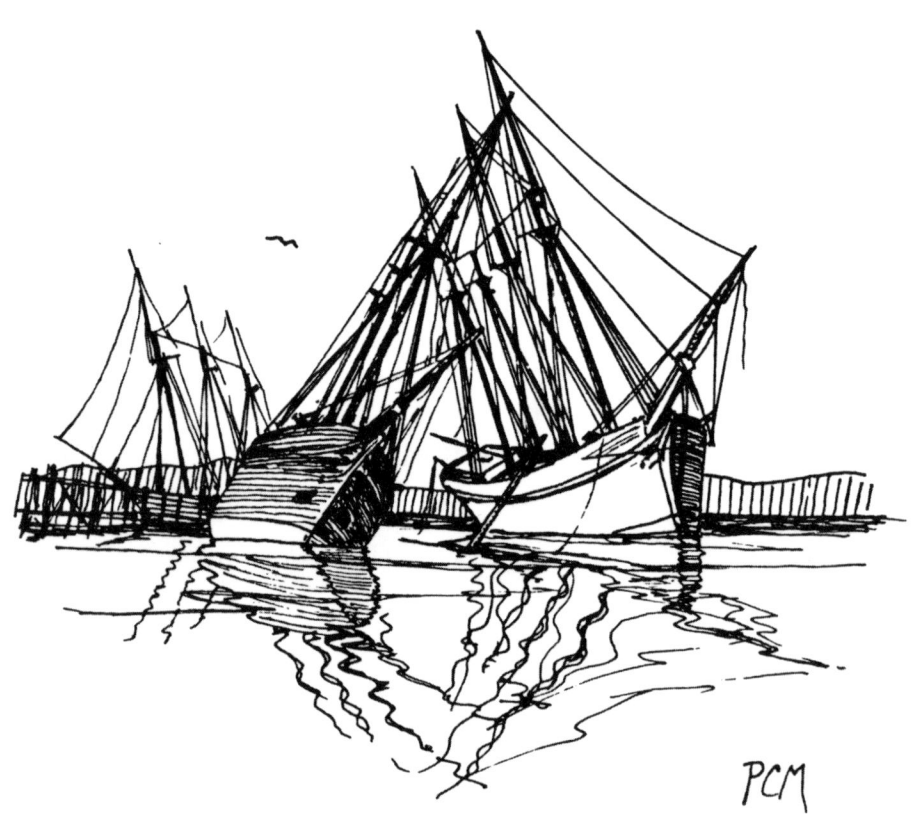

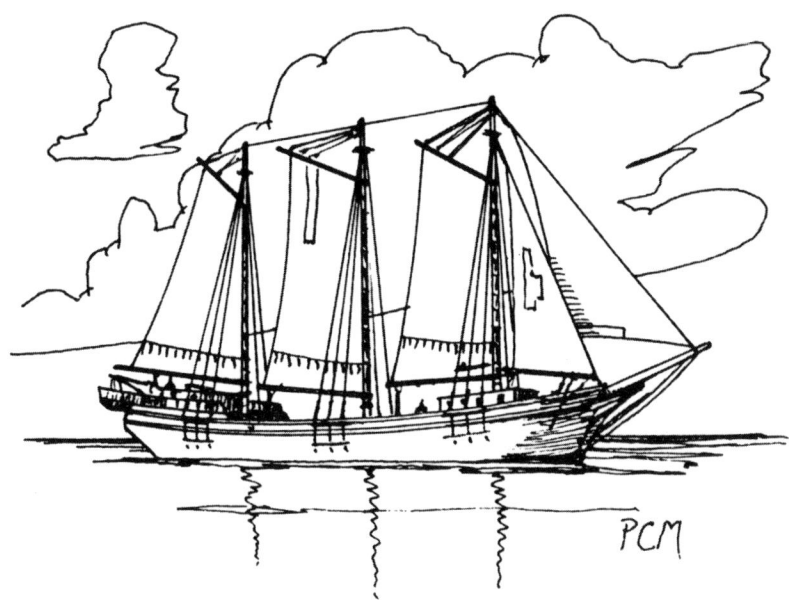

ABOVE: A Ram was a particular style of flat bottomed schooner that was built in the area of Chesapeake Bay. They were built so they could negotiate the locks in some of the canals in that region. They were usually "bald headed", with no topmasts. The only surviving three masted schooner that is sailing today is one of these rams. She is named "Victory Chimes", and sails out of Rockland, Maine. **BELOW:** While trade died out for many larger schooners in the 1920's, the smaller two and three masted schooners tried to scratch out a living. Some succeeded but were reduced to carrying almost anything that would squeeze out a profit. Being in a fixed trade became a thing of the past. (Illustrations used in *Sailing Coasters of the North Atlantic*.)

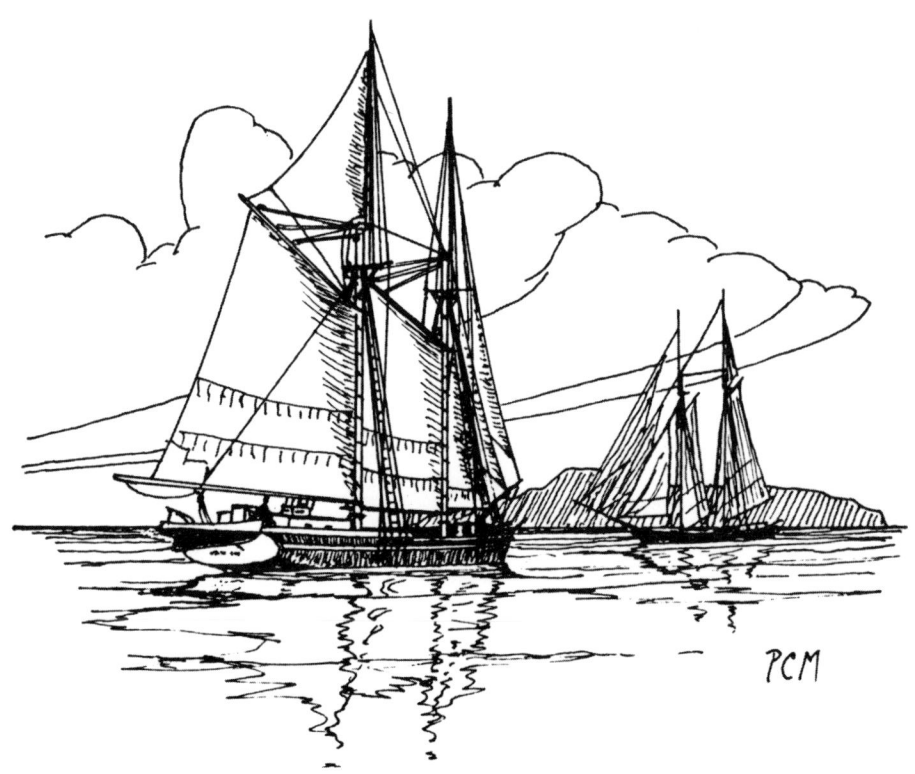

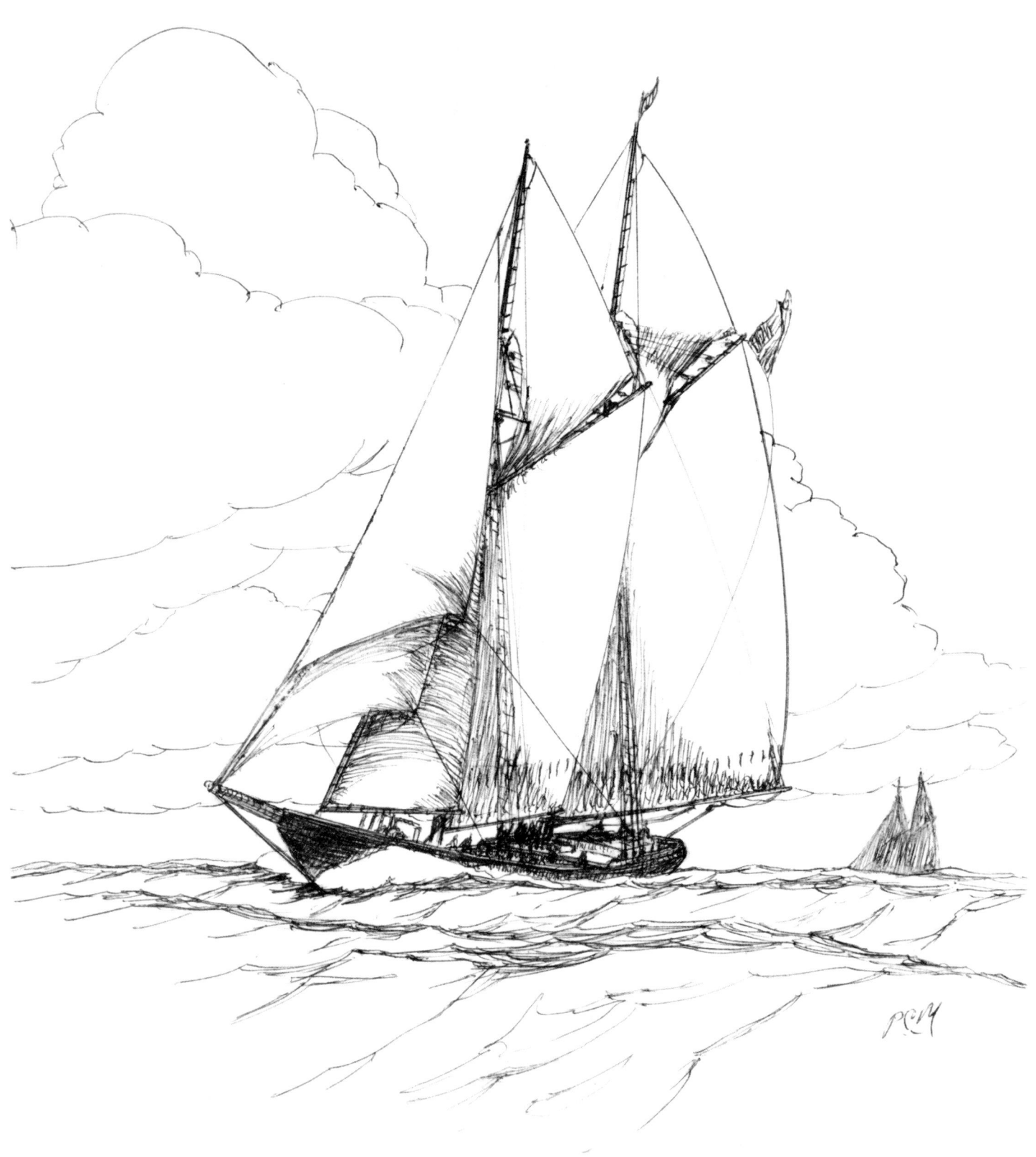

One of the most beautiful of the racing, fishing schooners that hailed from the port of Gloucester was the "Columbia". She was built in Essex, Massachusetts in 1923. This very fast vessel had a short and sad career. She was lost with all twenty-three hands on Aug. 24, 1927, off of Sable Island.

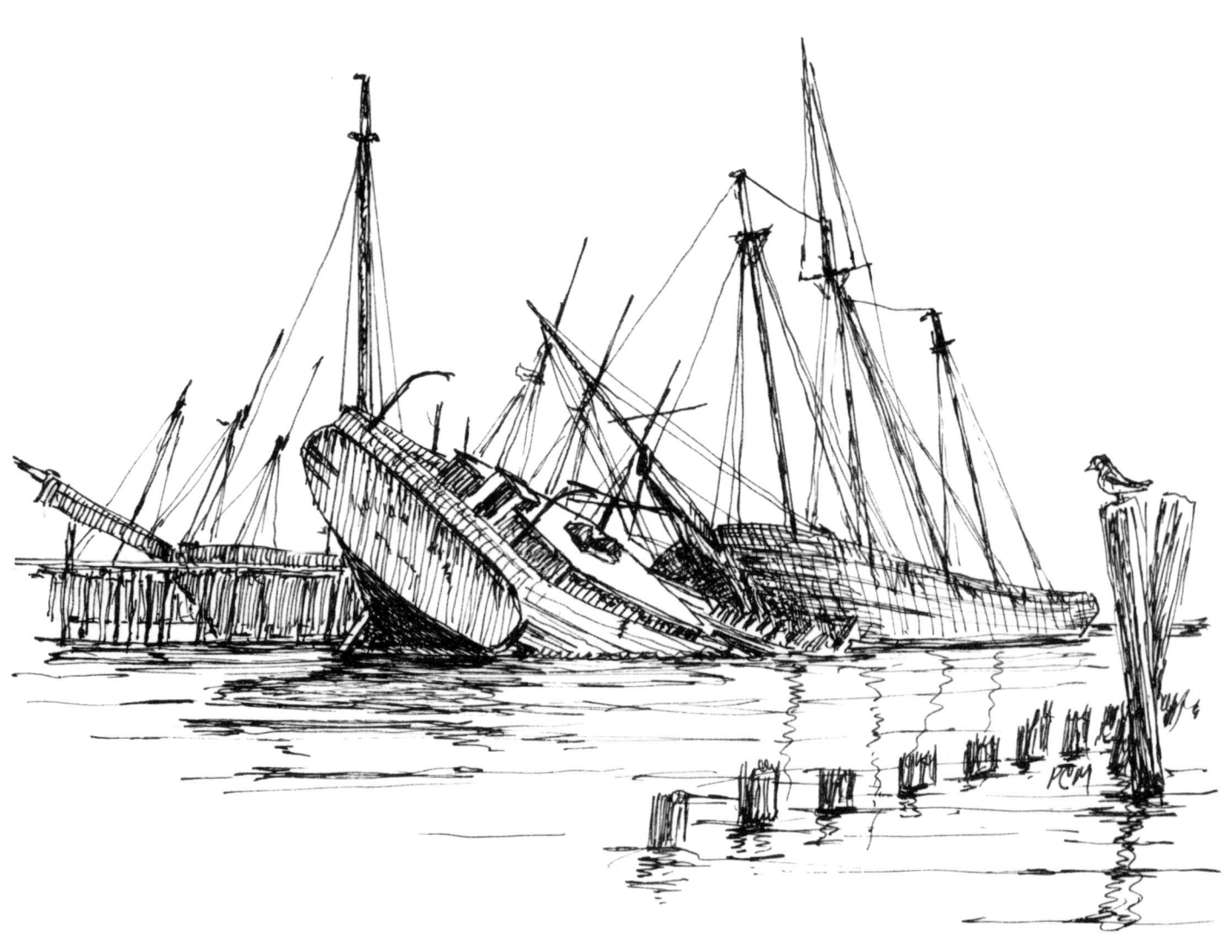

In places like Kill Van Kull, Staten Island, the old barges and schooners left tied to the coal piers gradually fell apart. In time both vessels and wharves went into complete decay. (Illustration used in *Four Masted Schooners of the East Coast*.)

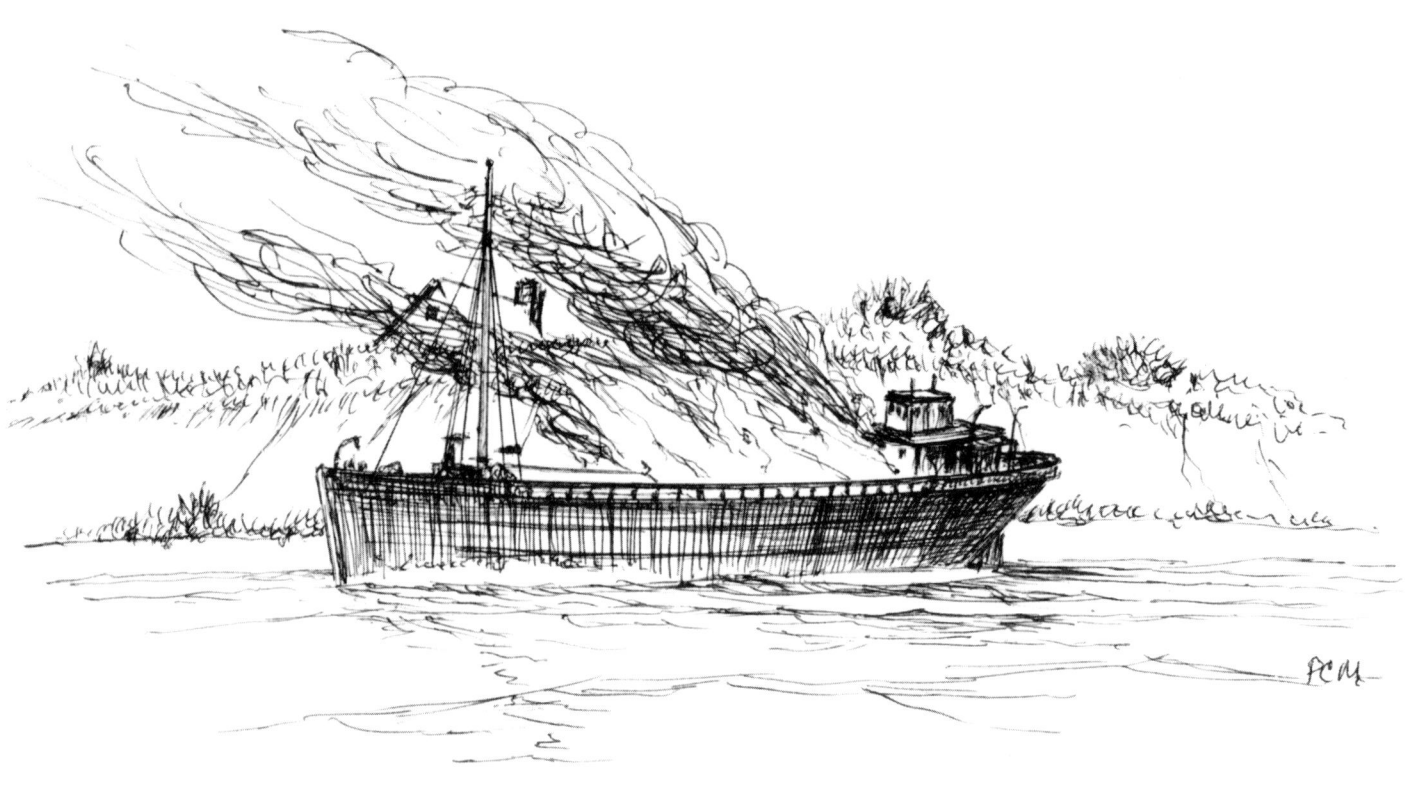

ABOVE: On Nov. 30, 1932, the sloop barge "L. & W.-B.C. Co. No. 9" blew ashore on Dionis Beach, Nantucket. Although she could have been easily salvaged, her owners abandoned her due to the difficult economics of the times. Vandals set the barge on fire and she burned for a week. **BELOW:** The older schooner barges continued to suffer losses during the 1920's and 1930's. By the time World War Two was started there weren't many schooner barges left. (Illustrations used in *Schooners and Schooner Barges*.)

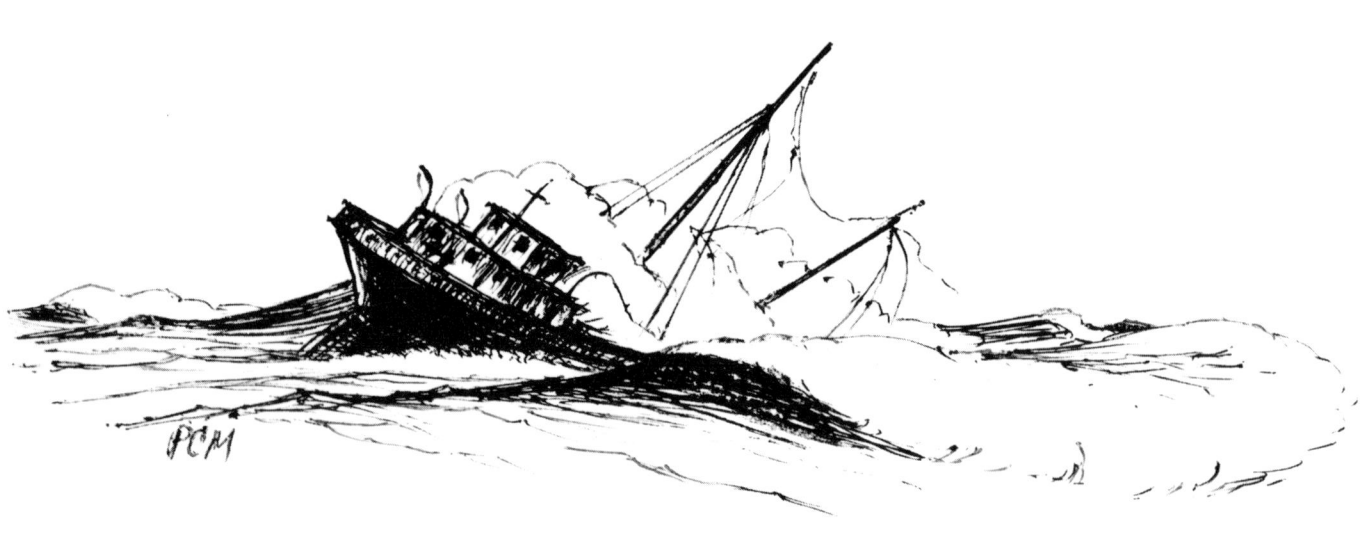

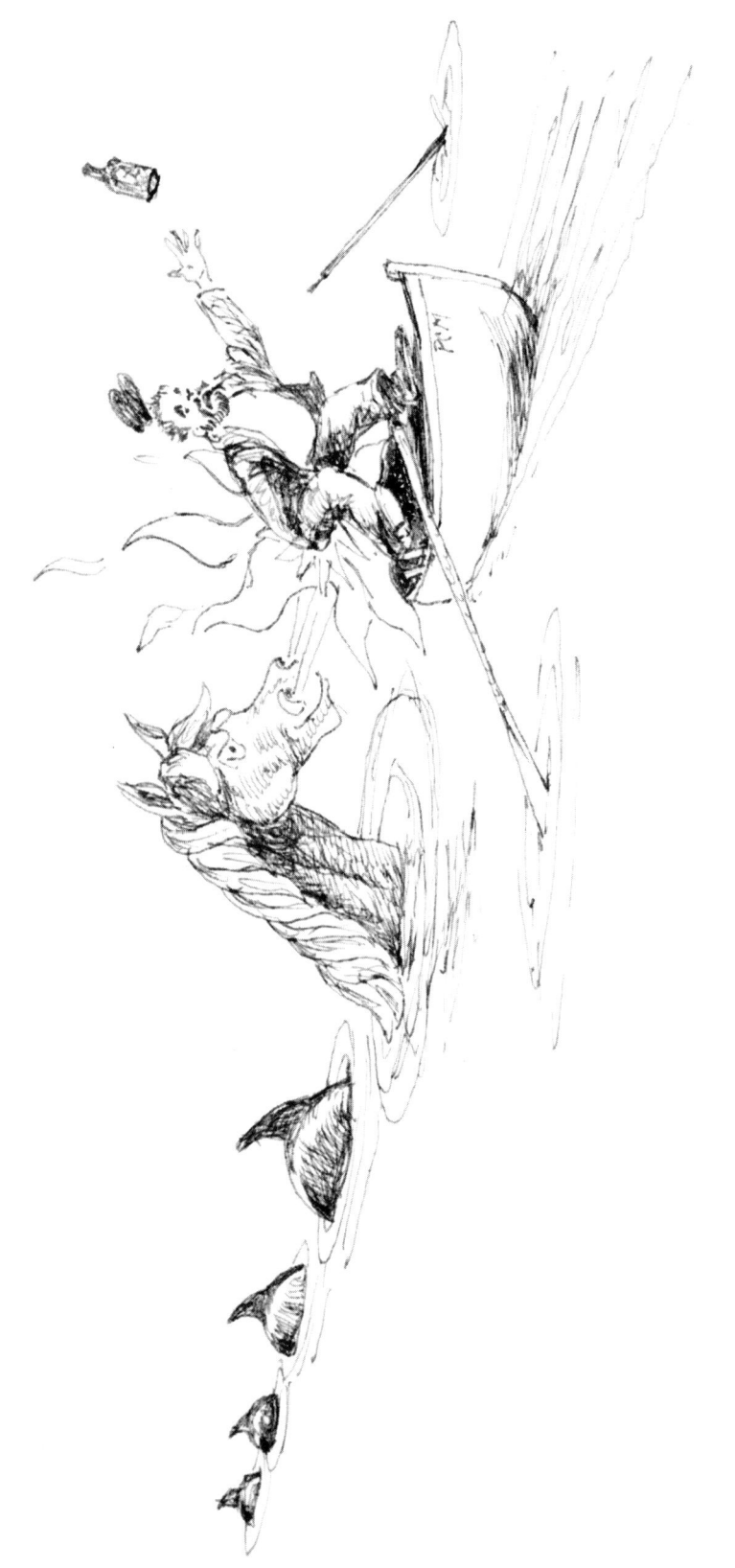

Sailors and fishermen love to spin a good "yarn". Take the Penboscot Bay sea serpent "Scotty", for example. There's more than one old "tar" in Maine who can recall a close encounter with this salty demon. (Illustration used in *Shipwrecks Around Maine*.)

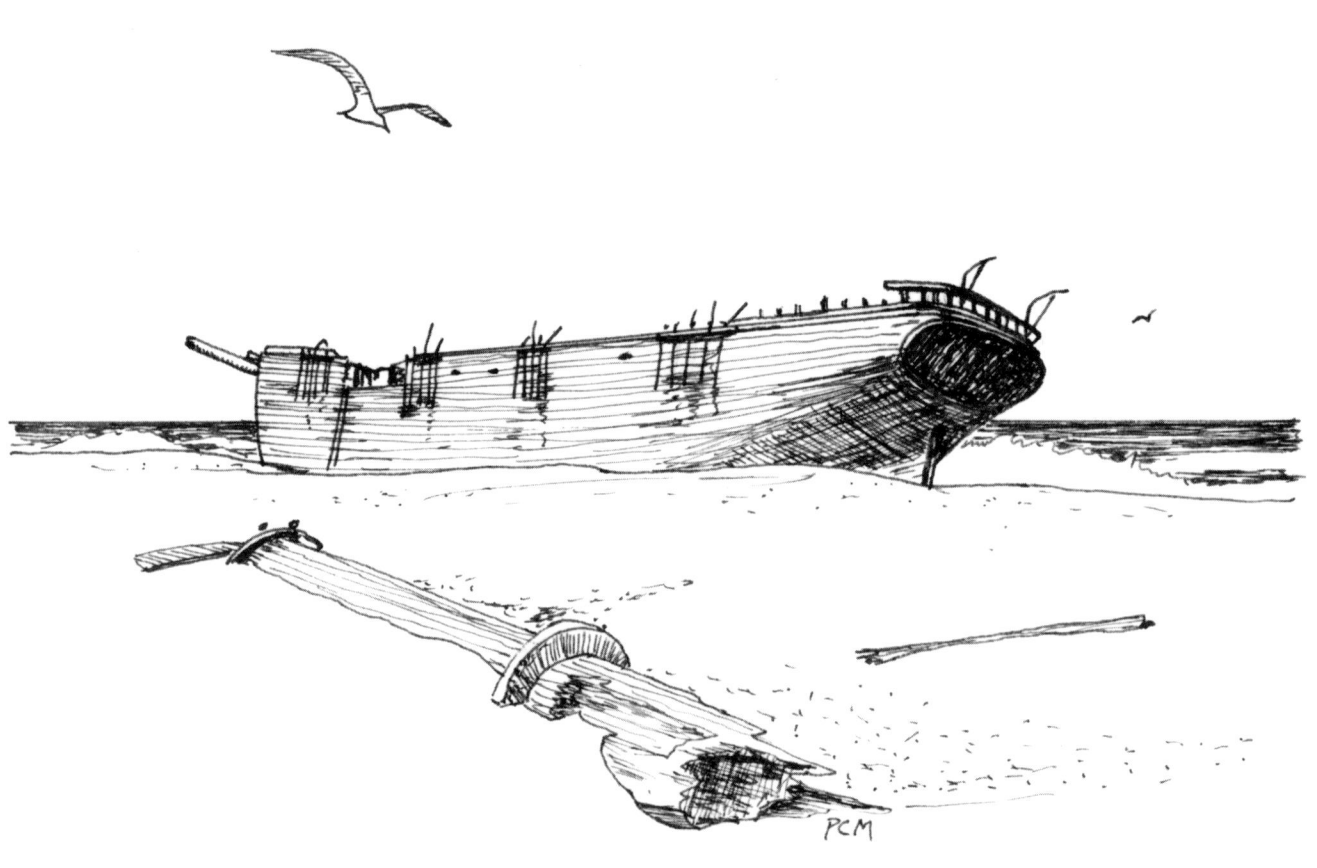

The four masted schooner "G. A. Kohler" was wrecked on Cape Hatteras, North Carolina, on Aug. 22, 1933. Her wreck lay there for a long time and was finally burned. (Illustration used in *Four Masted Schooners of the East Coast*.)

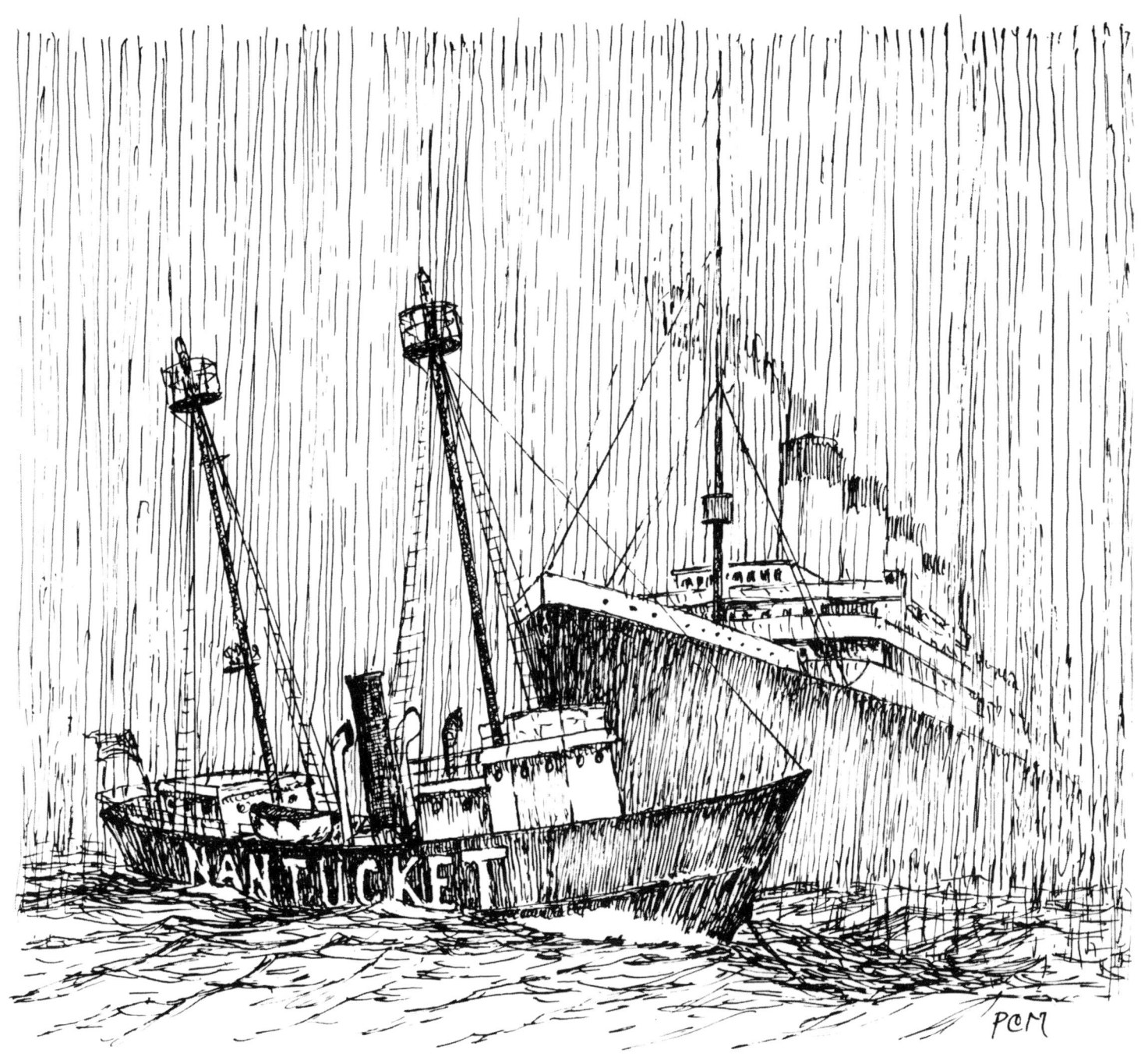

Passengers crossing the Atlantic in the 1930's still preferred the comfort of the big ocean liners. By then navigation aids along with radio communication had greatly improved. On May 15, 1934, the White Star liner "Olympic" rammed and sank the Nantucket lightship. The liner was following the radio beacon from the lightship during a thick fog and cut the little vessel in two. Seven men died and four were rescued. (Illustration used in *Shipwrecks Around New England*.)

The days of sailing coasting were rapidly coming to an end in the 1930's. More than one old vessel came to the termination of a long career in the years just before World War Two. (Illustration used in *Shipwrecks Around New England*.)

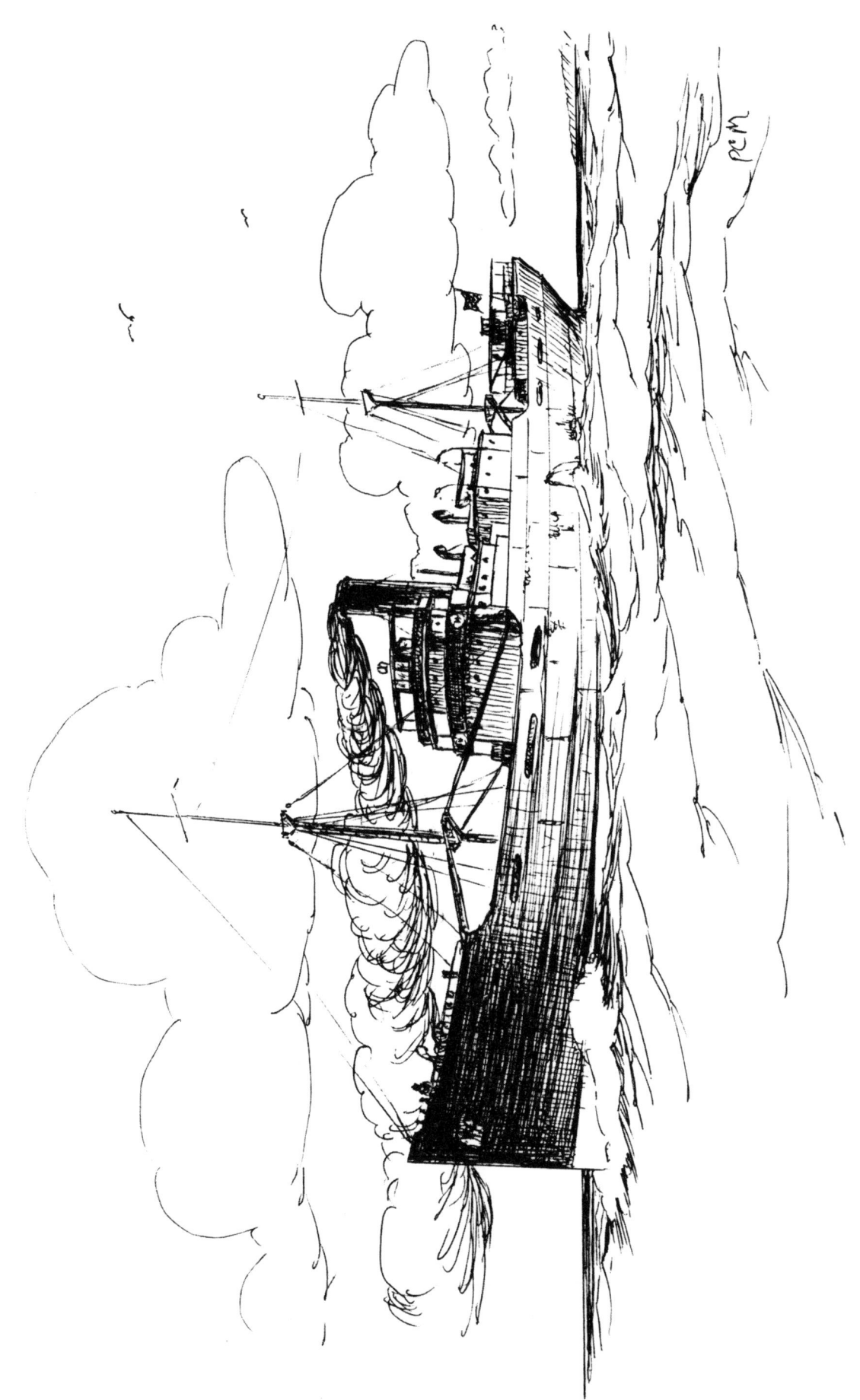

Following World War One, and into the 1920's and 1930's, the tramp steamer became a familiar part of the maritime scene. These vessels had no fixed schedules and traveled the world over, looking for cargoes.

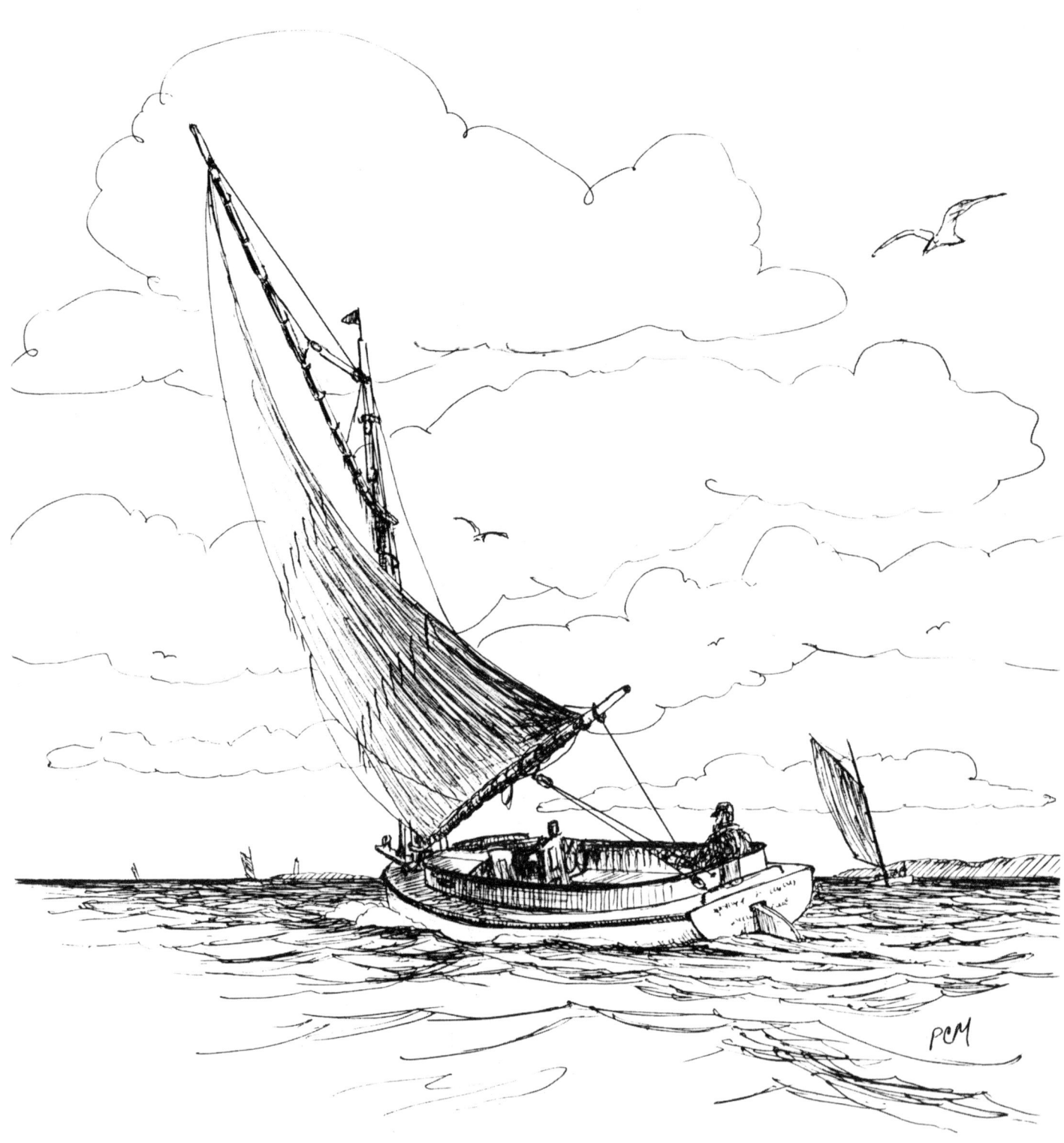

Along coastal waterways there were still many small sailing craft to be seen in the days following the Second World War. In Nantucket the catboat had been used for many years for fishing, carrying passengers and for yachting purposes. After the War many of these beamy little craft had been reduced to powered scallop boats with their masts removed. By the 1960's there were very few sizeable wooden, sailing catboats left. During that time Paul's Boat Livery on Nantucket operated the last commercial fleet of old time catboats on the island.

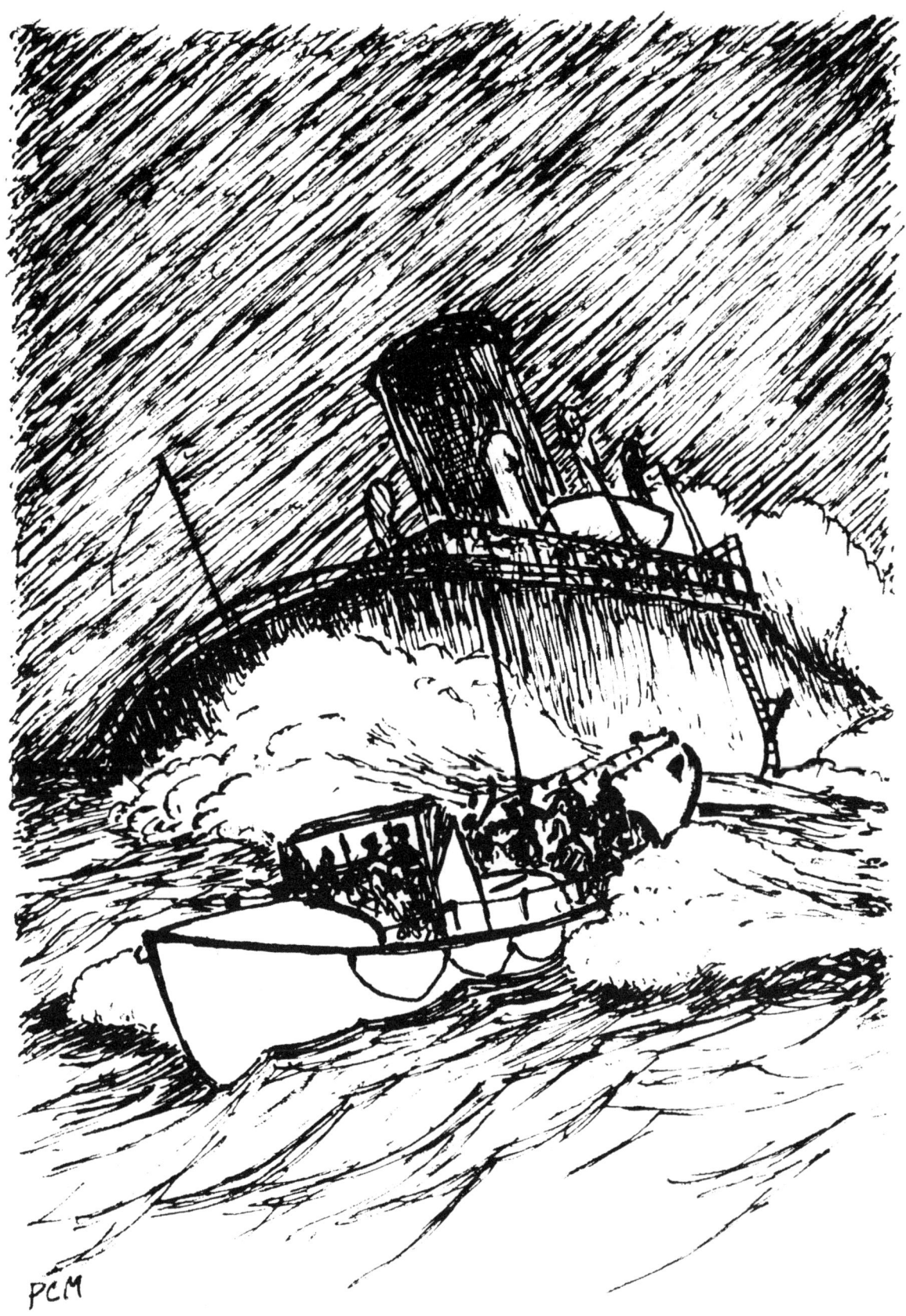

On the night of Feb. 18, 1952, during a furious northeast gale, the tanker "Pendleton" broke in two off of Cape Cod. The U.S. Coast Guard came to the rescue in the motor lifeboat "C.G. 36500". The heroic Coast Guardsmen were able to rescue 32 men from the stern of the doomed tanker. One man from the stricken vessel was lost. Today the "C.G. 36500" is being preserved as a monument to that fateful night. (Illustration used by the Orleans Historical Society.)

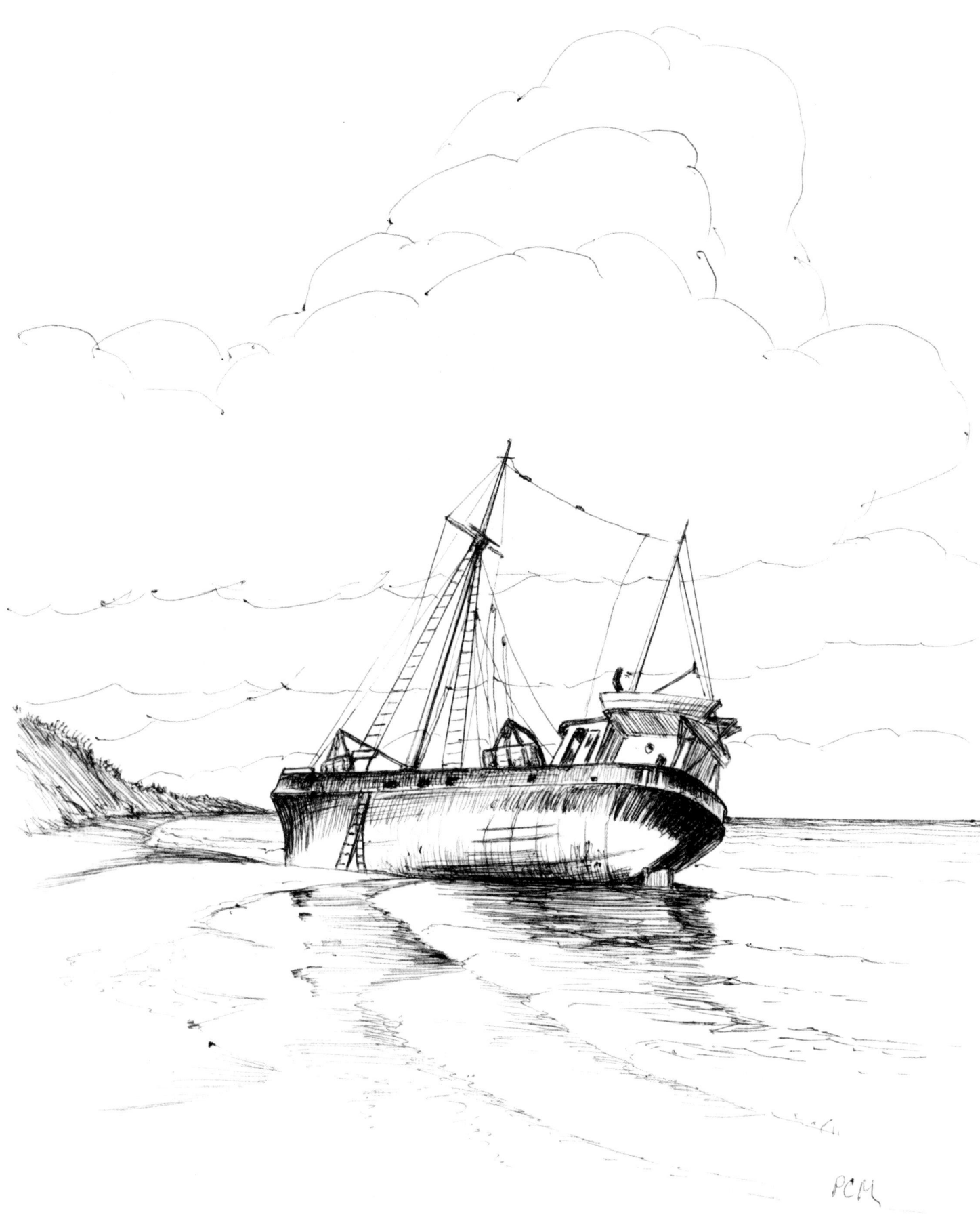

During the winter of 1962, the dragger "Sharon Louise" was driven ashore on the North side of Nantucket Island. Usually vessels going ashore during a gale are lost, but the "Sharon Louise" was lucky. She was eventually salvaged and returned to the hard work of catching fish.

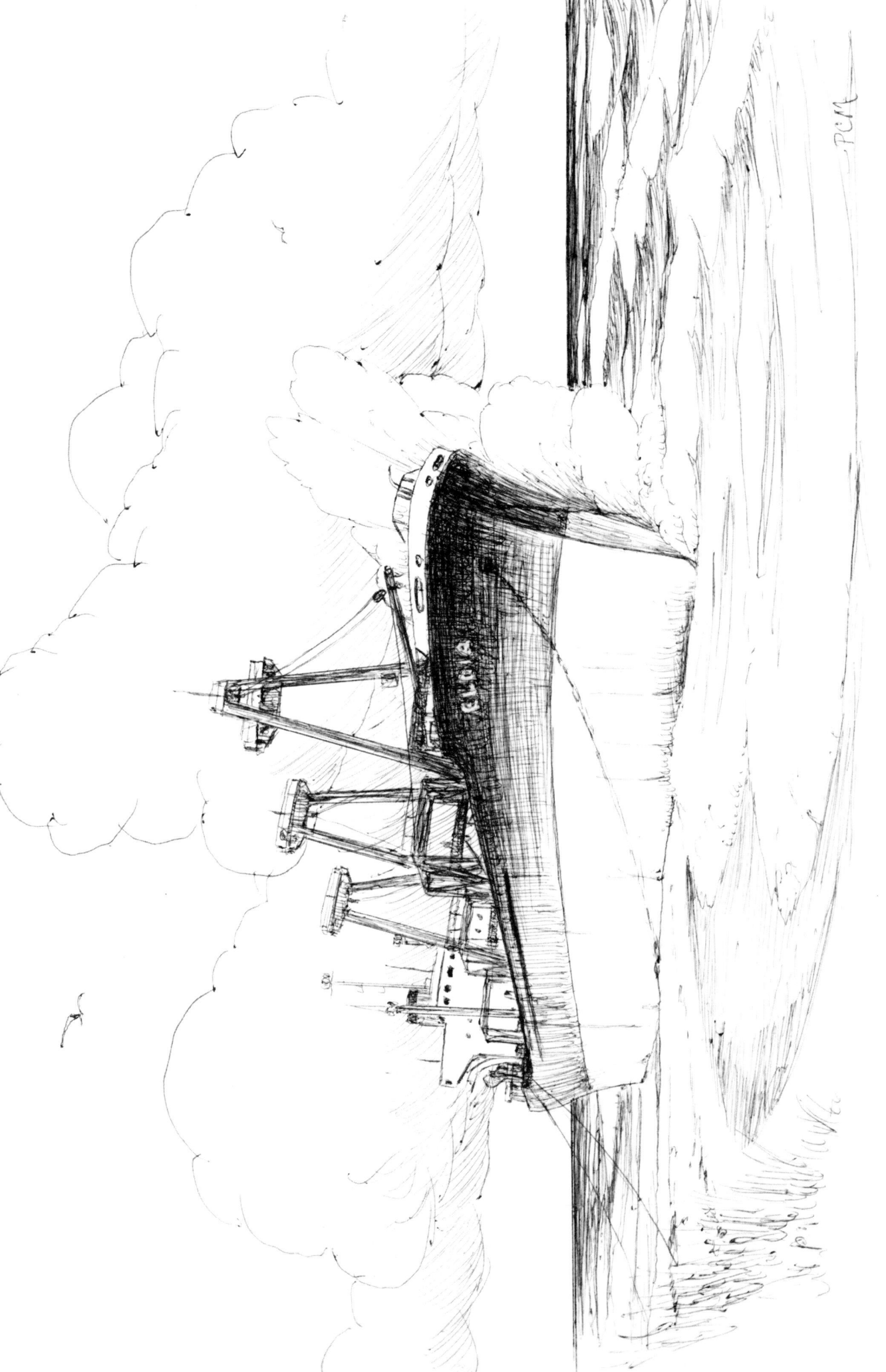

The "ELDIA" is a modern tramp cargo vessel. Registered out of Malta, she was heading empty, from St. Johns N.B., where she had delivered a cargo of sugar, to Norfolk, Virginia. She blew ashore off Orleans, on Cape Cod, on March 29, 1984 during a severe gale. She remained on the beach for 49 days and was a great attraction for the tourists. She was miraculously hauled off of this treacherous shore on May 17, and was towed to an anchorage off Newport, R.I.

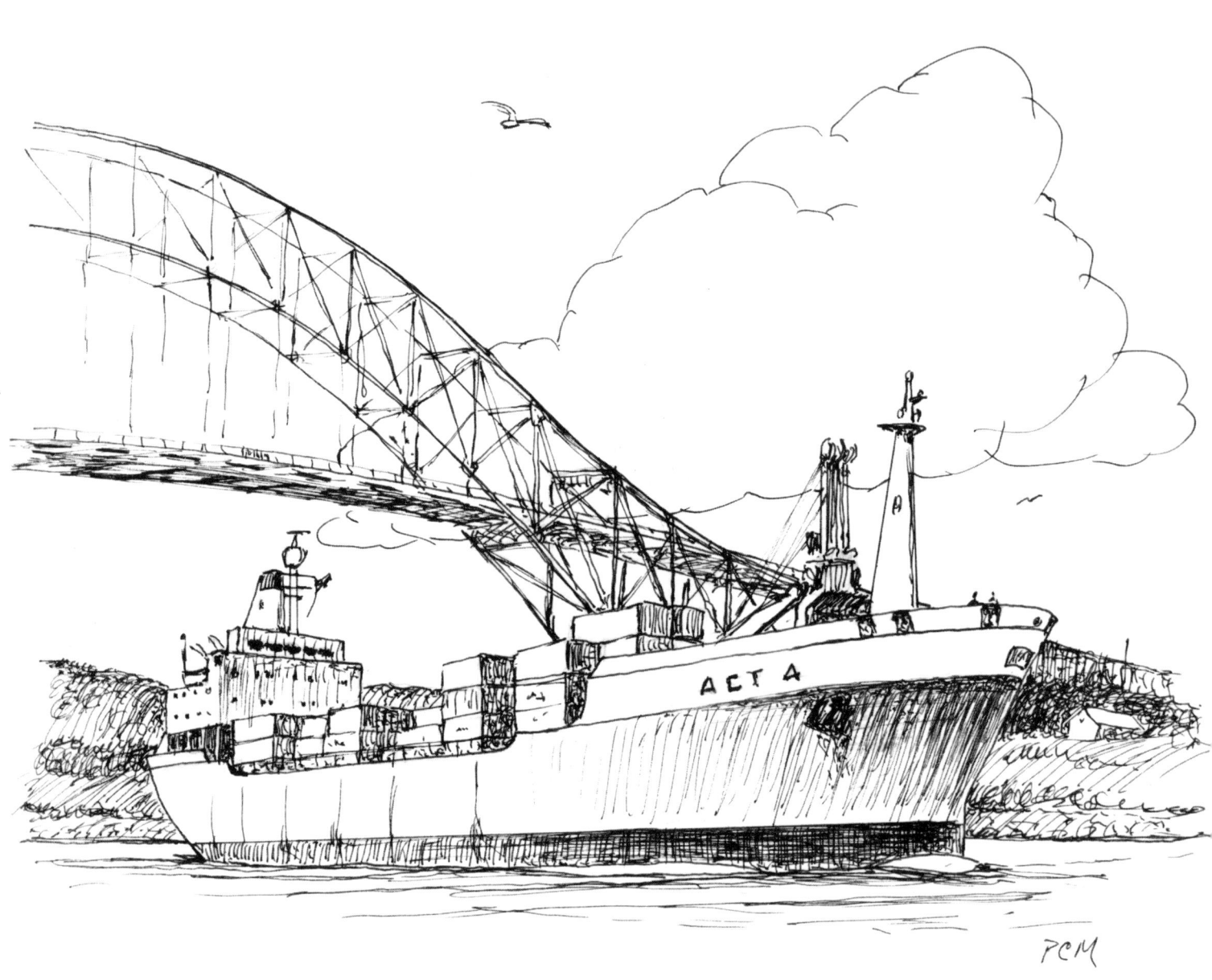

A modern container ship heads through the Cape Cod Canal bound for Boston. The need for the faster and efficient delivery of cargo has led to more utilitarian changes in ship design.